COMMON MAN MYTHIC VISION

The Paintings of Ben Shahn

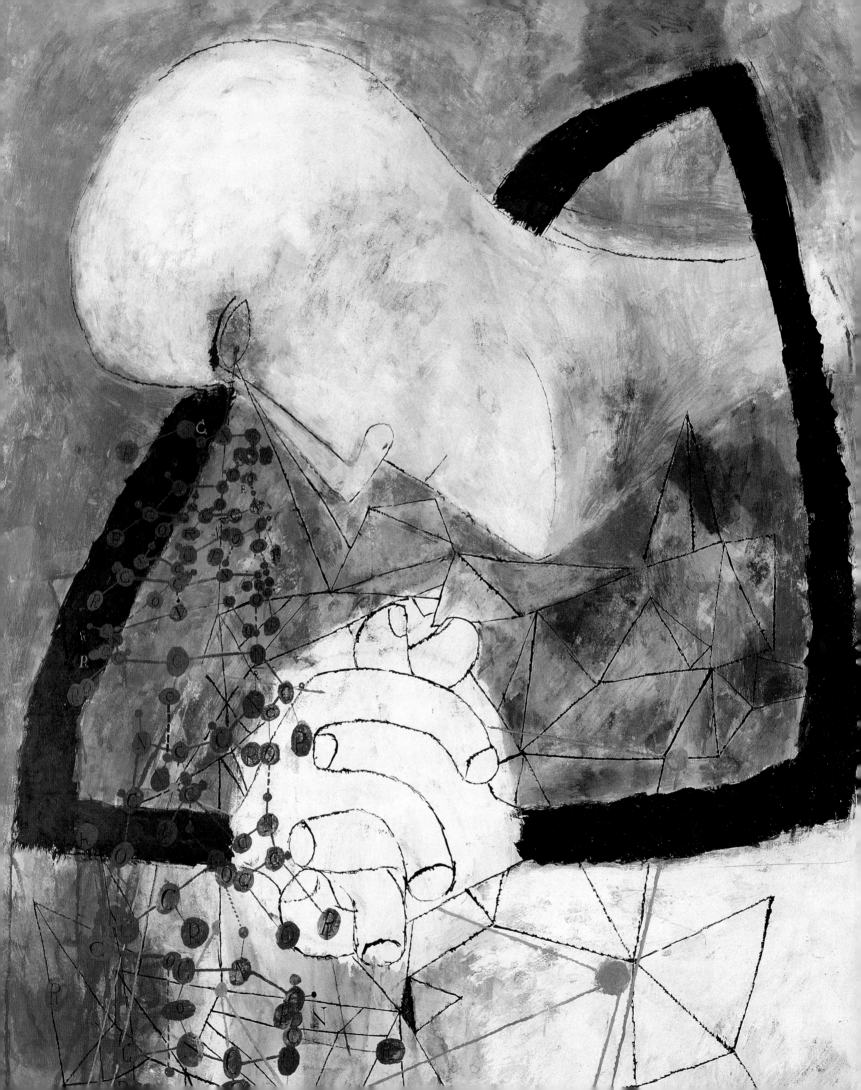

COMMON MAN MYTHIC VISION

The Paintings of Ben Shahn

SUSAN CHEVLOWE

With contributions by

DIANA L. LINDEN

STEPHEN POLCARI

FRANCES K. POHL

and HOWARD GREENFELD

THE JEWISH MUSEUM NEW YORK
Under the auspices of The Jewish Theological Seminary of America

PRINCETON UNIVERSITY PRESS

This book has been published in conjunction with the exhibition
Common Man, Mythic Vision: The Paintings of Ben Shahn

The Jewish Museum, New York
November 8, 1998–March 7, 1999

Allentown Art Museum
March 28–June 27, 1999

The Detroit Institute of Arts
July 25–October 31, 1999

Common Man, Mythic Vision: The Paintings of Ben Shahn has
been sponsored by

ΞΙΙ ERNST&YOUNG LLP

Major support was received through the generosity of
the Henry Luce Foundation. Additional funding was provided
by the National Endowment for the Arts, a federal agency.
The catalogue was published with the aid of a publications fund
established by the Dorot Foundation.

Exhibition Curator: Susan Chevlowe
Consulting Curator: Stephen Polcari
Exhibition Designer: Hut Sachs Studio
Catalogue Editor: Sheila Friedling

Front cover: Detail of *Spring,* 1947 (plate 12)
Back cover: *New York,* 1947 (plate 13)
Frontispiece: Detail of *Helix and Crystal,* 1957 (plate 25)
Pages 142–43: Detail of *Second Allegory,* 1953 (plate 20)

Published and distributed by:
Princeton University Press
41 William Street
Princeton, New Jersey 08540

In the United Kingdom:
Princeton University Press
Chichester, West Sussex

Designed by Carol S. Cates

This book has been composed in Monotype Bembo and Gill Sans by
Duke & Company, Devon, Pennsylvania

Printed and bound by CS Graphics, Singapore

(cloth) 10 9 8 7 6 5 4 3 2 1
(paper) 10 9 8 7 6 5 4 3 2 1

Library of Congress Cataloging-in-Publication Data
Chevlowe, Susan.
 Common man, mythic vision : the paintings of Ben Shahn / Susan
 Chevlowe ; with contributions by Diana L. Linden . . . [et al.].
 p. cm.
 Catalog of an exhibition held at the Jewish Museum, New York,
 Nov. 8, 1998–Mar. 7, 1999, the Allentown Art Museum, Pennsylvania,
 Mar. 28–June 27, 1999, and the Detroit Institute of Arts, Michigan,
 July 25–Oct. 31, 1999.
 Includes bibliographical references and index.
 ISBN 0-691-00406-4 (cloth : alk. paper). — ISBN 0-691-00407-2
 (pbk. : alk. paper)
 1. Shahn, Ben, 1898–1969—Exhibitions. I. Linden, Diana L.
 II. Shahn, Ben, 1898–1969. III. Jewish Museum (New York, N.Y.)
 IV. Allentown Art Museum. V. Detroit Institute of Arts. VI. Title.
 ND237.S465A4 1998
 759.13—dc21

 98-24384
 CIP

Contents

Lenders to the Exhibition

Albright-Knox Art Gallery, Buffalo, New York

Amon Carter Museum, Fort Worth, Texas

Mr. and Mrs. William C. Bahan

Merrill C. Berman

Curtis Galleries, Minneapolis, Minnesota

The Detroit Institute of Arts

Sid Deutsch Gallery, New York

Terry Dintenfass, Inc., in association with Salander-O'Reilly
 Galleries, New York

Dorothy Eweson

Forum Gallery, New York

Fred Jones Jr. Museum of Art, The University of Oklahoma,
 Norman

Fukushima Prefectural Museum of Art, Japan

Himeji City Museum of Art, Japan

Hirshhorn Museum and Sculpture Garden, Smithsonian
 Institution, Washington, D.C.

The Jewish Museum, New York

Irene and Mark Kauffman

Krannert Art Museum and Kinkead Pavilion, University of
 Illinois, Champaign

Mr. and Mrs. Maurice G. Levine

Maier Museum of Art, Randolph-Macon Woman's College,
 Lynchburg, Virginia

Mrs. Robert B. Mayer, Chicago

The Metropolitan Museum of Art, New York

Modern Art Museum of Fort Worth

Moderna Museet, Stockholm

Montgomery Museum of Fine Arts, Montgomery, Alabama

Munson-Williams-Proctor Institute Museum of Art,
 Utica, New York

Museum of American Art of the Pennsylvania Academy of the
 Fine Arts, Philadelphia

Museum of Contemporary Art, Chicago

The Museum of Modern Art, New York

Nationalmuseum, Stockholm

National Museum of American Art, Smithsonian Institution,
 Washington, D.C.

Neuberger Museum of Art, Purchase College, State University
 of New York

New Jersey State Museum, Trenton

Norton Museum of Art, West Palm Beach, Florida

San Diego Museum of Art

Bernarda B. Shahn

Sheldon Memorial Art Gallery, University of Nebraska-Lincoln

Alex and Beatrice Silverman

Carol A. Straus

Syracuse University Art Collection

Vatican Museums, Vatican City

Walker Art Center, Minneapolis, Minnesota

Mr. and Mrs. Jacob Weintraub

Whitney Museum of American Art, New York

Private Collections

Foreword

The works of visual and performing artists, like the speeches and writings of political radicals, often give voice to deeply felt concerns—moral outrage, a yearning for a better world, or a desire for social justice—that may remain unspoken among the larger population. Such were the concerns of the artist Ben Shahn throughout his forty-year career, and his work has indeed touched the lives of a broad public. An artist and a radical, noted in particular for his sharply etched and poignant portraits and scenes of American life, Shahn is important in the pantheon of distinguished twentieth-century American artists. Known also as an artist whose Jewishness infuses much of his work, Shahn is representative of a generation, now disappearing, of secular leftist Jews whose activism on behalf of social and political justice was influenced by their experience as Jewish immigrants from Eastern Europe and involvement with the struggles of the labor movement for social reform during the Depression era.

Not surprisingly, Shahn's work is collected and often exhibited at The Jewish Museum. In addition to a major retrospective in 1976, he was included that same year in an exhibition entitled *Jewish Experience in the Art of the Twentieth Century.* In 1991 several of his works were seen in the context of other immigrant Jewish artists in *Painting a Place in America: Jewish Artists in New York, 1900–1945.* Recently acquired, and included in the Museum's exhibition *Common Man, Mythic Vision,* are Shahn's tender autobiographical work *New York, 1947,* and a study for the Jersey Homesteads mural, *East Side Soap Box, 1936.* These works are among the most important of the Museum's Shahn holdings, which also include the original watercolor designs of 1930 for a later published Haggadah, as well as two other paintings and a number of mixed-media works, prints, and posters.

In 1998, this year of the centennial of the artist's birth, The Jewish Museum is delighted to present the exhibition and accompanying publication *Common Man, Mythic Vision: The Paintings of Ben Shahn.* While Shahn's frequently reproduced Social Realist works from the 1930s are familiar to many, the allegorical

and mythic works created later in his career have received less attention and, consequently, less appreciation. A goal of this exhibition is to give new consideration and perhaps inspire renewed critical and popular interest in Shahn's paintings from the 1940s and 1950s. Important works of his maturity, they demonstrate both the continuity and transformation of Shahn's major themes within an engaging narrative style. Some important Social Realist paintings are included in this presentation, but the emphasis is on major works created between the late 1930s and 1962: works of personal realism that explore subjective experience and memories, war paintings, allegories, mythic and surrealistic works of the 1940s and 1950s, as well as works from the *Lucky Dragon* series of the 1960s depicting the devastation brought about by nuclear weapons.

Shahn's mythic and allegorical style shares concerns with other American artists in responding to the trauma of World War II and the Holocaust as well as the nuclear age and the Cold War. In common with Expressionists such as Abraham Rattner, Hyman Bloom, and Rico Lebrun, and Abstract Expressionists such as Jackson Pollock, Barnett Newman, and Willem de Kooning, Shahn explored universal themes of war, destruction and renewal, and the fate of humanity in the face of catastrophic upheaval.

Throughout his life and career, Shahn's identity can be viewed as rooted in what might be called *Yiddishkayt,* the culture, values, and ethos of East European Jews, although he was a worldly artist who is associated with universal ideas. This identity is reflected in the subjects and themes of his work and in explicit Jewish and biblical imagery. During the 1930s Shahn painted watercolor portraits of the protagonists of the Dreyfus Affair, illustrations for a Passover Haggadah, and murals that depict the experience of Jewish immigrants in the labor movement as well as persecution of Jews in Europe. The postwar years saw a resurgence of Shahn's Jewish heritage. Explicit images taken from Jewish tradition, ritual, and history appear in the allegorical paintings of the late 1940s and 1950s, which also allude to tragic events of the Holocaust and the rebirth of Jewish life in the new state of Israel. Hebrew lettering, calligraphy, and text are employed throughout his career, and celebrated in particular in works created during the 1950s and 1960s.

Jewish Museum Associate Curator Susan Chevlowe has been both the exhibition curator and author of the accompanying catalogue. She has brought to bear her special knowledge of early- and mid-twentieth-century American art as well as her experience working with The Jewish Museum's collection and, in the process, has created a refreshing new view of Shahn's oeuvre and inspired a new body of scholarship. In this book she provides an informative overview of the artist's life and career that illuminates the organization of works in the

exhibition as well as the scope of the following important essays by leading art historians. Diana L. Linden, Visiting Assistant Professor of Art History at Pomona College, writes about Shahn's New Deal era murals in the context of his Jewish and political identity. Stephen Polcari, New York Director of the Archives of American Art and consulting curator for the exhibition, explores the shared themes and pictorial images of Shahn and other American artists during the war and postwar years. Frances K. Pohl, Dean and Associate Professor of Art History at Pomona College, focuses on the three *Allegory* paintings of 1948–55, situating them within the context of Shahn's development as an artist, writer, and political activist through the 1960s. Howard Greenfeld, author of a major new biography of Shahn, provides an informative chronology.

My great appreciation is extended to Stephen Polcari for his tremendous contribution to the conceptual framework of the project, in addition to his writing; and to advisors and essayists Diana Linden and Frances Pohl for their collegial support and great expertise. Special thanks to Deputy Director of Program Ruth Beesch for her oversight of all aspects of the exhibition and book, and to Sheila Friedling for her attention to every phase of the catalogue's editing and production.

A major financial undertaking is required to present a project of this scope, and I am tremendously grateful to those funders who recognized the importance and value of looking anew at Shahn's paintings in this year of his 100th birthday. Many thanks to Ernst & Young LLP for their great generosity in sponsoring *Common Man, Mythic Vision,* and additional thanks to the Henry Luce Foundation, the National Endowment for the Arts, and the Dorot Foundation for their important support.

The exhibition has had the benefit of wonderful cooperation from public and private collections located throughout the United States, in Japan, in Sweden, and at the Vatican. Their participation has not only allowed for the presentation of the exhibition in New York, but also for the opportunity to bring the show to a wider public in its tour to Allentown, Pennsylvania, and Detroit, Michigan. Many thanks to all of the lenders, listed on page vi, and further thanks for the enthusiastic support of the exhibition's presence in their museums to colleagues Peter Blume, Director of the Allentown Art Museum, and Maurice D. Parrish, Interim Director, and MaryAnn Wilkinson, Curator of Twentieth-Century Art, at The Detroit Institute of Arts.

Ben Shahn's life as an artist has spanned six decades—a significant part of this century. His art has expressed a continuity of vision in dynamic tension with the social and political transformations and upheavals taking place during the long period in which he worked. For many Americans, he has visualized

both the freedoms and nightmares of these years in a style and iconography that is highly communicative, moving, and fundamentally hopeful. In celebrating the 100th anniversary of his birth, we are grateful for his wisdom, commitment, and enormous talent, and hope that this exhibition and book will provide a renewed understanding of his remarkable achievement.

Joan Rosenbaum

Helen Goldsmith Menschel Director
The Jewish Museum

Preface

In early 1996, while on a short-term leave from The Jewish Museum, I received a phone call at home. Eric M. Zafran, the former Deputy Director of Curatorial Affairs at the Museum, had proposed an exhibition of the works of Ben Shahn timed to coincide with the centennial of the artist's birth in 1998. In anticipation of submitting a grant to the National Endowment for the Arts that spring, a Scholars Meeting was immediately called, and I was asked to join the group that February. As a historian of American and twentieth-century art I had earlier assisted Norman L. Kleeblatt with The Jewish Museum's 1991 exhibition *Painting a Place in America: Jewish Artists in New York, 1900–1945,* in which Shahn was one of fifty-one artists represented. Norman remains my mentor at the Museum.

Joining the staff at the initial meeting to conceptualize the Ben Shahn exhibition were Matthew Baigell, Professor of Art History at Rutgers University; Morris Dorsky, Professor Emeritus of Art History at Brooklyn College; Marlene Park, Professor of Art History at John Jay College and the Graduate Center, City University of New York; and Stephen Polcari, New York Director of the Archives of American Art, Smithsonian Institution.

The first questions brought to the table that day were how to conceptualize and interpret the work of one of the best-known American artists of the first half of the twentieth century. Shahn is immediately associated with Social Realism—American art of the 1930s dedicated to political causes and social reform. While his style and subject matter changed in the ensuing decades after World War II, Shahn remained a socially and politically committed artist until the end of his life. He was a contemporary of the Abstract Expressionists, and his later style—modernist yet always figurative—and subject matter shared much in common with theirs.

Dr. Zafran proposed that the group of scholars consider whether Shahn should be viewed in light of other cultural endeavors of his time—the arts, literature, and music; as a politician and poet; in the context of the American

Scene; purely in terms of his Jewish subjects; or in terms of his more universal spirituality. Dr. Polcari, author of the important study *Abstract Expressionism and the Modern Experience,* suggested that Shahn's work be examined in the context of the mythic American art of the 1940s and 1950s that was created in response to the catastrophic impact of World War II and the Holocaust. It was on that premise that we applied for and were successful in obtaining a grant from the National Endowment for the Arts.

With preliminary research for the exhibition completed during the next fourteen months, a second Scholars Meeting was held in April 1997. Stephen Polcari had formally joined the exhibition team as consulting curator. Now, along with Professor Baigell, we were joined by Diana L. Linden, Visiting Assistant Professor of Art History at Pomona College, who had recently completed her dissertation on Shahn's Jewish identity and his mural projects, and Frances K. Pohl, Professor of Art History at Pomona and author of the first major monographs on Shahn published since the 1970s. To demonstrate the continuity between the early and later work necessitated that we also include a selection of key works from the 1930s. With a slightly revised plan for the exhibition, we were once again successful in our grant application to the Henry Luce Foundation and later to Ernst & Young LLP, our corporate sponsors. Their input helped us to evolve a final conceptualization for the project.

I would like to thank Joan Rosenbaum, Helen Goldsmith Menschel Director of The Jewish Museum, and Ruth Beesch, Deputy Director for Program, for guiding this project and for their support of my work throughout. All along, it has been Joan Rosenbaum who has urged us not to lose sight of Shahn the political artist. Social Realism itself is an area of art history that has been overlooked or lightly dismissed on the basis of aesthetic pronouncements that have privileged later developments in American art. Our view of Shahn is not intended to once again relegate socially concerned figurative art to the basement of art history. Instead, we have attempted to broaden our understanding of Shahn's work beyond the framework of Social Realism that has also diminished it, while at the same time revealing the persistence of the artist's humanist message. It was very clear to us that presenting Shahn's work of the 1940s and 1950s alone would not suffice for our audience or do justice to Shahn. In fact, a broader context and understanding of Shahn's later work can only ensure that it will be considered newly relevant within this key period in American art history.

Common Man, Mythic Vision: The Paintings of Ben Shahn should also be seen in the context of two other important exhibitions that will follow in 1999 and 2000, respectively: *Ben Shahn's New York: The Photography of Social Conscience,*

organized by Deborah Martin Kao and Laura Katzman at the Fogg Art Museum, Harvard University Art Museums; and *Ben Shahn: The Passion of Sacco and Vanzetti,* organized by Alejandro Anreus at the Jersey City Museum. In all, these three shows represent a broad range of interpretations and in-depth appraisals of diverse aspects of Shahn's career.

The Jewish Museum's exhibition, *Common Man, Mythic Vision,* features a highly select group of tempera paintings with a few examples of Shahn's watercolor and gouache drawings. Eschewing oils, Shahn worked in the tempera medium that allowed him to constantly rework areas of his paintings to achieve a variety of effects—colors glowing and luminous or dull and flat, paint heavy or thin—not obtainable in other media. These sometimes fragile works of art have been assembled from more than forty public and private collections listed on page vi.

I am extremely grateful for the generosity of the individual lenders to the exhibition who were willing to part with the Shahn works that are so dear to them and to make them available to a wider audience. It has been my idealistic belief throughout this project that the custodians of these works have a responsibility to share them with the public, and I thank the lenders for their understanding in the face of my determination.

I especially acknowledge the administrative, curatorial, registrarial, rights and reproductions, and gallery staffs who gave us their unhesitating assistance in processing our loan requests and providing photographs and transparencies for reproduction in the catalogue. I wish to thank the following people in particular: Douglas G. Schultz, Laura Catalano, and Daisy Stroud of the Albright-Knox Art Gallery; Rick Stewart and Melissa Thompson at the Amon Carter Museum; Nancy Hartsfield at Auburn University; Myron Kunin and Vicki Gilmer at Curtis Galleries; Maurice D. Parrish, MaryAnn Wilkinson, Michelle S. Peplin, Alfred Ackerman, and Rebecca R. Hart at The Detroit Institute of Arts; Sid Deutsch and Harold E. Porcher at Sid Deutsch Gallery; Chanda Chapin of Terry Dintenfass, Inc., in association with Salander O'Reilly Galleries; Robert Fishko of Forum Gallery; Eric Lee and Gail Kana Anderson at The Fred Jones Jr. Museum of Art, Norman, Oklahoma; Mitsuhiko Hasebe and Yuko Yoshimura at Fukushima Prefectural Museum of Art; Ikuno Kosuge at Himeji City Museum of Art; James T. Demetrion, Phyllis Rosenzweig, Margaret Dong, Rita Sole, and Amy Densford at the Hirshhorn Museum and Sculpture Garden; Maarten van de Guchte and Leslie Brothers at the Krannert Art Museum and Kinkead Pavilion; Sarah Cash, Ellen Agnew, and Sharon Palladino at the Maier Museum of Art, Randolph-Macon Woman's College, Lynchburg, Virginia; Philippe de Montebello, Lowery S. Sims, Avril Peck, and

Trine L. Vanderwall of The Metropolitan Museum of Art; David Elliott, Cecilia Widemheim, Agneta Modig Tham, Iris Müller-Westermann, Lena Granath, and Elisabeth Höier of Moderna Museet, Stockholm; Michael Auping, Marla J. Price, Andrea Karnes, and Christine Berry at the Modern Art Museum of Fort Worth; Mark M. Johnson, Margaret Lynne Ausfeld, and Pamela Bransford at the Montgomery Museum of Fine Arts; Paul D. Schweitzer and Debora M. Winderl of the Munson-Williams-Proctor Institute Museum of Art, Utica, New York; Daniel Rosenfeld, Barbara Katus, and Lorena Seghal at the Museum of American Art of the Pennsylvania Academy of the Fine Arts; Kevin E. Consey, Lela Hersh, Mary Ellen Goeke, and Stacey Gengo at the Museum of Contemporary Art, Chicago; Magdalena Dabrowski and Kathleen Curry at The Museum of Modern Art, New York; Per Bjurström, Lillie Johansson, Gunilla Vogt, and Sussi Wesstrom of the Nationalmuseum, Stockholm; Elizabeth Broun, Melissa Kroning, and Abigail Terrones at the National Museum of American Art, Smithsonian Institution; Lucinda H. Gedeon and Patricia Magnani at the Neuberger Museum of Art, SUNY at Purchase; Leah Sloshberg and Margaret O'Reilly at the New Jersey State Museum, Trenton; Christina Orr-Cahall, David F. Setford, Pamela Parry, and Nancy Barrows at the Norton Museum of Art; Steven L. Brezzo, Scott Atkinson, Louis Goldich, and Jayne Johnson at the San Diego Museum of Art; George Neubert and Karen Merritt at the Sheldon Memorial Art Gallery and Sculpture Garden, Lincoln, Nebraska; David L. Prince of Syracuse University; Francesco Buranelli and Andrea Carignani of the Vatican Museums; Kathy Halbreich, Elizabeth Peck, and Renee van der Stelt at the Walker Art Center; and David A. Ross, Barbi Spieler, Ellin Burke, Nancy McGary, Juli Cho, and Anita Duquette at the Whitney Museum of American Art.

I also acknowledge with deep appreciation the assistance of Jeffrey Bergen of ACA Galleries; Lillian Brentwasser at Kennedy Galleries; Clarice Conly, Alice Doerner, and Annette Berhe at LeMoyne-Owen College, Memphis; Margaret Frame at Christie's; Howard Greenfeld; Chiaki Komuro at Nantenshi Gallery, Tokyo; Keith Kraft and Lee Haas at The Temple Congregation Ohabai Sholom, Nashville; Yasunari Kumon and Sumie Shibata at Kumon Fine Arts; Kate MacDonald at Sotheby's; Galerie Nichido, Tokyo; Sawako Noma and Stephen Connor of Kodansha International Ltd., Tokyo; Dr. Francis V. O'Connor; Michael Owen Gallery; Robert Panzer and Ann Prival of VAGA; Michael Rosenfeld Gallery; Tex Sato of Yamato Transport Co. Ltd., Tokyo; Philip J. Schiller; Katsuhige Susaki; Judy Throm at the Archives of American Art; and Dr. Michael P. Weinstein of the New Jersey Marine Sciences Consortium.

I would also like to thank Dolores Taller and Roia Ferrazares of the Stephen

Lee Taller Ben Shahn Archive for their assistance. Dr. Taller, who died in 1997, had assembled a private archive of holdings related to Shahn and his work. During the last twenty years of his life, Dr. Taller was unceasingly devoted to Shahn's work and to providing assistance to many scholars, including myself. Selections from the archive are on exhibition this fall at the Judah Magnes Museum in San Francisco before they are deposited at Harvard University.

Bernarda Bryson Shahn has been a great help and a joy to know and work with on this project since my first visit to the Shahn home and studio in Roosevelt, New Jersey, in March of 1997. Judith Shahn has graciously provided family photographs for use in the catalogue.

A number of people have acted as exhibition assistants on this project at various phases of its planning and implementation, including William Nash Ambler, Jonathan Canning, Lisa Mahoney, Sydelle Rubin, and Melissa Sprague. I thank each and every one of them, as well as the Fine Arts Department staff: Stefania Rosenstein, former Exhibition Assistant; Michelle Lapine, Curatorial Assistant; and Irene Z. Schenck, Research Associate.

My great thanks to Sheila Friedling for editing this book and working with all of the authors, including myself, on the content development of the essays and production of the manuscript. Her breadth of knowledge of Jewish culture and dedication to her task have helped to make this book a coherent and informative presentation of Shahn and his works.

Within the Museum, the interpretive team of Andrew Ingall of the National Jewish Archive of Broadcasting, Amy Trachtenberg and Lisa Mallin Salsberg of the Education Department, and Ruth Beesch has worked with Lisa Mahoney, Stephen Polcari, and me on interpretive strategies for the installation. These have been successfully implemented by our exhibition designers, Jane Sachs and Tom Hut of Hut Sachs Studio, and by graphic designer Sue Koch. Also at The Jewish Museum, thanks are due to the staffs of the many departments who participated in this project in its various phases: Thomas Dougherty, Deputy Director for Administration and Finance; Linda Freitag, Administrator; Donna Jeffrey, Controller; Debbie Schwab, Director of Retail Operations; Robin Cramer, Director of Product Development and Merchandising; Al Lazarte, Director of Operations; Susan Davis, Director of Restricted Funding, and Tara Tuomaala, Assistant Director of Restricted Funding; Linda Padawer, Director of Special Events; Deborah Siegel, Director of Membership and Annual Giving; Grace Rapkin, Director of Marketing; Anne Scher, Director of Public Relations; Jack Salzman, former Deputy Director for Education, Media, and Public Programs; Judith C. Siegel, former Director of Education, Media, and Public Programs; Aviva Weintraub, Director of Media and Public Programs;

Susan L. Palamara, Registrar and Collections Manager; Kathryn Potts, former Assistant Curator for Traveling Exhibitions, and Margie Weinstein, former Exhibition Assistant for Traveling Exhibitions; and to our counsel at The Jewish Theological Seminary of America, Ann Appelbaum.

It has been a pleasure to work with Patricia Fidler, Curtis Scott, and Carol Cates at Princeton University Press. Their creativity and expertise have resulted in this beautiful book.

Susan Chevlowe

Associate Curator
The Jewish Museum

COMMON MAN MYTHIC VISION

The Paintings of Ben Shahn

A Bull in a China Shop

AN INTRODUCTION TO BEN SHAHN

Susan Chevlowe

We have long known Ben Shahn as a Social Realist painter; yet as we look deeper, his life and art seem to defy such narrow categorization. At different times, under different personal, professional, and historical circumstances, Shahn presented different parts of himself, sometimes simultaneously: East European immigrant *and* successful American artist; thirties' political radical *and* postwar liberal; documentary photographer *and* fine artist; commercial lithographer *and* the highly acclaimed subject of a major retrospective at the Museum of Modern Art in 1947. This did not always mean that the artist was invariably in the right place at the right time. To the contrary, Shahn's work as a commercial artist in the 1950s obliged him to compare himself to a bull in a china shop at a moment when "self-expression" seemed the dominant aesthetic trend.[1] Even so, in 1954, the Museum of Modern Art chose Shahn— along with Willem de Kooning—to represent the United States at the Venice Biennale. And by the time of his posthumous retrospective at The Jewish Museum in 1976, Shahn was among the most extensively collected artists in the country, as the influential critic of Abstract Expressionism Harold Rosenberg noted in his review of the 1976 exhibition.[2] Although today—particularly in the artist's centennial year—his reputation is having a resurgence, it was for many decades eclipsed by the Abstract Expressionists who were his contemporaries.

Common Man, Mythic Vision: The Paintings of Ben Shahn traces the development of Shahn's career, focusing on his mature style that developed in response

to the horrors of World War II, as he began to explore subjective experience, including his own childhood memories, along with allegorical narrative content and form. Disappointed with the partisan political ideologies of the 1930s and the limitations of Social Realist modes of representation, he began to make his works less specific critiques of social issues, using instead allegorical, mythological, and biblical imagery to express personal and universal humanistic concerns. Personally, also, Shahn moved from the experience of being an immigrant to that of an American artist. Rather than seeing Shahn's varied aesthetic styles and personal roles as irresolvable contradictions, they can be viewed as shifting identities paradigmatic of a particular American experience.

Shahn's social views were his legacy from the Jewish Bundist tradition in Eastern Europe, which evolved, through personal experience, into a profound commitment to fight against injustice. Having immigrated to the United States as a child, Shahn gradually acculturated, moving away from religious observance and establishing a secular Jewish identity aligned with the causes of labor and social reform during the 1930s. As he grew disappointed with political ideologies, and in response to the trauma of World War II, his social criticism gave way increasingly to the symbolic rendering of biblical and mythological themes. The destruction of war is hauntingly realized in such works as *Italian Landscape,* 1943–44 (plate 5), *The Red Stairway,* 1944 (plate 7), and *Liberation,* 1945 (plate 8). Shahn's painting *Age of Anxiety,* 1953 (plate 21), is aptly titled in an era when the threat of nuclear destruction engendered the building of bomb shelters, and political paranoia led to the arrest and eventual execution of Ethel and Julius Rosenberg for allegedly selling atomic secrets to the Soviets.

As the decade wore on, Shahn expressed a new interest in Jewish traditions, and, in particular, in the Hebrew language, the characters of which he carefully lettered onto his paintings. Increasingly, at the end of the decade, such works expressed joyousness and celebration, as well as the themes of destruction and regeneration, sometimes understood as a response to the Holocaust and the establishment of the state of Israel. Shahn believed that the arts and humanistic traditions must provide a counterweight to the often dangerous effects of technology in the modern world. Jewish texts and symbols provided lessons for the contemporary world, whether in the words of the twelfth-century rabbinical authority and philosopher, in Shahn's *Maimonides,* 1954 (plate 23), or in the civil rights message contained in the Hebrew script of his *Ram's Horn and Menorah,* 1958 (plate 26) and in a related mosaic mural, *The Call of the Shofar* (fig. 73): "Have we not all one father? Hath not one God created us? Why do we deal treacherously every man against his brother, to profane the covenant of our father?"

Shahn's move away from topical subject matter toward symbolic interpretations parallels the Abstract Expressionists' search for "timeless and tragic" themes. Even so, Shahn, who was extremely knowledgeable in art history and contemporary art criticism, condemned Abstract Expressionist content as merely "the true impulsive compulsive self, revealed in paint," unconvinced of the Abstract Expressionist credo that personal liberation was the only political act possible in a restrictive age.[3] As Bernarda Bryson Shahn, the artist's second wife and sometime collaborator, observed, "Shahn's art stood somewhere between the abstract and what is called figurative, borrowing from the one its material riches of color, shape, and texture, its explorations in form, its preference for inner organization as against outer verisimilitude, from the other its focus upon man as the center of value and as the most interesting object on earth."[4]

A closer examination of Shahn's works created from 1943 onward, the central focus of this book and exhibition, reveals, nevertheless, the confluence of American aesthetic responses to the cataclysm of World War II as well as the continuing threat of nuclear apocalypse, as Stephen Polcari discusses in his essay. The havoc of war affected numerous artists who emerged from the diverse realist traditions of the 1930s and were transformed by their experiences both during the Depression and World War II; these included Regionalists, Expressionists, Social Realists, and Abstract Expressionists, from Thomas Hart Benton to Willem de Kooning.

IMMIGRANT AND ARTIST

Benjamin Zwi Shahn was born on September 12, 1898, in Kovno (Kaunas), Lithuania, the first of five children in a traditional Orthodox Jewish family. His parents were Joshua Hessel Shahn, a woodcarver and cabinetmaker, and Gittel Lieberman, who came from a family of potters. In 1902, after Shahn's father had been exiled to Siberia, the family moved to the smaller city of Vilkomir, where Jews had lived since at least the end of the seventeenth century, and where they then comprised roughly half the population, numbering over 7,200 (according to figures from 1897). The majority of the city's Jews were engaged in commerce and crafts.

An active socialist, Shahn's father fled the czarist authorities and traveled to Sweden, then to England, and finally to South Africa before reuniting with the family in the United States in 1906. Shahn traveled with his mother by stagecoach from Vilkomir to the railway in another town and from there to the port at Libau, Latvia, where a boat took them to London. After the sea journey from

England to America, the Shahns settled in Brooklyn. There is no evidence that Shahn was aware of the fate of the Jews of Vilkomir, but they were expelled from the city in 1915, although some returned following World War I. Jewish life again prospered during the period from 1918 to 1940, a time of independence for Lithuania, prior to annexation by the Soviet Union in June 1940. When the town fell into German hands in 1941, the remaining Jews were forced into the nearby forests and murdered.[5]

Many of Shahn's memories of the emigration experience and his first months in New York recall a particularly traumatic break with the past. This new world was strange and unfamiliar, and, most significantly, his grandfather—his father's father, with whom he had been extremely close—was absent from it. Shahn remembered that the old man had walked alongside the stagecoach as it pulled away from Vilkomir: "we were going very slowly and I holding on his hand [*sic*]. I hadn't the slightest desire to come here. I was desperate. If he would come I would have been all right, but he couldn't come. As I think of it now, it must have been a tragic thing. This was the last one of the family and he would never see my father or us again and he walked and walked and I held on desperately."[6] Living in Brooklyn, on the outskirts of Williamsburg, the Shahns resided in a brand new apartment building surrounded by open lots. Nevertheless, it was depressing for the young boy, who yearned for the green countryside and the connection to nature he had known before. "I'd go out and look at the moon on moonlit nights, particularly because I would join my grandfather on the blessing of the new moon, and I would console myself that he was looking at the same moon."[7]

Shahn's nostalgic reflections on his boyhood are particularly evident in his postwar work, such as the somber *Portrait of Myself When Young,* 1943 (plate 4), and especially in two paintings from 1947, *Spring* and *New York.* Shahn recalled how much he missed the countryside after emigrating and how, as a young boy, he searched out the small patches of green in public parks with a kind of desperation. *Spring* (plate 12) is one such parcel Shahn found in Brooklyn.[8] While ostensibly related to a "small boy's emblematic impressions of a fish market," the painting *New York* (plate 13) is actually based on a photograph Shahn had taken in the mid-1930s of a fish market on New York's Lower East Side (fig. 1).[9] Removed from their original context, the carp painted on the window (a pike in the painting) and the scale at left, as well as the figure at right of a bearded Jewish man on the street outside, give the composition a surreal quality. Shahn's addition of the young boy—either a self-portrait or, since he seems to be wearing bathing trunks, a reference to his younger brother Hymie, who died as a teenager in a swimming accident near Shahn's home in Truro, on Cape

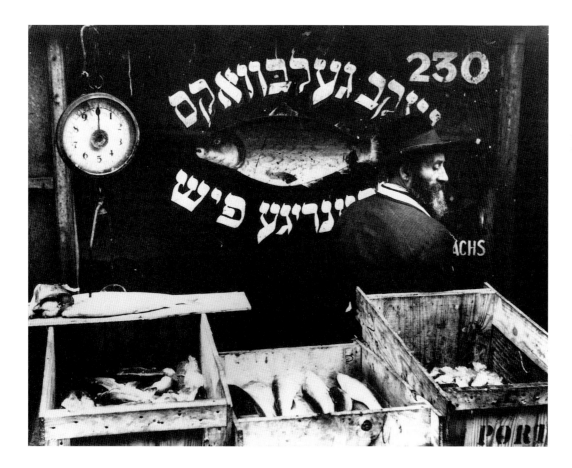

Figure 1

Ben Shahn

Untitled (Lower East Side, New York)

1936

Gelatin silver print

Ben Shahn Papers,

Archives of American Art,

Smithsonian Institution, Washington, D.C.

Cod, in 1926—demonstrates his recontextualization of borrowed motifs to
further his expressive intentions.

When young Ben was fourteen, at the insistence of his mother, he became
a lithographer's apprentice. At this age, he would have preferred to continue his
education. The apprenticeship was arranged through Shahn's uncle Moses
Hyman Cohn, an engraver, and another uncle, his father's older brother, also an
engraver and later a foreman in the *New York Times* gravure section. In order
to continue his education, Shahn devised a program of intensive self-study us-
ing the resources of the public library. He began with Homer's *Iliad,* and then
entered a drawing class, as well as evening high-school classes in Greek, book-
keeping, and chemistry.[10] This learning is apparent from the classical and scien-
tific allusions in Shahn's paintings as well as from the ease with which he refers
to various fields of knowledge in his own substantial writings, particularly
The Shape of Content, the published form of his 1956–57 Charles Eliot Norton
Poetry Lectures at Harvard University. By the time he was sixteen, Shahn was
hopeful of returning to Europe to study art, a dream interrupted by the onset
of World War I.

The war had a major impact on Shahn. As the United States itself turned
inward and isolationist, the artist experienced a personal transformation. As he

recalled: "The war curiously enough ended that homesickness that I spoke of. It came abruptly to an end. I knew then that this longing I had for this romantic nostalgia, my grandfather's shop and so on all of that left. Particularly we heard that my grandfather—this was after the war—had died and nobody knew quite where. . . . That brought that longing directly to an end and I became an American."[11]

WORKER AND ARTIST

Although Shahn resented his mother for taking him out of school, he appreciated having a trade that permitted him to earn a living as an artist as well as to finance his education between 1919 and 1921 at New York University, the City College of New York, and the National Academy of Design.

> To put it very briefly, lithography shaped my whole attitude toward art. . . . it was a profession or trade or a craft by which I could earn a living. Very early I began to call myself an artist and whatever I did was a work of art. Undoubtedly my values has [sic] changed over the years, what is art, but this attitude which I still hold, I consider myself a professional. I have this craft, this trade whatever you wish to call it. I expect always to earn my living by it.[12]

As well as shaping his attitude as a craftsman and artist, lithography profoundly influenced the evolution of Shahn's mature painting style. In particular, the chiseled line characteristic of lithographic engraving distinguishes Shahn's idiosyncratic style.

In 1922, Shahn married Tillie Goldstein, with whom he would have two children. Between 1925 and 1929, he made two extended trips abroad, traveling through Europe and North Africa and studying in Paris. While he sought to throw off the influence of French Impressionism and find his own style, he realized that he was a natural storyteller. As Shahn himself understood, this narrative mode, which is at the core of his work, was antithetical to the aims of modern art:

> One of the first things I had to face up to was that I loved to tell stories, I'm a raconteur, but I'd been taught right down the line that art does not tell stories. Well, I realize that was one of my failings, one of my inadequacies, but if I'm to be anything at all I must admit my inadequacies as well.[13]

Shahn returned to the United States in 1929, under the strong influence of French Impressionism but still in search of a creative direction.

Beginning in 1929, he shared a studio with the photographer Walker Evans, and thereafter photography would play a central role in his art.[14] In 1930, he had his first solo exhibition at the Downtown Gallery, where eleven one-person shows were mounted through 1961, the first comprising mostly North African subjects and the last, his series *The Saga of the Lucky Dragon*. He broke with the gallery in 1968, a year before his death.[15]

He also began exploring Jewish themes and using Hebrew calligraphy, a skill he had mastered as a lithographer's apprentice and which reemerged in greater frequency in his art after World War II; he created the watercolors for a *Haggadah for Passover*, 1931, now in the collection of The Jewish Museum. Shahn's interest in the Haggadah was consistent with a lifelong commitment to social justice. His use of Hebrew calligraphy and Jewish texts fuses Jewish ritual and tradition with contemporary concern for workers' rights and social equality: the story of the Exodus from Egypt—with its themes of revolt and liberation from slavery—is presented as a metaphor for the socioeconomic strife created by the Depression.

DEPRESSION AND THE NEW DEAL

During the 1930s, Shahn created works of art in response to the social, economic, and political conditions of the Depression, a style that became known as Social Realism. His narrative compositions of simplified forms incorporate broad, flat areas of color overlaid with strong calligraphic lines, and demonstrate his assimilation and adaptation of European modernism, particularly that of Cézanne and Klee. Shahn's first political series, completed in 1931, consisted of watercolor portraits of the major protagonists of the notorious Dreyfus Affair—the case, with its anti-Semitic implications, of the French Jewish military officer Alfred Dreyfus, who was charged with treason and later acquitted. Shahn's public recognition and personal style were achieved with his famous series on the controversial Sacco and Vanzetti case, the trial and execution of the Italian immigrant anarchists that also evoked charges of ethnic bias, and which the Downtown Gallery exhibited in 1932 under the title *The Passion of Sacco and Vanzetti* (fig. 2). The critic Lincoln Kirstein sought to play up the universal appeal in Shahn's choice of a highly charged political subject. Yet, even so, he captured the simplicity and direct appeal of these works, and the immediacy of the style Shahn had achieved and that would be typical of his rendering of humanity for the rest of his career:

> Shahn [he declared] did not imagine the apotheosis of the affair as an anarchist or a
> communist sympathizer, as an Italian or as the member of an oppressed class. But with

an appraising accuracy he merely installed the actors of that tragedy in their proper places in a frame, and their arrangement is an inscription more surgical than any partisan approach . . . neither naiviste nor primitivistic . . . but popular, like a postcard, with a human characterization blander than an insult and a color as fresh as a familiar folk-object—a painted harness or a tavern-sign.[16]

These paintings established Shahn's career: that year the Whitney Museum of American Art included one of his paintings in its first biennial exhibition,

and he was invited to participate in a mural show at the Museum of Modern Art. In 1932–33, Shahn again created a series of works to address the trial and eventual execution of labor leader Tom Mooney, convicted of setting off a bomb in San Francisco in 1916.

Shahn's leftist political activity continued in the early thirties, when he was invited by Bernarda Bryson to contribute to *Art Front,* the journal of the Artists' Union, an organization formed in 1933 as a trade union to represent artists working on government projects. He also assisted Diego Rivera on the controversial Rockefeller Center mural, which featured the likeness of Lenin, and which was destroyed in 1933 before its completion.

During these years Shahn became involved in the New Deal art programs created by the Roosevelt Administration. With government support, many artists were presented with the opportunity to create public murals that functioned as allegorical history paintings redefining American life and traditions. Best known among the 1930s muralists were such regional artists as Thomas Hart Benton and that great modern mythmaker, the Mexican, Rivera. Beginning in 1933, under the patronage of the Public Works of Art Project, Shahn created a series of gouaches on the theme of Prohibition for the Central Park Casino. These, however, were rejected by the Municipal Arts Commission. Shahn became a member of the American Artist's Congress, a Popular Front organization formed in 1935 to bring together artists of various leanings and to provide a forum for ideas and to sponsor exhibitions.

From 1935 until 1938, he worked for the Resettlement Administration as a photographer, traveling through the American South and Midwest. This government agency, a program of the New Deal, relocated families from destitute areas to new, federally sponsored communities and homesteads. These extended trips outside New York provided Shahn with his first views of the character and diversity of America and its people, and made a lasting impact on his life and work. Shahn began to focus intensely on labor and America's poor following his first three-month assignment, a trip through twelve states from Pennsylvania to Mississippi, with Bernarda Bryson accompanying him as driver.[17] His photographs, drawings, and the paintings he later completed feature farmers and cotton pickers at work or at leisure, singing, or simply sitting around. An uneasy restlessness characterizes Shahn's unidealized portrayal of the striking or out-of-work laborers—each one individually rendered and often based on the poses and expressions captured in his photographs—in paintings such as *Scotts Run, West Virginia,* 1937 (fig. 3).

In the late 1930s, Shahn became active as a painter on several federally financed projects, which are discussed by Diana L. Linden in her essay in this

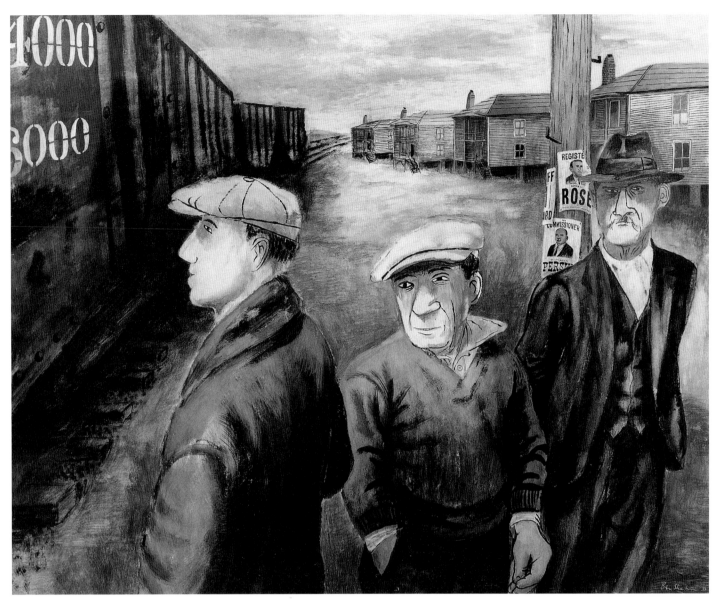

Figure 3

Scotts Run, West Virginia, 1937

Tempera on cardboard,

22¼ × 27⅞ in. (56.5 × 70.8 cm)

Collection of Whitney Museum

of American Art, New York

Purchase

book. These projects included a fresco for the Jersey Homesteads housing development, sponsored by the Resettlement Administration (see plate 2, figs. 23–25, 27). Jersey Homesteads was founded primarily for Jewish garment workers from New York City, and Shahn himself moved there in 1939. It was later renamed Roosevelt, New Jersey, after President Franklin D. Roosevelt's death in 1945. As Linden explains, in his Jersey Homesteads mural, 1936–38, Shahn shaped a vision of the American Jewish immigrant experience that expressed his concerns for labor and justice. As Linden points out, Shahn's murals addressed the sociopolitical concerns of the working-class, largely immigrant American Jewish community and responded to the anxieties of American Jewish life during the Depression. The Jersey Homesteads mural, as well as the controversial *Resources of America* panels for the Bronx Central Post Office, 1938–39 (figs. 28, 29), the rejected *Four Freedoms* mural proposed for the St.

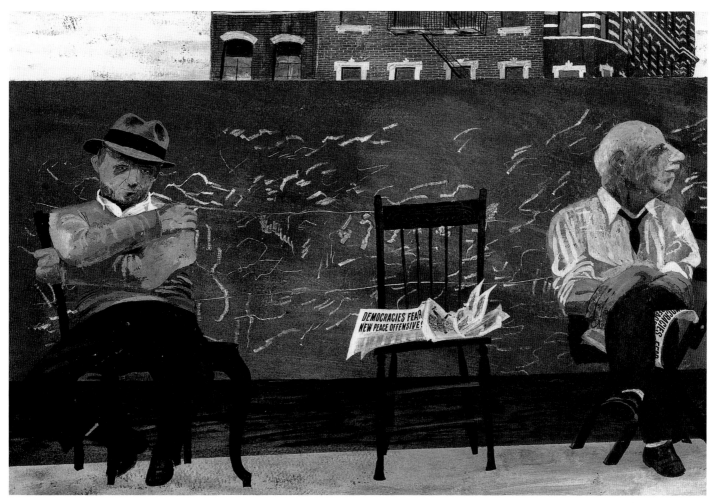

Figure 4

Democracies Fear New Peace Offensive (Spring 1940), 1940

Tempera on paper, 14¼ × 21⅜ in. (36.2 × 54.3 cm)

Collection Museum of Contemporary Art, Chicago

Promised Gift of the Mary and Earle Ludgin Collection

Louis, Missouri, Post Office, 1939 (figs. 31–33), and his related one-panel *Four Freedoms,* for the Jamaica, New York, Woodhaven Branch Post Office in Queens, 1940–41 (fig. 34), in Linden's words "reveal a dedication to liberal social policy, support for immigration reform, and desire for political and religious freedom."

THE 1940S: A PERSONAL AND UNIVERSAL VISION

Shahn himself recognized a shift in his work beginning shortly before World War II, when there is an evident change in mood (fig. 4). He defined this emerging introspective style as "personal realism," reflected in such works as *Sunday Painting,* 1938 (fig. 5) and *Pretty Girl Milking a Cow,* 1940. Now Shahn "found the qualities of people a constant pleasure." In contrast to his socially committed realism of the 1930s, he became fascinated with the plight of the individual rather than that of the larger society. These works may represent disillusionment with social theories and political ideologies, and perhaps also a respite from the intensive public projects Shahn was completing under various New Deal programs.

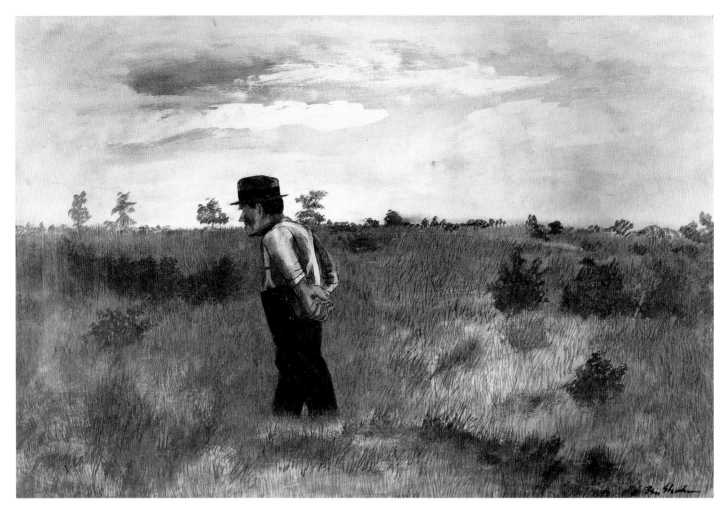

Figure 5

Sunday Painting, 1938

Tempera on gessoed Masonite panel,

15 × 23 in. (38.1 × 58.4 cm)

Courtesy of Bernarda B. Shahn

The entry of the United States into World War II in December 1941 signaled yet another change. According to Shahn, "Personal realism, personal observation of the way of people, the moods of life and places; all that is a great pleasure, but I felt some larger potentiality in art."[18] Like other American artists, Shahn was deeply affected by the war. Just after Pearl Harbor, Shahn moved from New York to Washington, D.C., where he worked as a graphic designer, creating posters for both the Office of War Information (OWI) from 1942 to 1943 and for the Congress of Industrial Organizations (CIO) from 1944 to 1946. He was still deeply involved in politics, working for the powerful CIO-Political Action Committee (CIO-PAC) toward Roosevelt's reelection in 1944. During his tenure at the OWI, Shahn portrayed the shocking brutality of World War II and the Holocaust in designs that feature isolated victims, including *Hunger*, 1942–43 (fig. 6), and *1943, A.D.*, c. 1943 (fig. 7). Too brutal, or perhaps too specifically Jewish, in fact, for the government to utilize, these designs were instead used as posters for CIO-PAC. According to art historian Matthew Baigell, the OWI's "policy held that [the fate of the Jewish

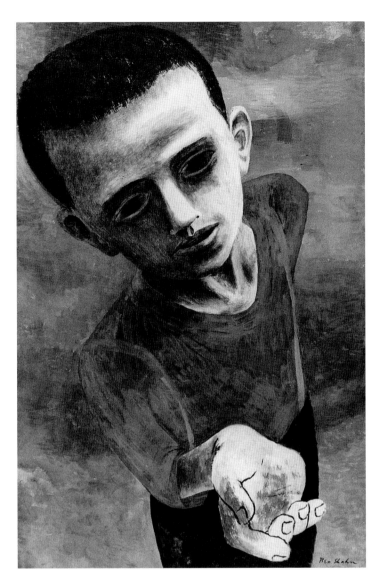

Figure 6

Hunger, 1942–43

Gouache on composition board,

40 x 26 in. (101.6 x 66 cm)

Collection Auburn University, Auburn, Alabama

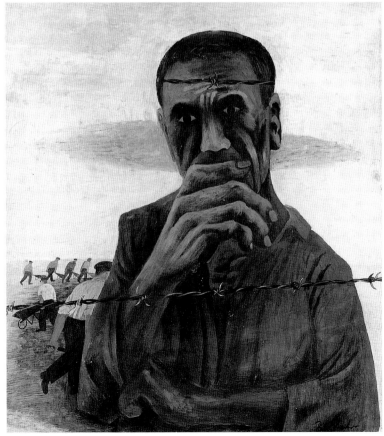

Figure 7

1943, A.D., c. 1943

Tempera on pressboard,

30¾ x 27¾ in. (78.1 x 70.5 cm)

Courtesy of the Syracuse University Art Collection

people] was to be considered coequal with that of other combatants and civilians."[19] In fact, Shahn himself universalized Jewish suffering in his works that followed.

WAR AND ITS AFTERMATH: SYMBOLIC AND MYTHIC IMAGES

A major focus of the exhibition and of this book will be Shahn's wartime paintings begun during the OWI period and succeeding works in which he responded to the cataclysm of war and the Holocaust with increasingly symbolic and allegorical imagery. In the earliest paintings, Shahn portrayed the physical destruction of the European landscape, its cities, and its people, and also offered signs of rebuilding and spiritual regeneration. Stephen Polcari discusses these themes in the context of Shahn's work and postwar American painting in detail in his essay. Shahn's paintings related specifically to Jewish life and the Holocaust also distinguish the wartime and postwar period and make it an important one for The Jewish Museum to examine. For example, works such as *Italian Landscape,* 1943–44 (plate 5), *Italian Landscape II: Europa,* 1944 (plate 6), *The Red Stairway,* 1944 (plate 7), *Cherubs and Children,* 1944 (fig. 35), and *Liberation,* 1945 (plate 8) refer, if sometimes subtly, to the devastation of European Jewry, as well as more overtly to universal suffering during the war.[20] As Frances K. Pohl discusses in her essay in this book, the personal and spiritual coalesce for Shahn in many of his wartime paintings featuring children, including *Cherubs and Children* and *Liberation* and, in particular, *Allegory,* 1948 (plate 14). There Shahn conflated historical events and deeply personal childhood memories and associations to create an emotional image of "inner disaster" in a work with a symbolic narrative content.

Beginning in earnest in 1944 with a commission from *Fortune,* Shahn's commercial career intensified as he became a frequent contributor to *The New Republic, Harper's, Masses and Mainstream, Seventeen, Scientific American, Time,* and *Nation.* After Franklin Delano Roosevelt's death in 1945, commemorated by such Shahn works as *Sing Sorrow,* 1946, Harry S. Truman succeeded to the presidency and a Republican Congress was swept in with the 1946 election. It seemed as if all the social-welfare reforms of the last half-century, in particular Roosevelt's New Deal, would be swept away. The changing political climate is reflected in such works as *Trouble* (fig. 53) and *Spring* (plate 12), both of 1947. For his part against this reaction, Shahn designed campaign materials for Progressive Party candidate Henry Wallace, a former vice president under Roosevelt, in his run against Truman and the Republican, Thomas Dewey, in 1948. Shahn's commercial illustrations were often reworked or expanded as the sub-

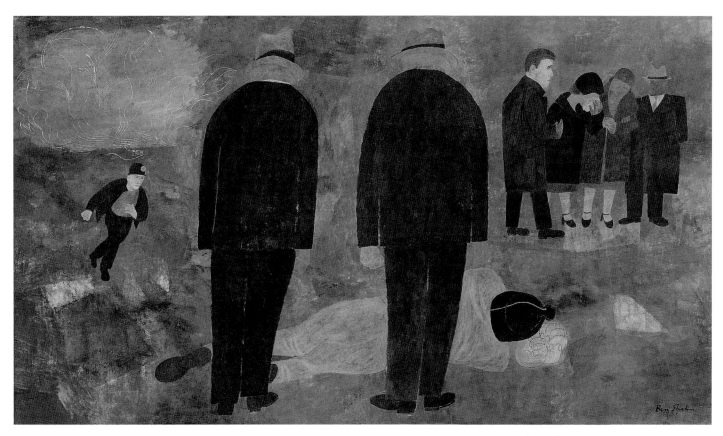

Figure 8
Death of a Miner, 1949
Tempera on muslin, treated with gesso, on wood,
27 × 48 in. (67.6 × 121.9 cm)
The Metropolitan Museum of Art, New York
Arthur Hoppock Hearn Fund, 1950

ject matter for his tempera paintings. For example, his drawings for two *Harper's* articles appearing in 1948, "The Blast in Centralia No. 5: A Mine Disaster No One Stopped" and "The Hickman Story," inspired such works as *Miners' Wives,* 1948 (plate 15), *Death of a Miner,* 1949 (fig. 8), and *Allegory,* 1948 (plate 14). In 1950, Shahn illustrated a story on Albert Einstein for *Scientific American,* and, in 1954, one on Robert Oppenheimer for the *Nation.* He greatly admired both scientists and their moral courage to speak out against atomic weapons. Shahn's *Time* covers, the last of which appeared in 1968, featured the likenesses of such diverse international figures as Vladimir Lenin, Alec Guinness, Adlai Stevenson, and Martin Luther King, Jr.

With their dreamlike juxtapositions and suggestions of vast space, a number of Shahn's paintings of the late 1940s and 1950s feature the expressive distortions of Surrealism. In addition, an enigmatic narrative seems to underlie such works as *Age of Anxiety,* 1953 (plate 21), no doubt entitled after W. H. Auden's poem of 1947. The latter also inspired a Leonard Bernstein symphony (1949) and a Jerome Robbins ballet (1950). In Shahn's work, painted in the year of the Rosenberg executions, a female figure at far left, seated with a tray containing what appears to be a glass (of water?) and a loaf of bread, may allude to Ethel Rosenberg. Irrational, dreamlike circus imagery can be found in *Deserted Fairground,* 1947 (fig. 9), *Epoch,* 1950, *Composition for Clarinets and Tin Horn,* 1951

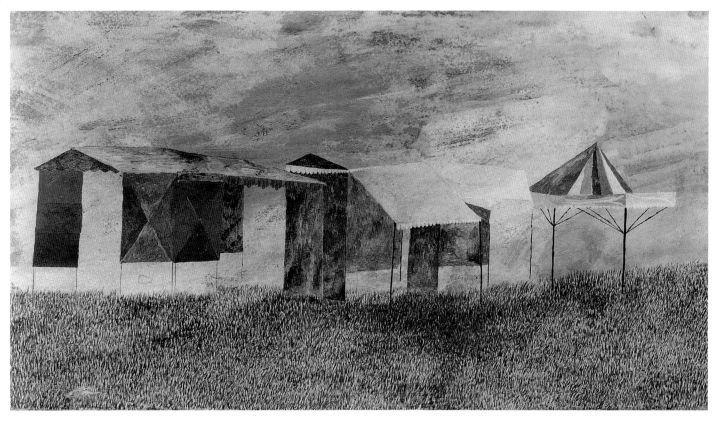

Figure 9

Deserted Fairground, 1947

Tempera on board,

11 × 20 in. (27.9 × 50.8 cm)

New Jersey State Museum Collection,

Trenton. Gift of Mrs. Eric Eweson, FA1991.20

(plate 18), *Everyman,* 1954 (fig. 10), and *Incubus,* 1954 (fig. 11). Music is also a theme, as in *Song,* 1950 (fig. 12).

Shahn's allusions to classical mythology are transformed into fantastic shapes and images in *Harpy,* 1951 (plate 17), depicting the mythic creature with a woman's head and a bird's body, and in *Prometheus,* 1956 (fig. 59), as well as in several works referring to the Daedalus myth (fig. 38). Beginning with *Allegory,* 1948 (plate 14), Shahn frequently used demonic imagery to create allegories with universal and multiple meanings, often with veiled references to topical events, such as nuclear weapons, as Frances Pohl discusses. Shahn refers to science and the scientist in such works as *Helix and Crystal,* 1957 (plate 25). The masks of Satan and God that he designed for Archibald MacLeish's 1958 play *J.B.* reappear in such later works as *Cat's Cradle in Blue,* c. 1959 (fig. 13), and *Branches of Water or Desire,* 1965 (fig. 14). A wrathful God also figures in Jerome Robbins's abstract, sociological ballet *Events,* for which Shahn designed the sets in 1961. Shahn portrayed a sightless figure in *The Blind Botanist,* 1954 (fig. 15). Blindness had been the subject of an earlier work, *Blind Accordion Player,* 1945 (fig. 16). Now in *The Blind Botanist*—one of several works featuring thorny plants—Shahn alludes to science as a double-edged sword, which could bring about discoveries beneficial to mankind, but which could possibly bring an end to all life on earth. In another version of this work (fig. 17), however, a botanist

Figure 10

Everyman, 1954
Tempera on composition board,
72 × 24 in. (182.9 × 61 cm)
Collection of Whitney Museum
of American Art, New York
Purchase

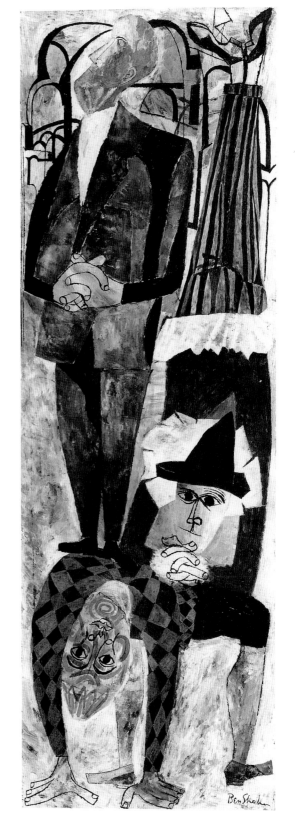

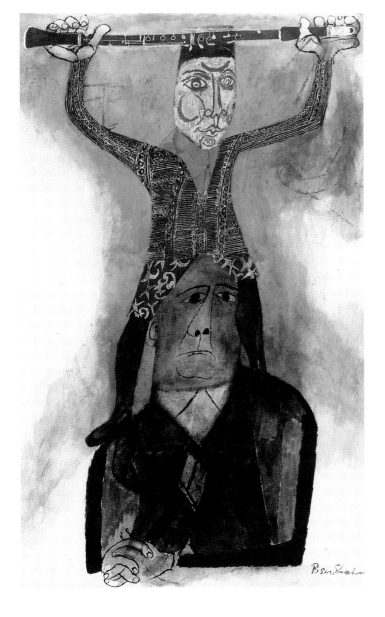

Figure 11

Incubus, 1954
Gouache on paper,
39 × 25 in. (99.1 × 63.5 cm)
Collection of Mr. and Mrs. William C. Bahan

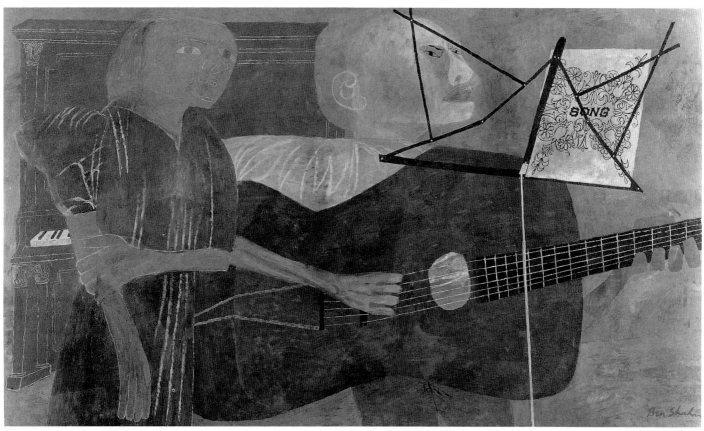

Figure 12

Song, 1950

Tempera on canvas mounted on wood,
30⅞ × 52 in. (78.4 × 132 cm)

Hirshhorn Museum and Sculpture Garden,

Smithsonian Institution, Washington, D.C.

Gift of Joseph H. Hirshhorn, 1966

with a blooming plant is shown. Shahn himself commented on the duality of his imagery: "My own concern with *The Blind Botanist*, was to express a curious quality of irrational hope that man seems to carry around with him, and then along with that to suggest the unpredictable miraculous vocation which he pursues."[21]

But Shahn disavowed any direct connection to Surrealism, instead:

> While I felt a growing conviction as to the validity of the inner view, I wanted not to re-tread the ground which had been so admirably illuminated by Surrealism. Indeed the subconscious, the unconscious, the dream-world does offer a rich almost limitless panorama for the explorations of art; but in that approach, I think we may call it the psychological approach, one may discern beyond the rich imagery certain limits and inevitable pitfalls.
>
> The limitation which circumscribed Surrealist art arose from its effort to reveal the subconscious. For in that effort control and intention were increasingly relinquished. Surrealism and the psychological approach led into that quagmire of the so-called automatic practices of art—the biomorphic, the fecal, the natal, and the other absurdities.[22]

For Shahn, Surrealism had always been an element in art, signaling the irrational and absurd. It could be found in the beasts and creatures of Romanesque

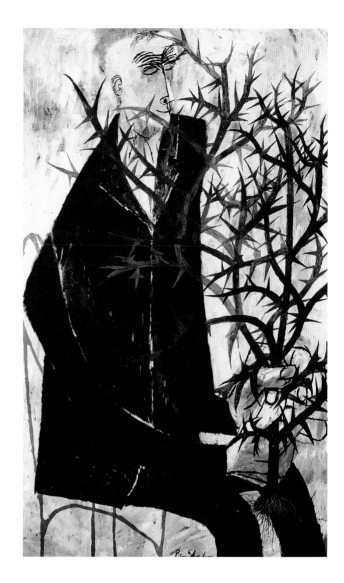

Figure 15
The Blind Botanist, 1954
Tempera on Masonite,
52 × 31 in. (132.1 × 80 cm)
Wichita Art Museum
The Roland P. Murdock Collection

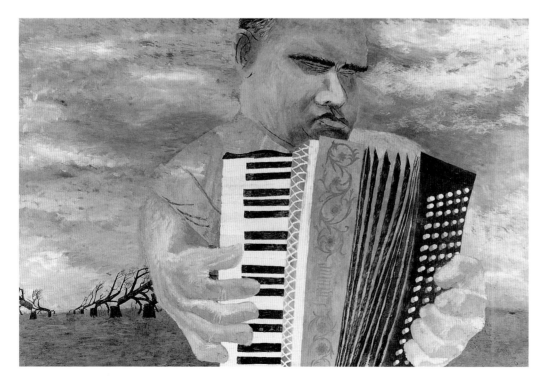

Figure 16
Blind Accordion Player, 1945
Tempera on board,
25½ × 38¼ in. (64.8 × 97.2 cm)
Collection Neuberger Museum of Art,
Purchase College, State University of New York
Gift of Roy R. Neuberger

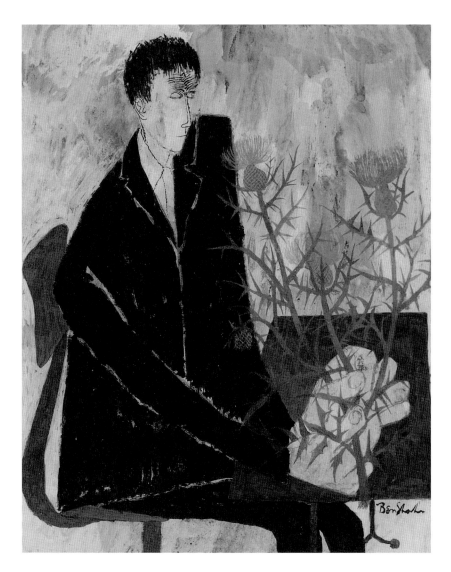

Figure 17

Blind Botanist #2, 1954

Tempera on canvas mounted on board,

21 1/8 × 17 1/4 in. (55.6 × 43.8 cm)

Collection Neuberger Museum of Art,

Purchase College, State University of New York

Gift from the Dina and Alexander E. Racolin Collection

architecture, in the decorative motifs in medieval manuscript illumination, in Brueghel and Bosch, and in primitive art. Shahn very much admired artists such as Balthus, de Chirico, Ernst, Magritte, and Klee, whose work expressed Surrealist tendencies.[23]

THE COMPLEXITIES OF JEWISH IDENTITY

In his later paintings and graphics, Shahn frequently focused on biblical themes, employing Hebrew calligraphy and text in a new context and using Jewish history to explore the continuity between his past and present. He was attracted to all kinds of writing and lettering, a consequence of his early lithographic training. Shahn particularly admired the fluid forms of Japanese calligraphy and the ability of contemporaries such as Jackson Pollock, Georges Mathieu, and Franz Kline to create memorable images that capture their rhythms without becoming imitations.[24] The use of the Hebrew alphabet in his work, absent for almost a

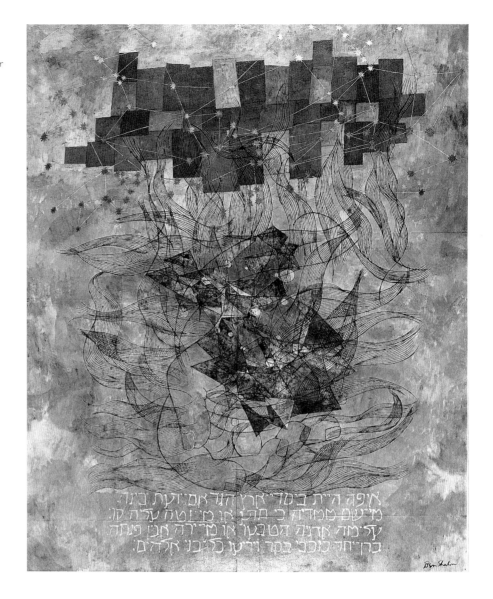

decade, reemerges in *Sound in the Mulberry Tree,* 1948 (fig. 72), and is elaborated in *Bookshop: Hebrew Books, Holy Day Books,* 1953 (plate 22), *Third Allegory,* 1955 (plate 24), *Ram's Horn and Menorah,* 1958 (plate 26), *"When the Morning Stars . . . ,"* 1959 (plate 27), and *Where Wast Thou?,* 1964 (fig. 18). In contrast to the surface realism of *Sound in the Mulberry Tree,* these later works are increasingly symbolic, allegorical, and abstract.[25]

Jewish themes dominate Shahn's work during the last decade of his life, which includes significant synagogue commissions. Yet, many years earlier, in his 1951 book, Shahn's first biographer Selden Rodman made much of Shahn's denial of and effort to escape from his Jewish background. Rodman depicted, in almost stereotypical fashion, the artist's intellectual and devoutly Orthodox father and his bitter, controlling mother, and an overbearing, close-knit Brooklyn Jewish community.[26] Whether overstated or not, it was Rodman's opinion that "like every other major figure in the arts in America, Shahn has been ob-

sessed with the isolation of the individual. To become an artist he had to break ruthlessly with the integrated 'community' of a possessive Jewish family."[27] However, Shahn had already chosen to live in the predominantly Jewish immigrant community of Jersey Homesteads. His *Yiddishkayt*—the basic culture, values, beliefs, and way of life of East European Jews—rather than Judaism, the religious faith, was at the core of his identity.

But for the rebellious Shahn, the religion of Judaism worked against itself, providing both the source of his lifelong commitment against injustice and a rationale for adopting, albeit gradually, a completely secular existence.[28] Several anecdotes Shahn would retell to different interviewers over the course of his life help to explain the shifting nature of his Jewish identity. The earliest telling of one of these stories is found in John D. Morse's 1944 interview with the artist. Shahn related his youthful reaction to a biblical story he had read in an Orthodox Jewish school in Russia. The story demonstrated to him that God was unfair or unjust because of the vengeance He wielded against those who could not meet a particular test of faith. "I hate injustice," Shahn said. "I guess that's about the only thing I really do hate. I've hated injustice ever since I read a story in school, and I hope I go on hating it all my life."[29] As a child, Shahn himself repeatedly tested the bounds of religious observance (such as prohibitions against travel on the Sabbath) to see if God would inflict such retribution on him.

Left-wing politics has long been considered the secular religion of many American Jews, particularly those who were shaped by the immigrant experience, by labor struggles, and by the Great Depression. This was particularly true for Ben Shahn, at least up until the late 1930s. Even thereafter, his liberal affiliations continued for the rest of his life, as is well known. But in the generation of Shahn's father, it was still possible to be both a believer and a socialist (as it was for those of Shahn's generation who unlike him might have lived more insular lives). Even before he left Russia, Shahn could not maintain this conviction; he himself failed the test of faith to which God had subjected the Jewish people. In America, social radicalism or progressive politics was a particular way for immigrant Jews to embrace the secularism of their new homeland in the face of changing social, cultural, and political conditions, yet still maintain a more universalized ethnic identity.[30] As Shahn's boyhood story of his reaction to injustice attests, Shahn could affirm his identity as a progressive American and secular Jew through his commitment to social justice at the same time that he disavowed religious beliefs.

Here the fact that Shahn misremembered details of a particular biblical story he retold—as Frances Pohl discusses at length in her essay—begins to

make sense. Shahn's childhood memories, imperfectly recalled, were imbued with the power of personal creation myths: strong impressions that formed his adult personality. In an interview with Forrest Selvig in 1968, near the end of Shahn's life, when an exploration of Jewish themes was more evident in his work, Shahn was asked, "In everyone's mind you're associated with the liberal movement—everything progressive all the way down the line. How did your involvement in all this come about?" And he responded, "It was a childish thing way back. I seemed to have sensed, or had an exaggerated sense of, injustice."[31] So it was not only a childhood memory of injustice, but, as if chiding himself retrospectively, Shahn recalled that it was also a child*ish* response. And in the retelling of the story as an old man, he added "I *claimed* it was an injustice on the part of God" (italics mine). If Shahn made his reputation with his elegy to the executed Italian anarchists Sacco and Vanzetti, it was the case of the Jewish victim of anti-Semitism, Alfred Dreyfus, that formed the subject of Shahn's first socially conscious work in 1931. And it was not only a book he picked up when he lived in Paris that had sparked Shahn's imagination, but his memories of hearing about the Dreyfus Affair in Lithuania as a child not too many years after it had actually happened. Although Shahn attributed his rebelliousness to Russian revolutionary fervor, his "conversion" at school was no doubt linked to specific political events as well as to the example of his father.

Perhaps one thing urging the necessity of this complex and contradictory self-identification was the pressure toward assimilation and for the representation of himself not as an immigrant artist, but as an American artist at a particular moment in history. Rodman asserted that "Shahn's evolution as a painter is the story of the artist as an American," going so far as to use the phrase as the title of his 1951 biography.[32] In some ways very much written from a Freudian perspective that shores up his account of Shahn as an American political liberal, Rodman's book noted how Shahn's early efforts to emulate the *peinture pure* of French modernism in the late 1920s left the young artist "unhappy and maladjusted." He found himself artistically through his portrayal of Sacco and Vanzetti, and could devote his time equally to commercial work for corporations and the Progressive party cause.[33] A long way to come for the son of a socialist whose childish behavior in pre-revolutionary Russia also included shouting at anyone in uniform—from a letter carrier to a policeman— "Down with the Czar!"[34]

Writing some twenty years later, Bernarda Bryson Shahn noted a significant change in her husband's work beginning shortly after Rodman's book was published:

Ben's reawakened interest in religious content and lore seems to have been stimulated by the first small books of carols and by *The Alphabet of Creation* [1954]. I believe that during his early years he had looked upon both religious and ethnic ties only as burdensome restraints on his freedom of life and opinion. But he was still and always a religious person. Later, when he had become assured in the authority of his own conscience, he began to rediscover the charm and wonder and the high literature that he had known so well, besides a spirituality that had so moved him in early Italian paintings.[35]

Shahn's works of the mid-1960s were increasingly abstracted and included rich decorative elements using the Hebrew alphabet, and were related to a renewed sense of his Jewish heritage and identity in the wake of the Holocaust. As the critic Harold Rosenberg, a spokesman for Abstract Expressionism, also noted at the time of Shahn's 1976 retrospective at The Jewish Museum, there was a moral rightness to Shahn's painting, self-evident in the 1930s, but extending as well to postwar works in which Shahn created "symbolic patterns out of the Hebrew alphabet." According to Rosenberg, Shahn's attention to this kind of "Jewish" subject matter was "right" because Shahn was a Jewish artist despite the fact that he was not religious.[36] What is the morality evident in the choice of such imagery? No doubt the choice is related to the Holocaust, which brought a renewed concern, also among Jewish artists, with commemorating the Jewish world that was destroyed. The "moral rightness" of the subject matter and imagery was born of and sustained by identification with the victims and responsibility toward their memory.

THE SAGA OF THE LUCKY DRAGON

In the last decade of his life, Shahn executed a series of paintings and drawings that once again demonstrated his innate abilities as a storyteller and reaffirmed his commitment to humanitarian causes. The theme was a tragic and highly publicized incident in which a Japanese fishing boat strayed into the range of American hydrogen-bomb testing near the Bikini atoll in March 1954. Again, this major series of fourteen paintings—the first on a single theme since *The Dreyfus Affair, Sacco and Vanzetti, Tom Mooney,* and *Prohibition*—and more than twenty drawings was inspired by a commercial assignment to illustrate a three-part article by Ralph E. Lapp that appeared in *Harper's* between December 1957 and February 1958. Several of the *Lucky Dragon* paintings, 1960–62 (plates 28–31; figs. 19–22, 36, 37, 66, 68), feature a dragon-headed beast that had evolved from its first appearance in the *Allegory* painting of 1948 (plate 14). Now with human arms and taloned feet, its fire-breath represented the hydrogen explo-

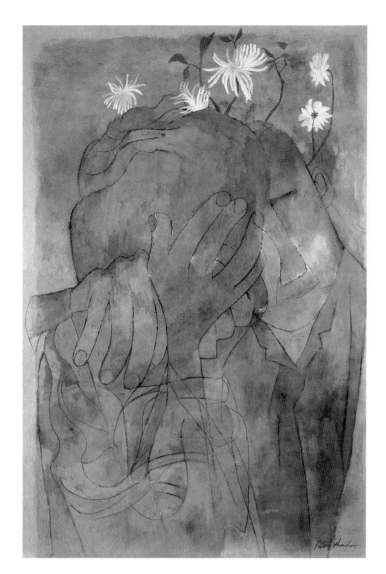

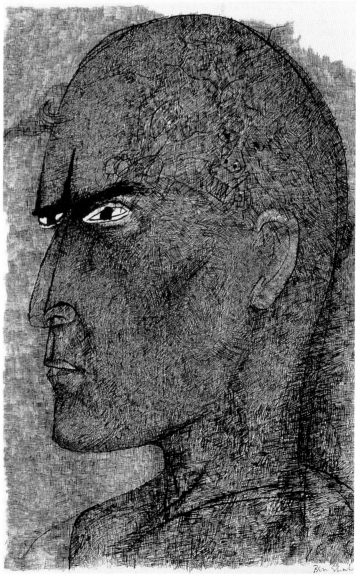

Figure 19
I Never Dared to Dream,
from the *Lucky Dragon* series, 1960
Gouache on paper mounted on board,
40 × 27 in. (101.6 × 68.6 cm)
Collection of the Norton Museum of Art,
West Palm Beach, Florida

Figure 20
Kuboyama,
from the *Lucky Dragon* series, 1961
Painting in ink on paper,
38 × 25 in. (96.5 × 63.5 cm)
Collection of Carol A. Straus

Figure 21
Why?,
from the *Lucky Dragon*
series, 1961
Gouache on paper,
20 × 26 in. (50.8 × 66 cm)
Okawa Museum of Art,
Gumma, Japan

sion that produced a snow-like fallout, covering the boat and its crew of twenty-three men, one of whom later died.

The dragon itself is a Japanese symbol of fate, an ironic twist for the ill-fated fishing boat. Unexpectedly and with dire consequences, this winter expedition in the Pacific began with numerous bad omens—among them, the boat having to make a detour to replace a spare part left behind, and then running aground when pulling into port. According to Bernarda Bryson Shahn, "More than any other of his works, grouped or singly, they established him in his world, expressed his relationship to it, told the role that he wanted to play in it."[37] Shahn's message against the bomb was evident when most of the series was exhibited as *The Saga of the Lucky Dragon* at the Downtown Gallery in New York in the fall of 1961, just months after the American Central Intelligence Agency had sponsored the failed invasion of Cuba, known as the Bay of Pigs, by Cuban exiles living in the United States.

The culmination of Shahn's interest in historical events imbued with universal meaning, the *Lucky Dragon* series, along with Shahn's *Portrait of Dag Hammarskjöld,* 1962 (plate 32), which shares with it the beast motif, aptly con-

Figure 22
Boy's Day,
from the *Lucky Dragon* series, 1962
Tempera on panel,
38 × 25¼ in. (96.5 × 64.1 cm)
Collection of Dorothy Eweson

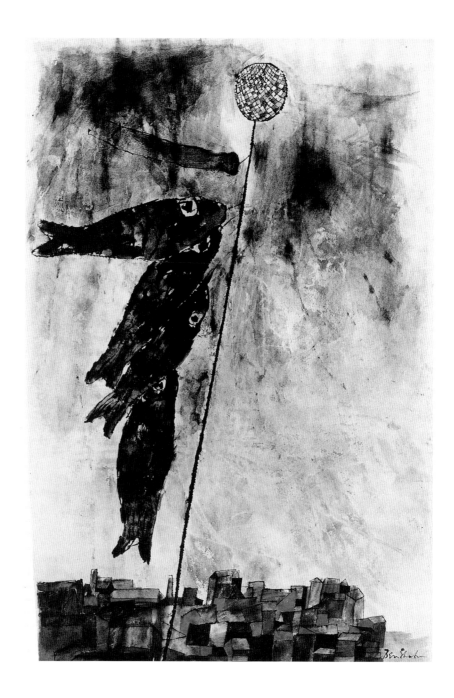

veys Shahn's personal sense of the individual's place in the world. Shahn much admired Hammarskjöld (1905–1961), Secretary General of the United Nations and winner of the Nobel Peace Prize. Shahn had accepted the commission from the Swedish National Portrait Gallery in 1959 and completed the painting from sketches and photographs following Hammarskjöld's death in an airplane crash. Shahn had wanted to express Hammarskjöld's isolation and loneliness, which to the painter were associated with the detachment needed to act fairly and justly on a global level. In so doing, Shahn affirmed his own political beliefs at the height of tensions between the world powers:

> I saw him as the kind of person who could make the United Nations a functioning reality.
> If the United Nations is that slim thread upon which a possible hopeful future for the

entire earth hangs, then an individual at its head capable of rising above either personal or national or East-West interests is an even slimmer thread on which all our hopes must hang. If the United Nations is to become, or be, a simple battering place for all sorts of vested interests, then it is nothing and can offer no solution for our growing powers and difficulties. That Dag Hammarskjöld could and did maintain an Olympian aloofness to "interests" to this side and that side was to many of us a source of joy and of hope. His calm justice, his vast perspective upon human affairs were those of the philosopher rather than of the politician.[38]

THE ESSAYS

The following essays broaden our understanding of Shahn's art and life, and his response to social issues, to war, and to the Holocaust. They focus on various aspects of his oeuvre for more than three decades, examining how his paintings express a connection to his ethnic and religious heritage as well as to the wider art world. Diana L. Linden challenges essentialist notions of Shahn's Jewish identity via the lens of his murals created during the New Deal era between 1937 and 1941. She suggests that the social and economic concerns reflected in Shahn's mural programs were directly linked to issues affecting American Jews between the wars and are expressions of the artist's experiences and ethnic identity as a secular Jew.

In an examination of Shahn's works painted between 1943 and 1962, Stephen Polcari places Shahn in the context of his contemporaries, both figurative and Abstract Expressionist painters and sculptors of the 1940s and 1950s, whose works reveal a tense reexamination of the fate of man in the postwar period. Polcari's essay examines how artists who worked in radically different styles—Regionalists, Expressionists, and Abstract Expressionists—shared a common ground in their postwar reactions to the moral and political crises of World War II. Like the abstract artists, Shahn created a new symbolic pictorial language, based on universal themes and images from myth, folklore, psychoanalysis, and Judeo-Christian tradition, to explore the meanings of war, survival, and anxious renewal.

With an in-depth analysis of three related paintings, *Allegory,* 1948 (plate 14), *Second Allegory,* 1953 (plate 20), and *Third Allegory,* 1955 (plate 24), Frances K. Pohl details Shahn's search for a symbolic language to represent the trauma of the individual in the postwar world. By combining stories from the Bible, Jewish traditions, and contemporary history with his own childhood memories, Shahn created pictures that share the narrative basis of his earlier work, yet address issues at once personal, topical, and universal.

CONCLUSION

It is not surprising, given the public success and visibility that Shahn had achieved by the time of his death, that some seven years later the explicit connections between Shahn's social activism, Jewishness, and American identity would all come together in his retrospective at The Jewish Museum. Despite, or perhaps because of, the disillusionment that followed upon the end of the Vietnam war and the Watergate era, by 1976 there was a nostalgia for the politically committed American past. As the critic Emily Genauer noted at the time of the 1976 exhibition, although there were no references to how artists fared during the forties and fifties, a number of then-current films, television shows, and books reflected renewed interest in the plight of other victims of witch hunts and blacklists, as portrayed, for example, in Lillian Hellman's *Scoundrel Time* or Woody Allen's *The Front*.

"The Jewish Museum takes pride," wrote the Museum's director at the time, "in presenting the work of Ben Shahn in the year of the American Bicentennial Celebration—1976. It is particularly appropriate to an American immigrant who, throughout his career, was dedicated to the American ideals of freedom, truth and justice." The show was curated by Kenneth Prescott, who, as director of the New Jersey State Museum in Trenton from 1963 to 1971, assembled what has come to be known as the definitive collection of Shahn's graphic work. The exhibition at The Jewish Museum was particularly notable for the comprehensiveness of its selection and for the importance it placed on Shahn's work in all media, most notably by including his poster production and photography.

According to the catalogue, the 1976 exhibition's central focus was the question "Why is it that an artist like Shahn unfurled the banner of human dignity and used his creative talents in a personal war against oppression?" In his review of this highly popular show, the critic Harold Rosenberg observed that the "general effect [of the exhibition] is to continue the identification of Shahn as a political artist." Conservative critic Hilton Kramer noted in a similar vein that the exhibition attracted something other than the "usual museum crowd":

> Some were young, to be sure, but most of them were not. They were not only older but looked less prosperous and less sophisticated, less used to being in a museum, than the people one commonly observes at the Whitney or at the Museum of Modern Art. Such impressions are always subjective, of course. Mine, on this occasion, were of people, mainly New Yorkers and mainly Jewish, close to retirement age or beyond it, who were probably members of a labor union during much of their lives. They struck

me as people who had come to this exhibition to relive something that had been important in their lives.[39]

Kramer, for the most part, while attempting to understand Shahn's popular appeal, cared little for Shahn as an artist, and appreciated his politics even less.

In many ways The Jewish Museum's view of Shahn as a humanist and politically committed artist remains unchanged. However, we revisit the artist's career more than twenty years later with a new focus, attempting to broaden our understanding of the artist beyond the category of "Social Realist" and to explore his significant but less well-known place in American art of the postwar period. Throughout the exhibition and this catalogue, we explore the relationship of Shahn's Jewish identity to the changing styles and subject matter of his art.

Another important aspect of this book and of the exhibition is that they expand the context for Shahn as an artist within a very complex period of American art history. Between the 1930s and the early 1960s, artists who had once shared much in common branched out on different paths. The artists who came to dominate were the Abstract Expressionists, although the others have received renewed scholarly attention in recent years.[40] Few such studies, however, attempt to discuss these divergent artists together, as Stephen Polcari does here. As with other artists of the time, the changes in Shahn's style reflected the invention of new pictorial means and imagery to address the traumatic effects of World War II and its aftermath. As we begin to analyze and interpret Shahn's allegories and to understand the shifting nature of his response to life around him, our appreciation and understanding of his work increases. Shahn's place in art history, like his position in American Jewish culture, remains complex, and beyond categorization. Shahn's identity as a Jew is intricately entwined with his artistic work. From the Jewish school of Vilkomir to an acculturated, secular life in Brooklyn to a resurgence of Jewish feeling and heritage in his later years, Ben Shahn's dedication to humanitarian causes and his belief in the regenerative powers of art offer a fascinating example of the paradigmatic path taken in the life of an immigrant American Jewish artist.

Notes

1. Saul Benison and Sandra Otter, Interview with Ben Shahn, October 29, 1956, Columbia University Oral History Research Office, transcript, 39.

2. Harold Rosenberg, "The Art World: Ben Shahn," *New Yorker,* December 13, 1976, 156.

3. Ben Shahn, *The Shape of Content* (Cambridge: Harvard University Press, 1957), 65; see also

Frances K. Pohl, *Ben Shahn: New Deal Artist in a Cold War Climate, 1947–1954* (Austin: University of Texas Press, 1989), 2.

4. Bernarda Bryson Shahn, *Ben Shahn* (New York: Harry N. Abrams, 1972), 15.

5. *Encyclopaedia Judaica* (Jerusalem: Keter, 1972), 15:1513.

6. Benison and Otter, Interview, 17–18.

7. Ibid., 23.

8. Ibid., 26–27, and Selden Rodman, *Portrait of the Artist as an American, Ben Shahn: A Biography with Pictures* (New York: Harper and Brothers, 1951), 165.

9. Rodman, *Portrait of the Artist,* 163–64. The figure on the right of the painting is a fish peddler, according to the preparatory drawing published in Rodman, 157. The photograph is in the Ben Shahn Papers, Archives of American Art, Smithsonian Institution, Washington, D.C., Roll 5027: 654. A microfilm copy is available at the Archives office in New York.

10. Benison and Otter, Interview, 32.

11. Ibid., 40.

12. Ibid., 39.

13. Ibid., 49–50.

14. Interestingly, according to Laura Katzman, James Thrall Soby, who organized Shahn's 1947 MOMA exhibition, was concerned that a full revelation of the relationship between Shahn's photography and Shahn's work in other media would compromise the aesthetic and/or market value of that work. See "The Politics of Media: Painting and Photography in the Art of Ben Shahn," *American Art* 7, no. 1 (Winter 1993): 60–87.

15. Diane Tepfer, "Edith Gregor Halpert and the Downtown Gallery Downtown: 1926–1940; A Study in American Art Patronage," 2 vols. (Ph.D. diss., University of Michigan, 1989), 105, 262.

16. Rodman, *Portrait of the Artist,* 121.

17. Information provided to John Charles Carlisle by Bernarda Bryson Shahn. See Carlisle, "A Biographical Study of How the Artist Became a Humanitarian Activist: Ben Shahn, 1930–1946" (Ph.D. diss., University of Michigan, 1972), 106. In addition to Pennsylvania and Mississippi, Shahn and Bernarda Bryson visited Arkansas, Delaware, Georgia, Kentucky, Louisiana, Maryland, Missouri, North Carolina, South Carolina, and West Virginia.

18. Ben Shahn, *Shape of Content,* 41.

19. Matthew Baigell, *Jewish-American Artists and the Holocaust* (New Brunswick, N.J.: Rutgers University Press, 1997), 17.

20. Ziva Amishai-Maisels posits that Shahn's references to specifically Jewish victims of the war are often hidden or covert. See "Ben Shahn and the Problem of Jewish Identity," *Jewish Art* 12–13 (1986–87), 304–19. See also Baigell, *Jewish-American Artists,* 33–35.

21. Ben Shahn, "Letter to Mrs. Elizabeth S. Navas, New York (1955)," in *Ben Shahn,* ed. John D. Morse (New York: Praeger, 1972), 63.

22. Shahn, *Shape of Content,* 43.

23. Shahn, *Ben Shahn,* 87–88.

24. Ben Shahn, *Love and Joy About Letters* (New York: Grossman, 1963), 45.

25. Ziva Amishai-Maisels identifies the first reappearance of Hebrew lettering in *Sound in the Mulberry Tree,* in "Ben Shahn and the Problem of Jewish Identity," 314.

26. Rodman, *Portrait of the Artist,* 156–59.

27. Ibid., 7.

28. Ibid., 171–72.

29. John D. Morse, "Ben Shahn: An Interview," *Magazine of Art* 37, no. 4 (April 1944): 136.

30. Anita Schwartz, "Ethnic Identity Among Left-Wing American Jews," *Ethnic Groups* 6, no. 1 (1984): 65. See also Matthew Baigell, "From Hester Street to Fifty-Seventh Street: Jewish-American Artists in New York," in *Painting a Place in America: Jewish Artists in New York, 1900–1945,* exh. cat., ed. Norman L. Kleeblatt and Susan Chevlowe (New York: The Jewish Museum; Bloomington: Indiana University Press, 1991), 28–71.

31. Forrest Selvig, "Interview: Ben Shahn Talks with Forrest Selvig," *Archives of American Art Journal* 17, no. 3 (Fall 1977): 14.

32. For more on Rodman's interpretation of Shahn and a fascinating account of the use of Rodman's material by the government with the support of the Ford Foundation to promote American culture abroad, see Pohl, *Ben Shahn: New Deal Artist,* 110–12, 144–46.

33. Rodman, *Portrait of the Artist,* 6.

34. Selvig, "Interview," 15.

35. Shahn, *Ben Shahn,* 257.

36. Rosenberg, "The Art World: Ben Shahn," 157.

37. Shahn, *Ben Shahn,* 272.

38. Ben Shahn, "Concerning Likeness in Portraiture," in *Ben Shahn,* ed. John D. Morse, 90.

39. Hilton Kramer, "Art View: Publicizing Social Causes on Canvas," *New York Times,* November 7, 1976, D23.

40. This interest originates with studies of artists' involvement in the Federal art programs of the New Deal and of Social Realism and Regionalism that peaked in the 1970s. A signal exhibition that sought to broaden understanding of wartime and postwar American art beyond the dominance of the Abstract Expressionist movement was organized by Greta Berman and Jeffrey Wechsler in 1981. See their book *Realism and Realities: The Other Side of American Painting, 1940–1960* (New Brunswick, N.J.: Rutgers University Art Gallery, 1981). Abstract Expressionism itself has been the subject of much scholarly attention since the 1980s with studies that have attempted to contextualize the movement, particularly in terms of politics and the Cold War. More recent studies explore the cultural context of the movement. See also Stephen Polcari, *Abstract Expressionism and the Modern Experience* (Cambridge: Cambridge University Press, 1991), and Michael Leja, *Reframing Abstract Expressionism: Subjectivity and Painting in the 1940s* (New Haven: Yale University Press, 1993). Further references are listed in the bibliography.

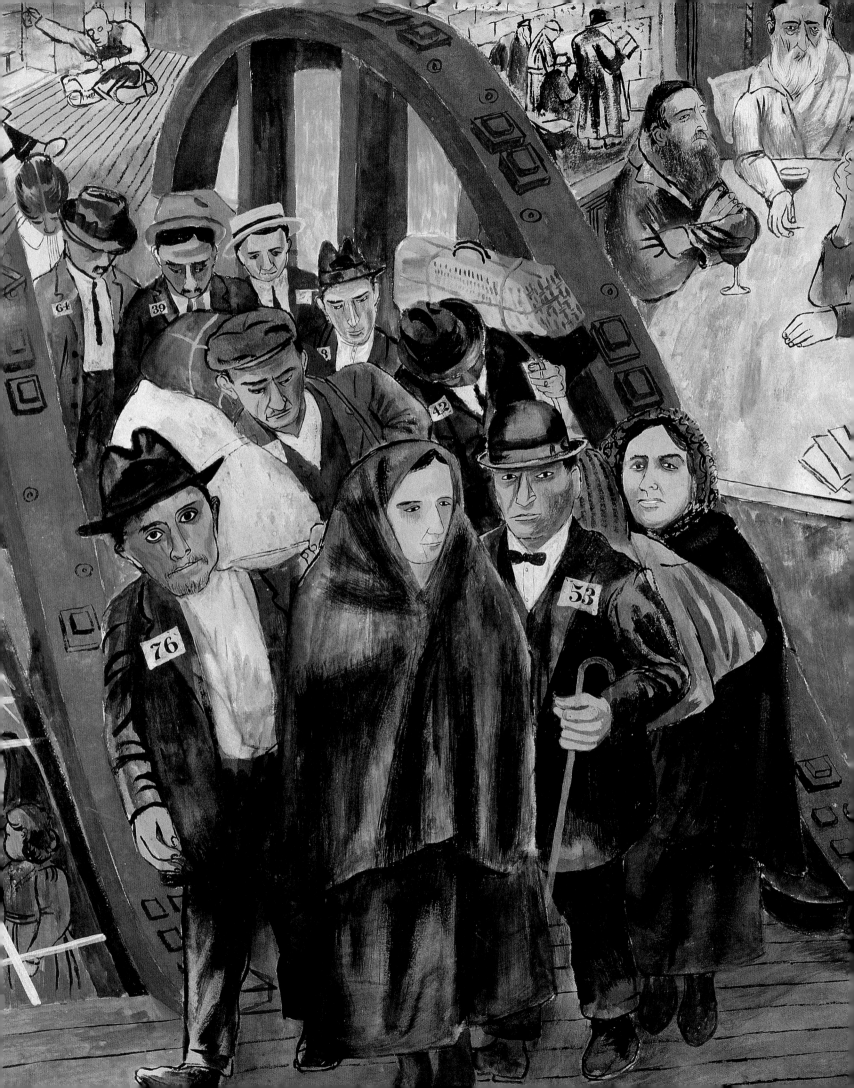

Ben Shahn's New Deal Murals

JEWISH IDENTITY IN THE AMERICAN SCENE

Diana L. Linden

Ben Shahn is well known today as a Jewish artist; yet many scholars disagree about what Shahn's Jewishness meant in his life and in his art. Shahn has been criticized for removing Jewish content from his work at the same time that he is chauvinistically celebrated as a distinctly Jewish artist. Authors have argued that Shahn's turn to the American Scene during the 1930s was at the expense of Jewish identity, while others locate his dedication to social issues as the natural outgrowth of his early Talmudic education.[1] Iconographic representations of Jews and Jewish subject matter are not immediately evident in viewing Shahn's murals of the thirties. Indeed, when Shahn did represent Jews—for example, Albert Einstein in his mural for the Jersey Homesteads (see fig. 23)—he did so as a vehicle to address social and political issues such as immigration and the plight of European refugees rather than to create a pantheon to ethnic pride.

This essay examines Ben Shahn's ongoing engagement with the cultural and historical experiences of Jewish life in America and the world during the New Deal era. Experiences such as immigration and involvement with the labor movement, along with Jewish interest in social justice, helped to form the artist's identity as a leftist secular Jew. Rather than debate "how Jewish" Shahn was, I will demonstrate how his murals speak about secular Jewish immigrant experiences in America during the early twentieth century. Shahn never left Jewish identity behind in creating these New Deal murals; rather, Shahn's themes addressed the sociopolitical concerns of a working-class American Jewish community that was redefining itself economically, culturally, and politically.

Detail of plate 2

His works responded to the often anxious experience of American Jewish life during the Great Depression, a period since overshadowed in historical literature by the Holocaust. His mural on immigration, labor, and New Deal reforms for the Jersey Homesteads, 1936–38 (see figs. 23–25), his *Resources of America,* 1938–39 (see figs. 28, 29)—and the debate it provoked—for the Bronx Central Post Office, his series on the *Four Freedoms,* 1939 (see figs. 31–33), proposed but rejected for the St. Louis, Missouri, Post Office, and his related one-panel *Four Freedoms,* 1940–41 (see fig. 34), for the Jamaica, New York, Woodhaven Branch Post Office in Queens, reveal a dedication to liberal social policy, support for immigration reform, and desire for political and religious freedom that, although not exclusive to American Jews, were markers of American Jewish ethnic identity during the interwar period.

JEWISHNESS AS ETHNIC IDENTITY

For many years, Shahn's work has been eclipsed by that of the Abstract Expressionists; yet the task of clarifying Jewish identity within Shahn's work intersects with the histories of abstraction and its theorists. During the 1960s, art historian and critic Harold Rosenberg questioned the existence and character of Jewish art.[2] Rosenberg summarily assessed, and dismissed as inadequate, a series of responses to the question "Is there a Jewish art?" For Rosenberg, "Jewish art" referred to art produced by Jews, ceremonial or ritual art, art expressing Jewish metaphysics, or art depicting Jewish subject matter. Along with Clement Greenberg, Rosenberg championed the Abstract Expressionists and privileged such artists as Mark Rothko, Adolph Gottlieb, and later, Philip Guston, all of whom had rejected biographical and communal aspects of Jewish identity in favor of a broader twentieth-century concept of existential identity.[3] In their engagement with formalism, these artists liberated themselves both from the weight of self and of Jewishness.[4] And, as art historian Margaret Olin proposes, Greenberg's and Rosenberg's denial of the subjective was, in fact, an "assimilationist tactic," a denial of personal identity as well as a means to negotiate the nationalism, anti-Semitism, and racism that were intertwined in the nineteenth-century origins of art-historical inquiry.[5] In holding up as the ideal those artists working in a purely abstract vocabulary, Rosenberg never looked beyond the borders of the frame, never venturing to gauge how the artists and their works were related to the immediate social and political context. During the 1940s, formalist critics such as Greenberg and Rosenberg would dismiss Shahn's narrative, figurative, and socially explicit images as "unimportant," "derivative," or "inconsequential" for contemporary painting.[6]

While the issue of identity has gained great currency in the "culture wars" of the 1980s and 1990s, debates on American Jewish identity extend beyond the realm of arts and letters, and reach far back to early in this century.[7] Further, the issue of identity continues today to be a central concern in Jewish academic, religious, and popular discourse. Laurence J. Silberstein notes that, during the past several years, cultural theorists such as Stuart Hall have questioned essentialist notions of ethnicity as fixed and stable, instead positing cultural identity as a changing social construct that is always in the process of becoming.[8] Yet commentators on Shahn's Jewish identity and its impact on his art are often concerned with essentialist ideas of character. Or they focus on the artist's later Jewish imagery: Shahn's allegories, psalms, and images of Maimonides are seen as a return to the Judaism of his youth in Lithuania. However, we should also be aware that at the same time the artist was celebrating Christian verse and imagery.[9] A broadening of the concept of Shahn's Jewishness to include dimensions of ethnic identity such as socioeconomic class, generation, and educational status allows for a more informative discussion than would a simply religious definition of identity.[10] Inspired by his ethnic rather than religious experience as a Jew, Shahn, by all accounts, was not observant.

THE NEW DEAL MURALS

Between 1933 and 1943, the federal government established numerous art programs to employ American artists, to maintain American culture during the depths of the Depression, and to make the arts accessible to a wider portion of the public. The government provided artists—whose training, style, and concerns varied—with specific thematic and stylistic guidelines. Artists were to depict the American Scene, celebratory images of the nation's past and present represented in a realist style.[11] One of many artists employed by the federal art programs, Shahn painted murals that are now heralded as among the finest of the New Deal period.

By the time that the federal programs were established in 1933, Shahn had already secured a reputation as a socially critical artist. As art historian Frances K. Pohl writes, in the early 1930s Shahn's "desire to tell a story and his search for subject matter relating to his own personal experiences" led to his first works probing social injustices.[12] He began with a series on *The Dreyfus Affair* and a Haggadah, both 1931, which, in part, contemporized the story of the Exodus; his awakening as a socially conscious artist drew both from recent Jewish secular history and from Jewish religious traditions. Yet, at this time, Shahn was still developing a style strong enough to convey his messages of justice and

social concern. He achieved this goal with his series of gouache and tempera panels entitled *The Passion of Sacco and Vanzetti, 1931–32,* and the subsequent series on labor leader Tom Mooney, 1932. These two series mark the debut of the mature artist, and are related to his subsequent murals by the social concerns of their subject matter, the simplified colors, and the use of outline to define bold shapes. An important milestone for Shahn was the opportunity to assist the Mexican muralist Diego Rivera (1886–1957) on the ill-fated fresco *Man at the Crossroads, 1933,* for Rockefeller Center.[13] Not only was Shahn one of the few New Deal artists to learn the fresco technique in this capacity, but he also experienced firsthand the ramifications of painting politically charged subjects. Inspired by Rivera, Shahn wanted to create his own murals.

Ben Shahn pursued eight separate commissions in his New Deal projects, establishing a pattern notably different from his contemporaries.[14] Shahn chose not to enroll in the New Deal's easel division, as did most of the other muralists, although he did work as a photographer for the Resettlement Administration/Farm Security Administration (RA/FSA).[15] Shahn was highly ambitious in his choice of mural commissions, and thorough in his preparations. He would propose murals to officials instead of waiting for juried competitions to be established; and he applied only to the most prestigious national competitions. In order to paint his multifigured, narrative proposals (see plate 2, fig. 27), Shahn did extensive preparatory study and research, drawing from books and articles, his travels, his own prior work, and popularly reproduced photographs.

The vast majority of Americans suffered during the Depression, and they did so along regional, racial, gender, and ethnic lines. Historian Beth S. Wegner clarifies that during the years of Shahn's mural production (1933–42), American Jews expressed great anxiety about their immediate economic situation, the employment, education, and housing quotas and barriers that they faced, and the rapid growth of fascism in Europe and of anti-Semitism in the United States, which was at its zenith.[16] Anti-Semitism, with its violence, restrictions, and resulting sense of danger and uncertainty about the future, is what set the American Jewish experience of the 1930s apart from that of other working-class ethnic groups. As art historian Matthew Baigell observes, Jewish artists were not impervious to this sense of anxiety since anti-Semitism was also pervasive within the art world.[17] Shahn's commentary on national and international political events as well as communal experiences was apparent to audiences in his time, but has in large measure since been ignored by historians. By recontextualizing the murals, however, the artist's full intent and involvement with world events is rediscovered.

Prior to these anxious years, modernization and acculturation contributed

to the destabilization of American Jewish institutions and communities. The secularization of American Jewish life weakened communal bonds formed by a shared language, religious traditions, and social interdependence; yet cultural, fraternal, and political institutions still forged common links.[18] As Wegner puts it, American Jews were reinventing "the personal and communal elements of ethnic culture" in the midst of the nation's "refashioning its political, economic, and social structure."[19] Until the candidacy of Franklin D. Roosevelt, Jews primarily voted the Socialist ticket; in November 1932, the Jewish vote changed allegiances with 85 to 90 percent supporting the Democrats.[20] Shahn, whose *Jersey Homesteads* fresco contains one of the few images of President Roosevelt to emerge from the federal mural programs, was devoted to the president whose social policies Shahn sought to support in his art. In hindsight, it has been proposed that the devotion to FDR was undeserved in light of his administration's refusal to intervene on behalf of European Holocaust victims and refugees as well as its refusal to pass anti-lynching legislation.[21]

The Popular Front's support for FDR and the New Deal, beginning in 1935, had a particular appeal for Jews. During the Popular Front era, when the Communist International openly proclaimed an antifascist position and supported democratic regimes opposed to fascism, the Left also espoused a new openness to ethnicity. Earlier in the 1930s, the Left and the American Communists had stressed the need to "Americanize," arguing that language, custom, and other ethnic markers were subservient to class and that ethnic cohesion was a barrier to class struggle.[22] This new openness to ethnicity by the Popular Front meant that leftist Jews could maintain their cultural and/or religious traditions at the same time that they were politically committed to the Left's fight against fascism and for democracy. Under the Popular Front, as historian Harvey Klehr observes, leftist Jews could announce themselves as the most strident opponents of Nazism.[23] The American Communist Party (CP-USA) formed new ethnic bureaus—the largest being the Jewish bureau—that hosted a variety of cultural and political activities.

Shahn supported FDR and the New Deal; he was wary of the rising momentum of cultural repression, censorship, and nativism in his country; and he was hopeful that artists could positively inform and reform society. Although the federal art projects were initiated in 1933 (as the Public Works of Art Project) and Shahn applied for commissions immediately, it would be several years before he saw a commission through to completion. In 1936, officials selected Shahn to paint a mural for the Jersey Homesteads (figs. 23–25), which was not only his first mural, but also his most open expression of the American Jewish experience.

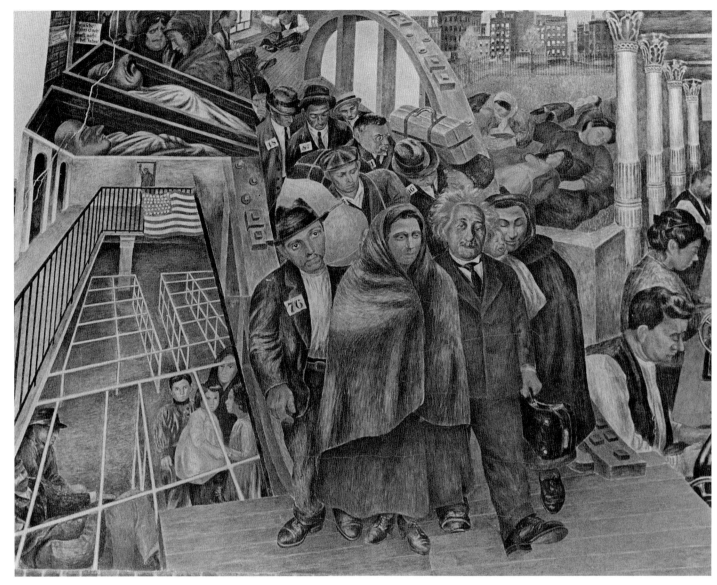

Figure 23

Jersey Homesteads Mural
(detail, left section), 1937–38
Fresco
Roosevelt, New Jersey

Established by the Resettlement Administration, the Jersey Homesteads (now Roosevelt, New Jersey) was a subsistence homesteading community created to house Jewish garment workers relocated from nearby New York City. (Shahn himself moved to the town in 1939 and lived there until his death.) The needle trades had been important to Jewish economy for decades. In the early 1930s, a full one-third of New York's Jewish population was employed in the garment industries, and they were left utterly devastated by layoffs during the Depression.[24] To counter this downward economic spiral, the Jersey Homesteads was to have a dual economic base, maintaining both agricultural production and garment factories.

Like many other inhabitants of Jersey Homesteads, Shahn was an East European Jewish immigrant. Shahn's untitled fresco tells the history of East European Jewish immigration to the United States—a major event in the American Jewish experience—the oppressive labor and living conditions that many Jews found in exploitative sweatshops and tenements, the better lives that they cre-

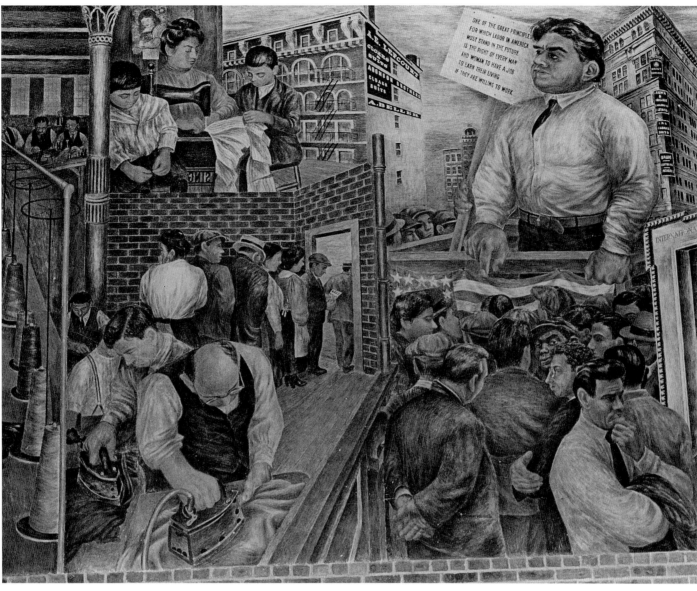

Figure 24

Jersey Homesteads Mural
(detail, center section), 1937–38
Fresco
Roosevelt, New Jersey

ated through trade unionism, and the labor reforms and social programs of the New Deal (figs. 23–25). Shahn's mural proposes a direction that Jewish American workers could follow, a path historically rooted in socially progressive ideals and earlier Jewish utopian initiatives that complemented those of the New Deal, and that stressed class and communal affiliation.

Although Shahn's mural focuses on urban imagery, the setting for the mural —the Jersey Homesteads—was, in fact, rural. American Jewish history has often been incorrectly presented as solely an urban experience centralized in New York's Lower East Side; and paintings of American Jewish life reflect a predominance of urban subjects.[25] However, Jewish agricultural and social utopias were an important part of the American experience, and saw a revitalized interest during the 1930s, bringing Jews into the general back-to-the-land movement of the decade.[26] A government press release reveals its expectations for the Homesteads:

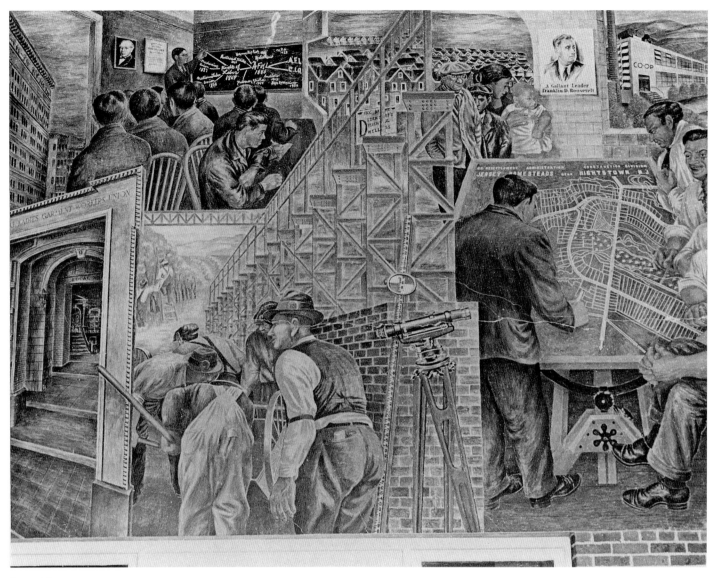

Figure 25

Jersey Homesteads Mural
(detail, right section), 1937–38
Fresco
Roosevelt, New Jersey

[I]t is popularly thought to be unusual for Jewish people to engage in a rural or semi-rural undertaking. The Jewish people are known as a gregarious race who have been highly urbanized for the past two thousand years, in large measure as the result of European laws which prohibited them from owning land. What is not so well known is that some 120,000 Jews are on farms in this country today. Attempts by other countries to settle Jewish families on the land have failed largely because they neglected the social side of life which is so important to the Jew. The Jew is a sociable citizen. He sets great store by family, friends, and community. He flees from isolation. The Jersey Homesteads plan promises him a semi-rural or suburban life, but one in which neighbors and the community are strongly emphasized. In such a community the advantages of subsistence homesteading are to be enjoyed with no loss of these fine social activities which go to make up the well-rounded life which the Jewish family demands.[27]

In order to establish the Jersey Homesteads community, organizer Benjamin Brown and others had to negotiate conflicts between union leader David Du–

binsky and the garment workers, with Albert Einstein serving as an intermediary.[28] Perhaps wanting to avoid similar struggles over his mural's content, Shahn proposed an advisory panel of four consultants. The four were Felix Adler (1851–1933,) founder of the Ethical Culture movement; Philadelphia rabbi William Fineschreiber (1878–1968), an outspoken opponent of political Zionism and the establishment of a Jewish state in Palestine; art historian and political activist Meyer Schapiro (1904–1996), whom Shahn knew from their work on the journal *Art Front*; and (Baruch) Charney Vladeck (1886–1938), socialist founder of the American Labor Party, former editor of the *Jewish Daily Forward,* advocate of Yiddish language and culture, and champion of public housing.[29] It is not known if the panel ever convened; in fact, Adler had died several years earlier. Nevertheless, the make-up of the proposed group speaks both of the pluralism of the American Jewish community during the 1930s and Shahn's receptivity to such diversity.

Notes (fig. 26), sketches (plate 2, fig. 27), and correspondence establish that Shahn changed both the overall theme of his mural and particular details as he worked on the project. Such rethinking of ideas and images is far from extraordinary, although Shahn's redirection has provoked some scholars to comment that the resulting changes effectively "hide" the Jewish meaning in his work.[30] From my position, Shahn's secular concept should not be seen as either renunciation or camouflage of his Jewishness. Shahn's mural establishes his desire to promote class affiliation, which he believed would establish a broader base for American Jews than would ethnic identification alone. Charney Vladeck similarly urged workers to build coalitions and inclusive bonds based on class and labor rather than ethnicity.[31]

With each change in his mural, Shahn privileged secular, contemporary American life and working-class identity over elements of religious tradition and ritual (with which the artist and many others in the Jersey Homesteads had broken). Yet, the mural's representation of immigration, Americanization, and labor and its references to Nazi Germany all explicitly speak to the then-contemporary Jewish social and political experience. Further, the changes that have drawn the most attention—namely Shahn's removal of a Passover scene, his changing the Yiddish text (of a speech that was originally presented in English by union leader John L. Lewis) into English, and his removal of references to pogroms in the final mural—are just a few among many changes that Shahn made in the murals (plates 1, 2, fig. 27). When the entire process of creating the mural is viewed as a whole, and the many changes Shahn made are considered, it becomes clear that, rather than concealing Jewishness, Shahn was redefining Jewishness in terms of class, labor, and secular life. In order to estab-

Figure 26

Ben Shahn's handwritten notes on themes
and content of *Jersey Homesteads Mural.*
Ben Shahn Papers, Archives of American Art,
Smithsonian Institution, Washington, D.C.

Figure 27

*Study for Jersey Homesteads
Mural,* c. 1936

Tempera on paper on
Masonite, 19½ × 27½ in.
(49.5 × 69.9 cm)
Private collection

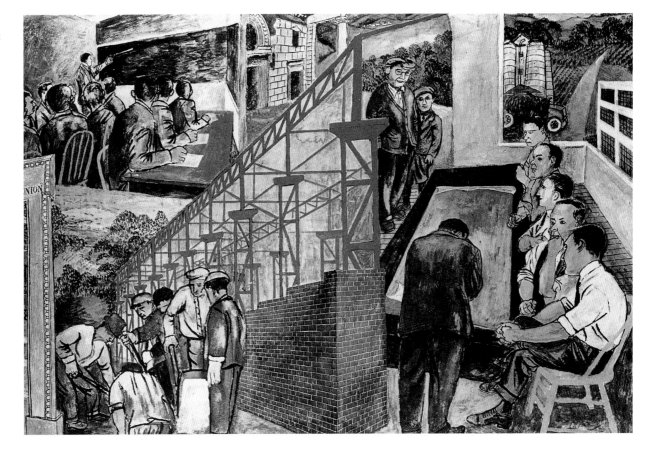

lish his vision of the Jewish working-class, Shahn had to address the competing voices of American Jewish life, including those within the Jersey Homesteads: friction between labor and organizers of the Homesteads; generational differences; conflicts between socialists and communists, and between Zionists and those opposed to a Jewish state, to name just a few.

Surrounded by town residents eager to make suggestions, Shahn began the project by scribbling a "laundry list" of preliminary ideas (fig. 26).[32] Shahn had envisioned the mural's tripartite structure as unfolding a narrative of the past, the present, and the hypothetical future.[33] The structure presents the mural's themes as "background," "immigration," and "unionization." Shahn begins his narrative in the Pale of Settlement, noting the repressive conditions under czarist rule, including accusations of blood ritual as in the Mendel Beilis case.[34] Zionism, immigration, or retreat into religion as solace are the options that Shahn sees for East European Jews.

But as Shahn continues his narrative, he shifts the action to the United States where he identifies two defining conditions of Jewish American life. The first is the generational tension between Old World Jews, raised in East European shtetls and ghetto communities, and the new breed of assimilated American Jews. For Shahn, the answer to this generational tension, and the goal and second condition of this new life in America, was for Jews and workers to be involved with labor, the garment unions, and the forging of class-based bonds. Looking warily at contemporary Germany, Shahn warns against assimilation, and instead promotes cooperative ventures among the working class, particularly among the unions.

In a later but undated essay, Shahn further develops his ideas for the mural, filling in the details presented in his first, sketchy list. Shahn was still seeking to resolve the issue of what path Jews should follow. A cloud, "in which the horrors of Jewish persecution in Hitler Germany are shown," hangs perilously above a young Jewish worker who has reached a divided pathway. Deciding that his future is not in Palestine, Shahn's worker instead ventures forth as an American Jew, returning to the land by living communally (Jersey Homesteads) and practicing his trade, but doing so without "sacrificing his racial and cultural treasures."[35]

As viewers of the final mural (see figs. 23–25), we follow the same path taken by the immigrants and the Homesteaders when we move from the darkness of the Old World to the bright new Eden of the Jersey Homesteads. Our role, as viewers, is to relive the experience of exodus, immigration, and American labor, which Shahn affords us by the extreme legibility of form, space, gesture, and life-size scale of the figures. Lettering in the form of signs and

documents that are placed throughout the mural help to locate us both temporally and geographically.

Shahn presents his narrative not in an explicit linear fashion but through an association of images that convey both personal and political meaning. The mural's story begins in the 1930s, where at upper left, in the darkest portion, a small figure of a Nazi soldier stands with signs of hate and warning written in German: "Germans beware: don't buy from Jews" and "Attention Jews, visit forbidden [*verboten*]" (see fig. 23). This scene refers to the 1933 Nazi boycott against Jews as well as the Nuremburg Laws of 1935. Shahn's inclusion of the Nazi soldier and the German text contributes to the antifascist sentiment of the work, suggesting also Shahn's involvement with the Popular Front movement against fascism.[36] This scene may be viewed as an expression of Shahn's Jewish concerns, since the Nazi persecution of the German Jews would be especially poignant for the residents of the Homesteads, although non-Jewish artists similarly worked against fascism. To the right of the soldier, and signaling a shift in time to 1927, two women raise their arms in anguish as they mourn beside open caskets displaying the corpses of the executed political martyrs Sacco and Vanzetti. Holding up the coffins, directly below, is the Ellis Island registry hall, where a small Statue of Liberty peers through the doorway at the far end of the room. To the right of the bereft women is a small scene of cramped figures hunched over piecework in their homes, a type of employment that existed despite the protective contracts of the garment unions.

Shahn created a pastiche of immigrants coming off a ship's gangplank, mixing the anonymous arrivals with portraits of his family, friends, and historical figures—all of whom had arrived at different times and from different countries, including Eastern Europe and Germany. Shahn's mother—whom he portrayed in this scene—came to the United States in 1906; and although the artist Raphael Soyer (1899–1987) had arrived as a teenager in 1912 with his family when his father, a Hebrew scholar, was fleeing persecution, Shahn shows the artist as a grown man. The German-born electrical engineer and socialist Charles Steinmetz had actually arrived in 1889, before Ellis Island was used as an entry point. Shahn placed Albert Einstein as the leader of the group (see fig. 23).[37] Unlike the residents of the Homesteads, who were from Eastern Europe, Einstein had recently arrived from Germany, having renounced his German citizenship in 1933, to settle in Princeton, near the Homesteads.

In the United States, Einstein spoke on behalf of the European refugees, organizing disparate Jewish groups, raising both money and public awareness about the plight of Jews in Germany, and, in private, writing the numerous affidavits required to secure visas.[38] Throughout the 1930s and 1940s, Einstein monitored the volatile global climate; with an eye fixed on Hitler's growing

powers, he applied pressure on leaders, including FDR, to lift the immigration barriers. Significantly, Shahn chose to portray open immigration to America when, in actuality, current restrictive policies prevented refugees and exiles from reaching safety in the United States. Shahn's portrait of the physicist, added late in the process of creating the mural, is a direct reference to the refugee crisis of the 1930s and the restrictions placed on immigration.

The montage of images spilling out from the darkness of the Nazi scene culminates in the depiction of these arriving immigrants. The group strides forward, commanding the greatest space within the composition to symbolize freedom breaking free from oppression, exploitation, and persecution. It is the common cause behind their flight to America, namely, persecution on either religious or political grounds, that takes precedence over the actual dates of entry to the United States. Together, celebrated individuals such as Einstein, Shahn's personal friends and relatives, including his mother, and the anonymous figures symbolize Jewish refugees throughout history and the Diaspora who have sought freedom through immigration to the United States. The residents of the Homesteads were involved and vocal on the refugee issue, passing a town referendum, in response to Kristallnacht, that asked President Roosevelt to condemn the destruction of Jewish property and persons (which they compared to the Kishinev pogroms), and working with the American Jewish Congress to relocate refugees.[39]

In the center panel of the composition (see fig. 24), Shahn refers specifically to labor history and the unions, including visual references to non-union manufacturers and the tragic Triangle Shirtwaist Company fire in 1911 (indicated by signs Shahn paints on the buildings).[40] The figure of a union organizer making a speech, and bearing a strong resemblance to John L. Lewis, dominates the scene, his sign displaying this message: "One of the great principles for which labor and America must stand in the future is the right of every man and woman to have a job, to earn their living if they are willing to work." In a preparatory study entitled *East Side Soap Box* (plate 1), Shahn had experimented with translating Lewis's speech into Yiddish; but he chose English words taken from Lewis's actual text for the final mural. Shahn took the quotation from Lewis's closing address at the CIO's conference in Atlantic City, New Jersey, in 1937. A crowd of workers mills below the grandstand; each figure casts his eyes in a different direction, indicating that the workers have yet to coalesce into a collective body.

The last panel of the mural (fig. 25) displays the benefits of organized labor and the New Deal. In order for the painted workers and today's viewers to arrive at the depicted version of the Jersey Homesteads, one must pass through the doorway marked "ILGWU" (International Ladies' Garment Workers

Union), reminding viewers that only due to the efforts of organized labor can we gain entry into this better life. Once through the doorway, workers gather in a classroom to learn the history of American labor. At right, a group of men gather around a table whose top is tilted upward to display the town's building plans. In this group, Shahn portrayed John Brophy, director of the CIO; Sidney Hillman, president of Amalgamated Clothing Workers of America; David Dubinsky of the ILGWU; Heywood Broun of the American Newspaper Guild; and New York Senator Robert F. Wagner, who drafted crucial labor-reform legislation during this period. Surrounding these two scenes of men involved in learning and planning are images of fertile land, families, and a thriving—presumably cooperative—factory. Following the mural's progression from the dark scenes of Nazi Germany to this land of growth and plenty, its viewers, along with the workers, have been delivered to a new Eden, a place of safety and economic self-sufficiency.

CONFRONTING CENSORSHIP: THE BRONX CENTRAL POST OFFICE MURAL

Labor continued to occupy Shahn's concerns in his next mural, *Resources of America* (figs. 28–29), for the Bronx Central Post Office (1938–39), a commission that would bring the artist in sharp conflict with the forces of artistic censure. Although labor was the explicit subject for the Bronx mural, the artist's experience of its creation highlighted the importance of artistic freedom. The experience of working in the Bronx would inform his later proposals for murals in St. Louis and in Queens, New York, on the themes of freedom and civil liberties.

Shahn covered the walls of the Bronx Central Post Office with a panoramic suite of workers, thirteen monumental frescoes painted in tawny tones celebrating Americans at work in a variety of agricultural and industrial jobs. Despite the recent fluctuations in the New Deal, this mural is extremely optimistic, showing worker productivity and pride.[41] On its central panel, Shahn depicted the American poet Walt Whitman lecturing to a group of workers (fig. 29). With flowing beard, Whitman resembles a composite of Karl Marx and Moses, and gestures to lines of his poetry written on a blackboard. In Shahn's original plans, the verse was taken from "Thou Mother with Thy Equal Brood" (1872). When Shahn's studies were put on display in the Post Office, objectors to Whitman's humanistic outlook challenged Shahn's commission.

The Reverend Ignatius W. Cox, a professor of Ethics at Fordham University in the Bronx, led the outcry. In a Brooklyn church, Cox delivered a sermon describing the panel as promoting irreligion and insulting to Christianity.[42] He encouraged parishioners to write letters demanding that the commission be

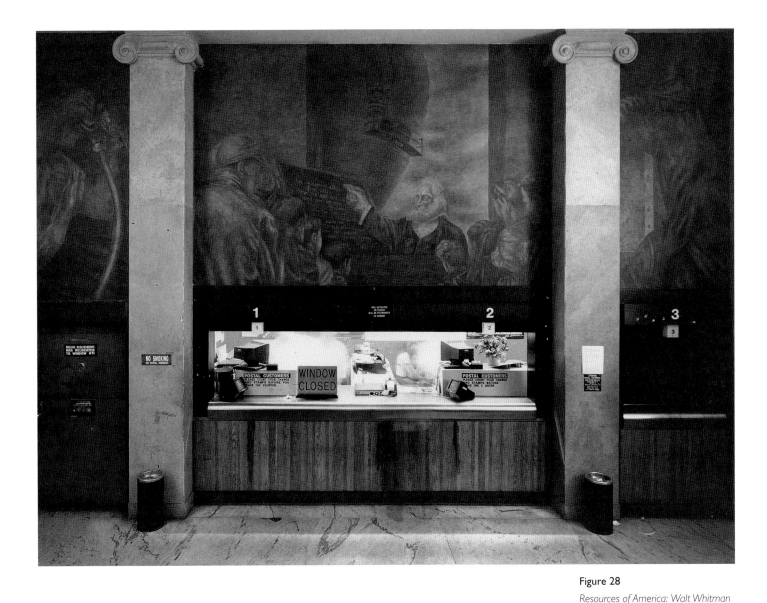

Figure 28

Resources of America: Walt Whitman
(and flanking panels), 1938–39
Egg tempera applied to plaster
Bronx Central Post Office

canceled.[43] Shahn would later mock the narrow-mindedness of Cox's sermon in the painting *Myself Among the Churchgoers,* 1939 (plate 3), in which the artist represented the name of both Cox's church and speech on a signboard. Brooklyn, it should be mentioned, was the national stronghold for supporters of the right-wing priest Father Charles "The Radio Priest" Coughlin, the most potent spokesman for American fascism and anti-Semitism, and also the subject of a Shahn caricature (fig. 30).[44] The official newspaper of the Catholic arch-diocese in Brooklyn, the *Brooklyn Tablet,* openly supported Coughlin, attacked Jews and leftists, and opposed immigration reform.

Shahn objected to the proposed cancellation, arguing against the right of a single group to dictate public taste in art and noting that "with democracy rather on its mettle these days, it gives one quite a shock to hear 'verboten' directed against a traditionally American poet."[45] Shahn's purposeful use of the German word *verboten* recalls the artist's painting of this same word in the upper-left corner of his Jersey Homesteads mural—astride a Nazi soldier who

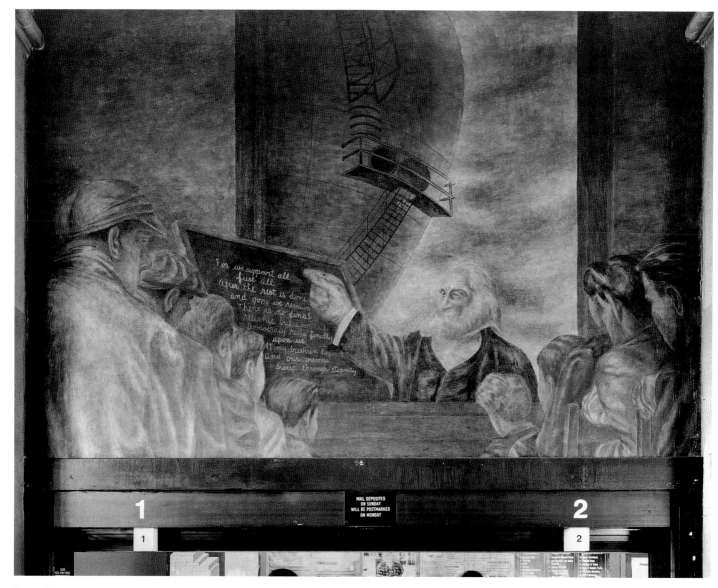

Figure 29

Resources of America: Walt Whitman (detail),
1938–39

Egg tempera applied to plaster

Bronx Central Post Office

wears a signboard brandishing anti-Jewish restrictions. With his pointed use of *verboten*, Shahn highlights the relationship between anti-Semitism in Europe, the rise of anti-democratic movements in the United States, and the suppression of American artistic freedom and personal liberties: with this word and image, the artist sounds a warning cry.

In order to facilitate the completion of his mural, Shahn acquiesced to his critics and replaced the "objectionable" lines from Whitman with a stanza from the poet's "As I Walk These Broad Majestic Days." However, his own experience of censorship, along with his growing awareness of the refugee crisis, would inform the themes and images of Shahn's next murals. Freedom, rather than labor, would become his most pressing agenda. Shahn would continue to be influenced by current world events and to refract them in his works.

Figure 30

Father Coughlin, 1939

Ink and wash on paper,

15½ × 12 in. (39.4 × 30.5 cm)

The Collection of Philip J. and Suzanne Schiller

American Social Commentary Art—1930–1970

IMMIGRATION: FIGHTING RESTRICTIVE QUOTAS

In 1935, Nazi leaders instituted the Nuremburg Laws, which legally and officially disenfranchised Jews, who were now classified as non-citizens.[46] From 1936 to 1939, life for Jews in Germany became steadily more precarious, controlled, and oppressive; the last year that the community exerted any communal autonomy was 1938. Up until then, the Jewish exiles—as refugees were then considered—assumed that they would safely return to Germany once the Nazi regime had fallen.[47] But the Anschluss and Kristallnacht, both of which took place in 1938, changed the status of exiles into refugees.

In the spring of 1939, the Treasury Section art program announced its national competition to decorate the St. Louis Post Office lobby. While Missouri should have been Shahn's sole focus, the events in Europe would influence his concepts and design for the mural. Shahn received from Treasury officials a

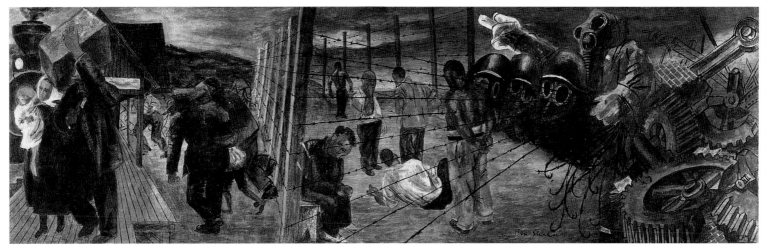

Figure 31
Immigration, 1939
Tempera on board,
5½ × 15½ in. (14 × 39.4 cm)
Private collection

thick bibliography on St. Louis history, legends, and lore designed to help in preparing proposals. The sponsors suggested that "a continuous story based on the colorful history of the mail in and around St. Louis would offer fascinating subject matter for frescoes."[48] Shahn thought not. Shahn grouped the nine suggested studies into three distinct themes: regional history with scenes of Missouri river traffic, wagon trains, and frontier life; the First Amendment's Four Freedoms; and immigration to America. Shahn painted two preliminary studies entitled *Immigration,* a subject that he selected and that was in no way related to the sponsor's guidelines.

An urgent and violent mood pulses through the first *Immigration* scene, a montage divided into three parts (fig. 31). In the first third, a family begins a new life with babies and bundles in hand. This hopeful scene brushes up against that of a crude prison or concentration camp enclosed by barbed wire, which holds a half-dozen semiclad, despondent men.[49] The ominous background, darkened sky, and bare ground create a bleak mood but do not establish the precise time or location of the scene.[50] In the concluding panel, a gas-masked military figure reaches back toward the image of the camp; with his left hand he pulls taut the barbed wire. At the time that Shahn was creating his St. Louis proposal, American newspapers had begun to report the existence of concentration camps. With this sharp gesture, Shahn forces us to confront the connection between immigration, detention, and war.

Shahn opened the second *Immigration* panel with scenes of war (fig. 32). Anonymous soldiers clad in metal helmets flank a bombed-out building. At center, from a dizzying overhead perspective, Shahn painted people scurrying about chaotically. Toward the right, the lean figure of a man wearing the long coat and beard of an Orthodox Jew catches the eye. Rather than the people of Missouri, this man represents the East European Jews who arrived in the

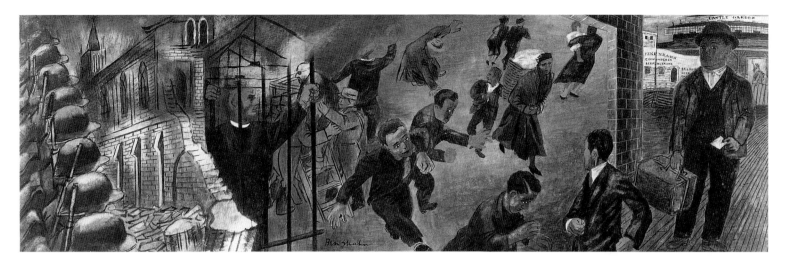

Figure 32
Immigration, 1939
Tempera on board,
5½ x 15½ in. (14 x 39.4 cm)
Private collection

United States in great numbers during the late nineteenth and early twentieth
centuries, the period of Shahn's own arrival.[51] Shahn concludes this panel with
a picture of a nineteenth-century immigrant from Europe, his meager belong-
ings in hand, standing in front of the Statue of Liberty and Castle Garden.
These images also bring to mind the grim circumstances of East European
Jews in the late 1930s, particularly in Poland, and the denial of their immi-
gration to America under current laws.

Shahn's panel *Freedom of Religion,* 1939 (fig. 33), was intended to open his
submission to the St. Louis competition. Within its horizontal frame, Shahn
assembled identifiable symbols, people, and structures that represent America's
dominant religions. The Statue of Liberty's uplifted torch dominates the center,
painted as if it were formed from stained glass rather than three-dimensional
bronze, and joining the ideas of freedom and religion. Shahn next interpreted
the clauses of the First Amendment that provide for freedom of speech and
freedom of the press, and depicted citizens actively setting the course of their
government by means of the ballot and grass-roots activism. In his St. Louis
proposal, rather than telling the story of the St. Louis mail in a regional context,
Shahn chose to focus on the nation's heritage of civil and political rights—
now especially pertinent to Jews—and to relevant issues such as immigration.

During the 1930s, immigration and the refugee crisis were openly debated.
Until about 1910, the United States had maintained a policy of unrestricted
immigration, which made possible the mass influx of East European Jewry that
had begun in the 1880s. But after 1910, popular sentiment rose up against the
immigrants. The Ku Klux Klan was reestablished after a dormant period, and
xenophobic authors decried the dilution of America's superior racial stock as
a consequence of unrestricted immigration.[52] The United States' entrance into
World War I coincided with the end of liberal immigration policies. Immi-

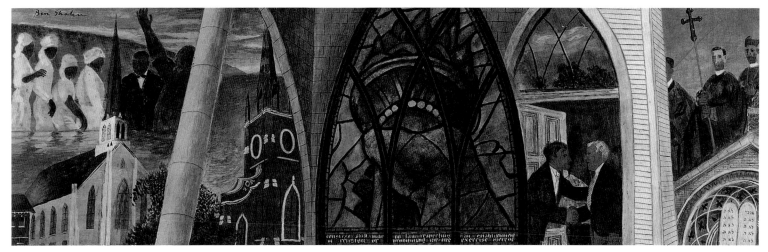

Figure 33

Freedom of Religion, 1939

Tempera on board,

5½ × 15½ in. (14 × 39.4 cm)

Private collection

gration was steadily restricted. In 1921, Congressman Albert Johnson of Washington, chair of the House Immigration Committee, proposed a two-year suspension of immigration as an emergency measure to prevent an influx of Jews from Poland, where they had been the target of violence. The 1924 Johnson-Reed Act further limited entrance figures to 2 percent of the existing U.S. ethnic stock as measured by the 1890 census, which immediately put an end to mass Jewish immigration.[53]

In 1930, President Herbert Hoover instructed the State Department to adhere strictly to the "public charge" provision of the Immigration Act, which addressed the likelihood of new arrivals remaining unemployed; as a result, total immigration figures for both Jews and non-Jews sharply dropped from 242,000 in 1931 to 35,000 in 1932. Between 1933 and 1941, the American Jewish Committee, the Coordinating Foundation, the American Jewish Congress, the Anti-Defamation League, and the Jewish Labor Committee, along with non-Jewish organizations, fought hard to bring a sum total of 157,000 German Jews into the United States—a figure almost identical to the number that arrived in the single year 1906.[54] Consuls made the ultimate decision about who would or would not be granted a visa, and they saw refugees as either potential economic burdens or spies—or both. Breckinridge Long of the State Department was determined to stop the flow of immigrants.[55] An early admirer of Hitler and Mussolini, Long added undue layers of policy and bureaucracy to keep out refugees and immigrants.[56]

After Kristallnacht, the crisis in Germany fueled a corresponding rise in American anti-Semitism. Nativist factions sought to maintain the low immigration quotas by focusing on the lingering economic effects of the Depression to mask their racist motivations. In a *Fortune* magazine poll, 64.7 percent of respondents cited employment concerns as the reason for their objections to liberalizing immigration policies. Yet, the majority of Americans opposed in-

creasing immigration quotas even for political refugees. Organizations that opposed the entry of refugees and supported the quotas included the Daughters of the American Revolution (DAR), the Veterans of Foreign Wars (VFW), and the American Legion.[57]

In 1938, in New York City, the primary destination of most refugees and immigrants, opponents of immigration found support from Father Coughlin. At a rally, they carried signs with such slogans as "Refugees Get Jobs in This Country! Why Don't 100% Americans?" The *Brooklyn Tablet* fueled nativist sentiments by publishing false accusations that Jewish businesses were pledged to hiring refugees who would take jobs from American citizens.

Within President Roosevelt's cabinet, one voice separated the talk of jobs from the anti-Semitic message. Secretary of Labor Frances Perkins dismissed the argument that refugees would take jobs from unemployed Americans or would further cripple the economy, and she asked the president to lift the quotas and restrictions that blocked access to safety. FDR did neither. American hesitancy and inaction were, unfortunately, consistent with the worldwide paralysis in the face of Nazi persecution and aggression.

In 1939, against this tide of inaction, New York Senator Robert F. Wagner spoke out boldly, on behalf of the refugees, for lifting the immigration quotas. Wagner, whom Shahn portrayed in his Jersey Homesteads mural (see fig. 25), introduced a bill on the Senate floor that would have facilitated the entry of 20,000 refugee children into America under a dispensation of the quota.[58]

Two major member organizations of the Jewish Labor Committee—the International Ladies' Garment Workers Union (ILGWU) and the Amalgamated Clothing Workers of America—supported the bill. Moreover, the rank and file donated a day's pay—this during the depths of the Depression—to help the refugees; and both the AFL and CIO endorsed the bill.[59] Although the bill was sponsored as a humanitarian measure to rescue children, it was opposed in Congress; with no active presidential endorsement, the bill was defeated in committee.

When Congress voted down the measure, Wagner took to the air waves in a last-ditch effort to build popular support for his bill. In his dramatic radio address, he identified the plight of the refugee children with that of the passengers on the ill-fated SS *St. Louis* to exemplify the desperate nature of the situation. In mid-May of 1939, the *St. Louis* had left Germany for Havana, carrying 907 refugees bearing passports stamped with a red *J* that clearly marked them as Jews. All passengers held landing permits signed by the Cuban Director of Immigration, which the Hamburg-America line had bought wholesale and resold to the refugees. However, the week before the ship departed from Germany, Cuba invalidated all landing certificates. Cuban officials had advised

the Hamburg–America line *in advance of* the ship's European departure that the passengers held useless permits and, therefore, the journey might prove futile. Nevertheless, the company let the ship proceed on its cross-Atlantic trip. On May 27, 1939, while Shahn was still working on his St. Louis mural studies, the *St. Louis* arrived and docked in Havana. The ship's passengers attempted to disembark, but Cuban officials blocked them. Immediately, the passengers were thrown into diplomatic limbo, beginning several weeks of waiting and negotiations on their behalf, and extensive news coverage of their ordeal.[60]

For the refugees on the *St. Louis,* Cuba was to have been only a temporary place of sanctuary en route to the United States and safety. They had fulfilled U.S. immigration requirements and held quota numbers that would allow them entry, but their entrance dates varied from three months to three years after their arrival in Cuba. Still, since they had papers in hand, they believed that the American government would be humane and waive the delay. As the weeks dragged on, newspapers reported the testimony of the relatives waiting on shore and printed impassioned letters from refugee mothers on board the ship; one mother wrote:

> It is strange how near, and yet how cut off we really are. Because many boats come close to us throughout the day bringing greetings from relatives and friends, many millions of rumors are gossiped on the boat. The result is that two-thirds of the passengers are absolutely panicky. I am not one of them.[61]

Jewish relief agencies gathered these reports, letters, and testimonies with the hopes of persuading the United States to validate immediately the quota numbers, but they were unsuccessful. As a result of the United States' inaction, the ship was forced to return to Europe, where the crew distributed the passengers among various countries that were soon overtaken by the Nazis. The vast majority of passengers were killed in the Holocaust. Nazi propaganda fully exploited the United States' refusal of the *St. Louis,* wryly commenting in the August 1939 issue of *Der Weltkampf*: "We are saying openly that we do not want the Jews while the democracies keep on claiming that they are willing to receive them—and then leave the guests out in the cold! Aren't we savages better men after all?"[62]

THE FOUR FREEDOMS: IN DEFENSE OF LIBERTY

In his unfulfilled St. Louis proposal, Shahn neither directly answered the rhetoric of the Nazis nor confronted American inaction, nor explicitly narrated the

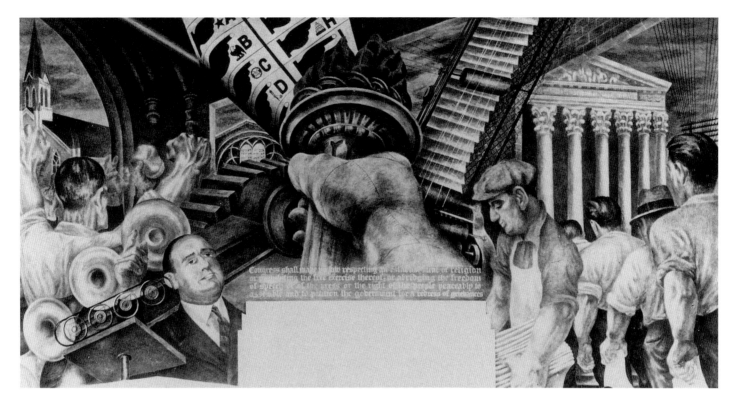

Figure 34
The Four Freedoms, 1940–41
Egg tempera on canvas, 8 ft. 6 in. × 16 ft.
(259 × 487.7 cm)
Jamaica, New York,
Woodhaven Branch Post Office, Queens

events of the refugee crisis and the *St. Louis.* Instead, he emphasized the values of liberty, civil and human rights, and the opportunities for life—including his own—made possible because of past liberal immigration policies, as contrasted with the horrors of war, concentration camps, and religious persecution. While the jury never qualified their rejection of Shahn's mural, it was remarked that the work "contained political distractions."[63]

Shahn soon had the opportunity to condense his nine St. Louis studies into a one-panel mural (fig. 34). In early 1940, Treasury Section officials invited Shahn to submit designs for the Woodhaven Branch Post Office, in Queens.[64] Freed from the constraints of having to tailor his ideas to Missouri history, Shahn concentrated on his message of the interconnections between American freedom and immigration. To symbolize these dual and related concerns, Shahn placed the Statue of Liberty's oxidized green hand and uplifted torch prominently at the composition's center. The powerful hand at the center of the Queens mural calls to mind another representation of a hand by Shahn. As part of his 1931 *Haggadah,* Shahn represented the "mighty hand" and "outstretched arm" of God. Where a Haggadah retells the story of the Exodus, Shahn's Woodhaven Branch mural retells the impetus for immigration—in particular, Jewish immigration—to the United States. Shahn drew a parallel between the ancient and more recent Jewish exodus in his proposal for the Jersey Homesteads, writing:

[T]he Passover symbolizes the departure of the Jews from Egypt, the land of bondage. So, with the feast of the Passover, and out of the background of the Ghettos and pogroms comes a stream of immigrants to America with hope in their faces. Above them hovers the dream of America—a land of fruit and flowers, big cities with streets paved with gold, the Statue of Liberty—symbol of a new life to the immigrant.[65]

For the Queens mural, Shahn focused on the Bill of Rights and the Four Freedoms. Beneath the Statue of Liberty's torch, at center, he has inscribed the First Amendment. Before Shahn could begin his proposed project, he had to quibble with officials over small points of perspective, scale, and placement of the figures. Officials objected to the inscription accompanying the image, which they felt was not needed to convey the theme. Shahn challenged each point, writing with the greatest degree of clarity and emotional charge in his defense of artistic prerogatives: "The thing that I have tried to put into this mural, I feel very strongly. I feel that it has profound significance for every American, more significance every day because of increasing threats to our rights and liberties. I feel that if I, as an artist, can bring home to the people who see this work any added realization of how these basic rights project into their lives and activities, then I've done as good a piece of work as I want to, and don't much mind breaking the rules for pure art."[66]

On January 6, 1941, President Roosevelt addressed Congress in his annual message, noting the "unprecedented" threat to American security from outside its borders and the consequent need for a "world founded upon four essential human freedoms."[67] Shahn installed the Woodhaven Branch mural in 1941, at a time when both the national and international climate was dangerously precarious. According to historian Henry L. Feingold, the year 1941 concluded the "refugee phase of the Holocaust"; the time and opportunity for rescue had ended.[68] In light of FDR's inaction during the refugee crisis and his decision to maintain the Johnson-Reed Act immigration quotas, it appears clear that his administration, the State Department, and Congress did little to ensure these Four Freedoms for refugees. Instead of representing the policies of a president he so admired, Shahn's St. Louis and Queens murals offer a moral and legislative direction that the United States in fact chose not to follow.

As the art historian Linda Nochlin writes, "hovering, unspoken for the most part, above the discourse about Jewish identity and representation after the middle of the twentieth century is the shadow of the Holocaust."[69] Shahn's exploration in his New Deal murals of Jewish experiences, identities, social and political concerns, and of progressive responses to the denial of civil and human rights here and abroad, is undertaken with a stark awareness of the rise

of National Socialism in the 1930s, also foreshadowing the oncoming Holocaust, the establishment of Israel, and the repression of the Cold War—themes that informed Shahn's work during the 1940s and 1950s. Through his art and his writing, Shahn argued for the unity of form and content and the importance of representational art.[70] The 1930s and early 1940s were a particular moment for Jews in America, one now distant. For Shahn, the New Deal era was a singular opportunity for him to explore and depict, in a public forum, themes of Jewish content related to human rights and social reform. Shahn's murals represent the height of his expression of secular Jewish experience. The question lingers: Was Shahn's prewar focus on class identification too optimistic, given what was to come? Within the context of his later work of the 1940s and 1950s as well as the reappraisal of Shahn's art and career on the occasion of his centennial, this book, together with his art, seeks to provide some meaningful answers.

Notes

I would like to thank Marlene Park and Frances K. Pohl for facilitating my work on Shahn, Shahn's biographer Howard Greenfeld for graciously answering queries, Matthew Baigell, Rita Chin, and Dan Segal for their helpful comments, and Peter W. Ross for his support. I would like to dedicate this essay to the memory of Dr. Stephen L. Taller.

1. See, for example, Ziva Amishai-Maisels, "Ben Shahn and the Problem of Jewish Identity," *Jewish Art* 12–13 (1986–87): 304–19; Susan Noyes Platt, "The Jersey Homesteads Mural: Ben Shahn, Bernarda Bryson, and History Painting in the 1930s," in *Redefining American History Painting,* ed. Patricia Burnham and Lucretia Giese (Cambridge: Cambridge University Press, 1995); and Francis V. O'Connor, "The Influence of Diego Rivera on the Arts of the United States during the 1930s and After," in *Diego Rivera: A Retrospective,* exh. cat. (Detroit: Detroit Institute of Arts, 1986). The Shahn literature has created a false dichotomy with regard to wife Tillie Goldstein and artist Bernarda Bryson. Goldstein was, in fact, politically active—a former suffragette—and was involved with secular Jewish culture and politics of the Left. Ben Shahn had long since shed his religious affiliation by the time he met Bryson (telephone interview with Ezra Shahn and Judy Shahn, August 20, 1996).
2. Harold Rosenberg, "Is there a Jewish Art?" *Commentary* 42, no. 1 (July 1966): 57–60.
3. For further discussion of the Jewish heritage of the Abstract Expressionists, see Matthew Baigell, "From Hester Street to Fifty-Seventh Street: Jewish-American Artists in New York," in *Painting a Place in America: Jewish Artists in New York 1900–1945,* exh. cat., ed. Norman L. Kleeblatt and Susan Chevlowe (New York: The Jewish Museum; Bloomington: Indiana University Press, 1991), 64–69; and Baigell, "Barnett Newman's Stripe Paintings and Kabbalah: A Jewish Take," *American Art* 8 (Spring 1994): 32–43.
4. Rosenberg, "Is there a Jewish Art?" 57–60.
5. Margaret Olin, "C[lement] Hardesh [Greenberg] and Company: Formal Criticism and Jew-

ish Identity," in *Too Jewish?: Challenging Traditional Jewish Identities* (New York: The Jewish Museum; New Brunswick: Rutgers University Press, 1996), 39–59.

6. Clement Greenberg, "Art," *The Nation,* November 11, 1947, 481.

7. See Seth Korelitz, "The Menorah Idea: From Religion to Culture, from Race to Ethnicity," *American Jewish History* 85, no. 1 (March 1997): 75–100.

8. Laurence J. Silberstein, "Others Within and Others Without: Rethinking Jewish Identity and Culture," in *The Other in Jewish Thought and History: Constructions of Jewish Culture and Identity,* ed. Laurence J. Silberstein and Robert L. Cohn (New York: New York University Press, 1994), 3–5; and David Theo Goldberg and Michael Kraus, eds., *Jewish Identity* (Philadelphia: Temple University Press, 1993).

9. For further discussion of Shahn's allegorical works, see the essays by Frances K. Pohl and Stephen Polcari in this book.

10. Arthur Liebman, *Jews and the Left* (New York: John Wiley and Sons, 1978), 3; Max Weber, "Ethnic Groups," in *Theories of Society,* ed. Talcott Parsons (New York: The Free Press, 1961).

11. Marlene Park and Gerald E. Markowitz, *Democratic Vistas: Post Offices and Public Art in the New Deal* (Philadelphia: Temple University Press, 1984), 125, 139–42.

12. Frances K. Pohl, *Ben Shahn: With Ben Shahn's Writings* (Rohnert Park, Calif.: Pomegranate Artbooks, 1993), 11.

13. Laurence P. Hurlburt, *The Mexican Muralists in the United States* (Albuquerque: University of New Mexico Press, 1989); and O'Connor, "The Influence of Diego Rivera."

14. Shahn completed four New Deal murals: a fresco on immigration and the labor movement for the Jersey Homesteads, 1936–38; *Resources of America,* 1938–39, for the Bronx Central Post Office, New York; the *Four Freedoms,* 1940–41, for the Jamaica, New York, Woodhaven Branch Post Office, Queens; and the *Meaning of Social Security,* 1940–42, for the Social Security Building, Washington, D.C. Officials and competition juries rejected his satirical *Prohibition Era,* c. 1933–34, for the Central Park Casino, New York; his *The Great State of Wisconsin,* c. 1937, for the planned community of Greendale, Wisconsin; and his *Four Freedoms,* 1939, submitted to the St. Louis, Missouri, Post Office competition. Officials canceled his project for Riker's Island Penitentiary, New York, c. 1933–35, as Shahn began work on the site.

15. See Susan H. Edwards, "Ben Shahn: A New Deal Photographer in the Old South" (Ph.D. diss., City University of New York, 1996); and Laura Katzman, "The Politics of Media: Ben Shahn and Photography" (Ph.D. diss., Yale University, 1997).

16. Beth S. Wegner, *New York Jews and the Great Depression: Uncertain Promise* (New Haven: Yale University Press, 1996), 3.

17. The xenophobic critic Thomas Craven and painter Thomas Hart Benton denigrated the ability of urban, Jewish artists—and other artists who were not of Anglo-Saxon origin or from the Midwest—to comprehend and represent what the pair saw as authentic American subject matter. See Matthew Baigell, *Jewish-American Artists and the Holocaust* (New Brunswick, N.J., and London: Rutgers University Press, 1997), 12–13.

18. Marshall Sklare, *Observing America's Jews* (Hanover, N.H.: University Press of New England, 1993), 21, 26; and Henry L. Feingold, *Bearing Witness: How America and Its Jews Responded to the Holocaust* (Syracuse, N.Y.: Syracuse University Press, 1995), 210.

19. See Wegner, *New York Jews,* 5; Nathan Goldberg, "Economic Trends among American Jewish," *Jewish Affairs* 1 (October 1946): 11–16, quoted in Henry L. Feingold, *The Jewish People in America: Entering the Mainstream, 1920–1945* (Baltimore: Johns Hopkins University Press, 1992), 127; and Howard M. Sachar, *A History of the Jews in America* (New York: Alfred A. Knopf, 1992), 428.

20. Deborah Dash Moore, *At Home in America: Second-Generation New York Jews* (New York: Columbia University Press, 1981), 210–11; and Lawrence Fuchs, "American Jews and the Presidental Vote," in *American Ethnic Politics,* ed. Lawrence Fuchs (New York and Evanston, Ill.: Harper Torchbooks, 1968), 52–54.

21. Questions surrounding FDR and his administration's policies and actions regarding the refugees, the Holocaust, and World War II were the focus of the recent conference "Policies and Responses of the American Government toward the Holocaust," held at the Franklin D. Roosevelt Library on November 11–12, 1993. For the proceedings, see *FDR and the Holocaust,* ed. Verne W. Newton (Hyde Park, N.Y.: Franklin and Eleanor Roosevelt Institute, 1996).

22. Harvey Klehr, *The Heyday of American Communism: The Depression Decade* (New York: Basic Books, 1984), 381–85. See also Michael Denning, *The Cultural Front: The Laboring of American Culture in the Twentieth Century* (New York and London: Verso, 1996).

23. Klehr, *The Heyday of American Communism,* 282–83.

24. Wegner, *New York Jews,* 15, 18.

25. See Beth S. Wegner, "Memory as Identity: The Invention of the Lower East Side," *American Jewish History* 85, no. 1 (March 1997): 3–28.

26. See Gertrude Dubrovsky, *The Land Was Theirs: Jewish Farmers in the Garden State* (Tuscaloosa: University of Alabama Press, 1992); and Uri D. Herscher, *Jewish Agricultural Utopias in America, 1880–1910* (Detroit: Wayne State University Press, 1981).

27. United States Department of Interior Press Release, March 10, 1935, Ben Shahn Papers, Archives of American Art, Smithsonian Institution, Washington, D.C.

28. David Dubinsky, "The Project of the Hightstown Colony and the Cloakmakers' Union," *Jewish Daily Forward,* November 6, 1935, 3, Roosevelt, N.J., Collection, Rutgers University Library, New Brunswick, N.J.; and Benjamin Stolberg, *Tailor's Progress: The Story of a Famous Union and the Men Who Made It* (Garden City, N.Y.: Doubleday, 1941), 167. See also Diana L. Linden, "The New Deal Murals of Ben Shahn: The Intersection of Jewish Identity, Social Reform, and Government Patronage" (Ph.D. diss., City University of New York, 1997), 124–28, 130–32.

29. See Andrew Hemingway, "Meyer Schapiro and Marxism in the 1930s," *Oxford Art Journal* 17 (1994): 13–29; Patricia Hills, "1936: Meyer Schapiro, *Art Front,* and the Popular Front," *Oxford Art Journal* 17 (1994): 30–41; Donald Kuspit, "Meyer Schapiro's Jewish Unconscious," *Prospects* 21 (1996): 491–508; and Meyer Schapiro, "Public Use of Art," *Art Front* (November 1936): 4–6, and "Race, Nationality and Art," *Art Front* (March 1936): 10–12.

30. See Platt, "The Jersey Homesteads Mural," 301, who describes Shahn as having made the work as he was "leaving Jewish life behind"; and Ziva Amishai-Maisels, "Ben Shahn and the Problem of Jewish Identity," 304–6.

31. Quoted in Bruce Bliven, *The Jewish Refugee Problem* (New York: League for Industrial Democracy, 1939), 4. Bliven, then editor of the *New Republic,* dedicates his booklet to Vladeck.

32. Undated manuscript, Ben Shahn Papers, Archives of American Art.

33. See Linden, "New Deal Murals," 137–41.

34. See Albert S. Lindemann, *The Jew Accused: Three Anti-Semitic Affairs (Dreyfus, Beilis, Frank), 1894–1915* (New York: Cambridge University Press, 1991).

35. Undated manuscript, Ben Shahn Papers, Archives of American Art. See Linden, "New Deal Murals," 141–43.

36. Frances K. Pohl, "Constructing History: A Mural by Ben Shahn," *Arts Magazine* 62 (September 1987): 38.

37. See Frances K. Pohl, *Ben Shahn: New Deal Artist in a Cold War Climate, 1947–1954* (Austin: University of Texas Press, 1989), 83, 86.

38. Peter A. Bucky, *The Private Albert Einstein* (Kansas City: Andrews and McMeel, 1992), 62–65; Abraham Pais, *Einstein Lived Here* (New York: Oxford University Press, 1994), 197–214. See also Einstein, *The World as I See It* (New York: Covici, Friede, 1934).

39. See Minutes of Borough Meetings, November 15, 1938, Roosevelt, N.J., Collection, Rutgers University, New Brunswick, N.J.; and Minutes of the Joint Board of Jersey Homesteads, February 10, 1938.

40. Shahn wanted to include names of manufacturers from the early 1900s who had fought the International Ladies' Garment Workers Union (ILGWU) and who went out of business as a result. See Charles H. Green to Ben Shahn, February 11, 1938, Ben Shahn Papers, Archives of American Art.

41. Saul Benison, interview with Ben Shahn, October 29, 1956, Columbia University Oral History Research Office, transcript.

42. Quoted in the *New York Times,* December 12, 1938.

43. These letters, as well as unsolicited letters in support of Shahn and Whitman, are in the National Archives, Washington, D.C., Record Group-121; and in the Ben Shahn Papers, Archives of American Art.

44. In 1935, more than 20,000 Coughlin supporters gathered in Brooklyn to hear the fiery priest. An FBI raid in Brooklyn uncovered a cache of weapons, along with plans to kill Jews and Communists (for Coughlin and his followers, they were one and the same). See Alan Brinkley, *Voices of Protest: Huey Long, Father Coughlin, and the Great Depression* (New York: Alfred A. Knopf, 1982); Sheldon Marcus, *Father Coughlin: The Tumultuous Life of the Priest of the Little Flower* (Boston: Little, Brown, and Co., 1973); Raymond Swing, *Forerunners of American Fascism* (New York: Julian Messner, 1935).

45. *New York Herald Tribune,* December 12, 1938.

46. See Lucy S. Dawidowicz, *The War Against the Jews, 1933–1945* (New York: Holt, Rinehart and Winston, 1975).

47. Newton, *FDR and the Holocaust,* ix.

48. Ben Shahn Papers, Archives of American Art.

49. The central passage of this panel has been identified as the prototype for Shahn's *Concentration Camp,* 1944. See Amishai-Maisels, "The Problem of Jewish Identity," 306; and *The Mural Art of Ben Shahn,* exh. cat. (Syracuse, N.Y.: Lowe Art Gallery, Syracuse University, 1977).

50. See Deborah E. Lipstadt, *Beyond Belief: The American Press and the Coming of the Holocaust, 1933–1945* (New York: The Free Press, 1986), for in-depth discussion of reports (and misreports) of events in Europe.

51. Between 1881 and 1914, close to 2 million Jews, mainly from Eastern Europe, arrived in the United States. See Arthur A. Goren, *The American Jews* (Cambridge: Harvard University Press, 1982), 1, 37; and Moses Rischin, *The Promised City: New York's Jews, 1870–1914* (Cambridge: Harvard University Press, 1962), 20, 33.

52. Arthur Hertzberg, *The Jews in America: Four Centuries of an Uneasy Encounter: A History* (New York: Simon and Schuster, 1989), 240–45.

53. Ibid., 239–45. The varying percentages by which each foreign group was permitted entry reveals the government's biases, for while the bill provided entry for only 600 Jews from Romania, a total of 34,000 nationals from Great Britain and Northern Ireland could be admitted. Speaking in support of the measure, Secretary of Commerce Laughlin presented

"scientific" data proving that Eastern and Southern Europeans were intellectually inferior to native-born Americans.

54. Naomi Cohen, *Not Free to Desist: The American Jewish Committee, 1906–1966* (Philadelphia: The Jewish Publication Society of America, 1972), 186–88; and Goren, *The American Jews,* 87–88.

55. See Henry L. Feingold, "'Courage First and Intelligence Second': The American Jewish Secular Elite, Roosevelt, and the Failure to Rescue," in Newton, ed., *FDR and the Holocaust,* and in Feingold, *Bearing Witness,* 7.

56. See David Wyman, *Paper Walls: America and the Refugee Crisis, 1938–1941* (Boston: University of Massachusetts Press, 1968), 36.

57. Jamie Sayen, *Einstein in America: The Scientist's Conscience in the Age of Hitler and Hiroshima* (New York: Crown Publishers, 1985), 112.

58. Wagner's bill called for the admission of 20,000 German refugee children under the age of fourteen on a non-quota basis over two years. Wagner strategically selected specific numbers and used guarded terms when speaking. His proposed figure of 20,000 matched exactly the anticipated need; and his use of "German" instead of "Jewish" children was intended to diminish anti-Semitic opposition. Residents of Roosevelt, N.J., had previously demonstrated concern over the fate of the refugee children. Town records show that "the question of the refugee children was taken up. A motion was made and accepted to refer the refugee situation to the civic council to decide." See Minutes, Joint Board of the Jersey Homesteads, August 17, 1938, Roosevelt, N.J., Collection.

59. Therefore, those Jews still within the working classes were able to unite and speak out en masse, even while Jews within FDR's cabinet were limited in their engagement. See Henry L. Feingold, "'Courage First and Intelligence Second,'" 51–87.

60. See "Fear Suicide Wave on Refugees' Ship," *New York Times,* June 1, 1939, 16; "Cuba Orders Liner and Refugees to Go," *New York Times,* June 2, 1939, 1; and "Man's Inhumanity," *New York Times,* June 9, 1939, 20.

61. Herbert Druks, *The Failure to Rescue* (New York: Robert Speller and Sons, 1977), 24.

62. Gordon Thomas and Max Morgan Witts, *Voyage of the Damned* (New York: Stein and Day, 1974), 295–304.

63. Forbes Watson to Edward B. Rowan, September 22, 1939, National Archives, Washington, D.C., Record Group-121.

64. Edward B. Rowan to Ben Shahn, January 6, 1940, National Archives, Washington, D.C., Record Group-121.

65. Ben Shahn Papers, Archives of American Art.

66. Ben Shahn to Edward B. Rowan, June 18, 1940, Ben Shahn Papers, Archives of American Art.

67. Samuel Rosenman, ed., *The Public Papers and Addresses of Franklin D. Roosevelt* (New York: Macmillan, 1941), 672.

68. Feingold, *Bearing Witness,* 7.

69. Linda Nochlin, "Starting with the Self: Modernity and the Construction of Identity," in *The Jew in the Text: Modernity and the Construction of Identity,* ed. Linda Nochlin and Tamar Garb (London: Thames and Hudson, 1995), 10.

70. Ben Shahn, *The Shape of Content* (Cambridge: Harvard University Press, 1957).

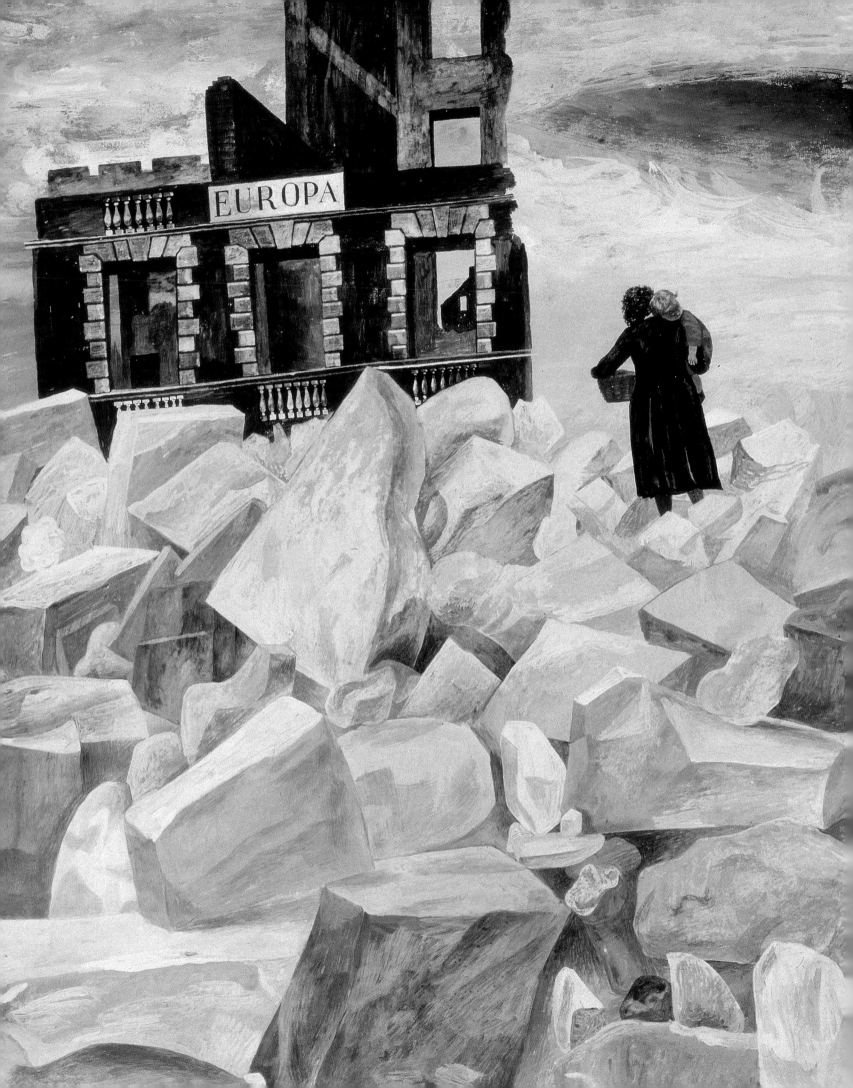

Ben Shahn and Postwar American Art

Stephen Polcari

It was at this time, towards the end of the last war, that the horrors of its destruction entered deeply into the American mind. Innumerable paintings elaborating that destruction were produced, but the majority lacked that cognizance which alone can justify them: the expression of rebirth which is contained in every decay.
—*W. R. Valentiner,* Nine Paintings by Rico Lebrun, *1950*

Those who take it upon themselves to minister to the human spirit shall themselves be moved primarily by things of the spirit.
—*Ben Shahn,* Paragraphs of Art, *1952*

Painting . . . [changes] what is disfigured into what is transfigured.
—*Rico Lebrun,* New Images of Man, *The Museum of Modern Art, New York, 1961*

Art is still the citadel of the individual.
—*Ben Shahn,* Kennedy Galleries, *1971*

The study of art history as the history of styles is in abeyance. With the welcome growth in the study of history as subject matter and content in art, certain insights have become possible that were not apparent previously. Now, for example, styles that formerly seemed to have little in common are seen to share similar subjects, ideas, and feelings, although they are expressed differently. It is possible to reconcile what were once thought to be very different, even hostile modes of expression because they newly can be seen as varying representations of a shared time, place, and experience.

During and after World War II, whether one was a Social Realist like Ben Shahn and the WPA artists, a Regionalist like Thomas Hart Benton, an Expressionist like Rico Lebrun, Hyman Bloom, or Abraham Rattner, or an Abstract

Expressionist like Mark Rothko, Jackson Pollock, and Willem de Kooning, most American artists engaged the principal crisis of their time: the survival of the nation and of humane civilization. This crisis was global and thus universal. As a result, most art of the 1940s and 1950s moved toward a consideration of the universal and humanist, that is, of the fate of man.

As we know, the styles of art of this period differed. However, the artists employed their varied interests and agendas to approach common truths about a shared experience. This thematic reconciliation paralleled that of the nation as a whole in finding common cause among its various factions in the early 1940s. Eventually, artistic differences became more marked again, or more re-marked upon by critics, both contemporary and later. Nevertheless, community and commonality as the universal history and fate of man overrode issues of aesthetic style and transformed American art at that time. For that moment, subject matter, rather than modernist innovation for its own sake, was the cen-tral concern of most American artists. This essay examines the confluences of American art during the 1940s and early 1950s, particularly as evident in the work of Ben Shahn and many of his contemporaries.

The changes that took place in Ben Shahn's work illuminate the larger shift in American art of that time. As generally understood by art historians, Shahn represents the quintessential sociopolitical artist of the 1930s and afterward. For those with sociopolitical agendas, his politics are his strength; but for other crit-ics, styles such as Abstract Expressionism are more significant.

Abstract Expressionism was once thought to epitomize individual expres-sions of personal suffering and defiance as well as the quest for new form. However, new study has now reconceived this movement as an inventive mode of coming to terms with the disasters of its time—the Depression and two world wars.[1] Abstract Expressionism now appears as a modern mode of ritual and mythic representation of universal themes of global carnage, survival, and bitter transcendence. It represents the tragic history of its time in its own way, through modern abstract form.

In this sense, Abstract Expressionism shares much with the work of Shahn and others during the postwar era of the 1940s and 1950s. The Expressionists, for example, addressed history through "fantasy, Surrealism, allegory."[2] Artists such as Rico Lebrun, Hyman Bloom, and Abraham Rattner employed styles of intense emotion, bright colors, and fragmented and unstable semi-figurative forms to engage the effects of World War II. "Expressionism," of course, was a tendency most associated with twentieth-century German art such as that of the Bridge group and the Blue Rider. But as a general expression of intensi-fied reality through loose, painterly forms, it was quite widespread in Europe.

In the early 1940s in America, however, its forms seemed to be new and bold, and Expressionists were thought to represent the cutting edge of the new American modern art.[3] Rattner's *Darkness Fell Over All the Land,* 1942, for example, was highlighted as the cover of the latest book on contemporary art, Samuel Kootz's *New Frontiers in American Painting* of 1943, and Rattner won the Temple Gold Medal at the Pennsylvania Academy of the Fine Arts in 1945. Both Lebrun and Bloom had a number of canvases in Dorothy Miller's first "Americans" exhibition at the Museum of Modern Art in 1942, and Bloom exhibited at the Venice Biennale in 1950. Willem de Kooning and Franz Kline considered Bloom one of the first Abstract Expressionists, and Elaine de Kooning, a quintessential artist and promoter of the New York School, wrote about him.[4]

It is ironic, then, that the American Expressionists fell out of favor in the 1950s, when they were superseded in esteem by the art of the burgeoning Abstract Expressionists, both of the first generation—Still, Rothko, Newman, Pollock, de Kooning, Gottlieb, Baziotes, among others—and the second generation, known as the New York School—Kline, Guston, Rivers, among others too numerous to mention. (Originally, there was no distinction between the two forms of expressionism.) Bloom and Rattner eventually lost their avant-garde status, although many of their fellow artists angrily attacked the New York School in their own magazine, *Reality.* There they denounced Abstract Expressionism—and Shahn agreed with them—as no more than technical experimentation: useful, ingenious, but devoid of humanist content. Meanwhile, supporters of the Abstract Expressionists derided the more figurative and conservative artists as passé. With the perspective of more than fifty years, however, it is evident that these opposing groups shared common issues and themes, however differently they may have realized them. As the Expressionist Rico Lebrun, speaking for many of his generation, noted: "My true task here is that the forms themselves should carry meaning of terror and pity. . . . I want more connotations of universality."[5] To this new quest for universality the artists added profound introspection. "And now I seem to be deeply preoccupied with the Universe within man," the realist fantasist Peppino Mangravite observed.[6] Peter Blume, a sociopolitical Surrealist of the 1930s, summed up this new emphasis in the work of a variety of artists: "Social realism and the social scene shifted to the philosophical and poetical."[7] Individual artists became philosophical about humanity and its fate, and their subjective expressions newly addressed what were conceived as shared or universal concerns. World War II thus led to the reconciliation of sharply different aesthetic styles, not only those of the 1940s but those of the 1930s as well.

Shahn shared the general disillusionment with the exclusively social perspective on reality. His loss of confidence was due not only to the failure of socialism, but also to his realization that socialism was irrelevant to the American experience. Like many Americans in the late 1930s, Shahn traveled throughout the country. He left the cities and journeyed to the hinterlands, where he found a strong people, optimistic, patriotic, with faith in their country. In other words, he found that his big-city "progressivism" did not relate to or inspire the American people, who had their own sources of strength. As a result, Shahn rethought his "social dream."

In a remarkable passage in an essay published in 1957, Shahn made all of this clear. He wrote:

> I was not the only artist who had been entranced by the social dream, and who could no longer reconcile that view with the private and inner objectives of art. As during the thirties art had been swept by mass ideas, so during the forties there took place a mass movement toward abstraction. . . . The change in art, mine included, was accomplished during World War II. For me, it had begun during the late thirties when I worked in the Resettlement Administration. I had then crossed and recrossed many sections of the country, and had come to know well so many people of all kinds of belief and temperament, which they maintained with a transcendent indifference to their lot in life. Theories had melted before such experience. My own painting then had turned from what is called "social realism" into a sort of personal realism.[8]

Shahn's change of mind is ironic, because that most visible opponent of Social Realism, the Regionalist Thomas Hart Benton—the ultimate intellectual playing the country hayseed, the articulate and hated opponent of big-city "progressivism," who had declared Marxism and politically radical art irrelevant —had long criticized the Social Realist mode of thinking for the same reasons that Shahn now did. Although Benton was a long-standing progressive in his own terms, he often said: "If the radical movement is to get anywhere in this country it has got to drop Marxism as an outworn historical and economic notion and rely wholly on a pragmatic observance of developing facts. You can't impose imported ideologies on people."[9]

Shahn's new "personal realism" would not be limited to his own life. It was not meant as a retreat; rather it would enlarge his perspective by expressing feeling, the subjective life, his own personal responses to what he observed and encountered. Shahn's reactions to World War II and the Holocaust were largely

responsible for this new attitude. He felt the need to deepen the effects of his art; emotion would be its new field:

> Personal realism, personal observation of the way of people, the mood of life and places; all that is a great pleasure, but I felt some larger potentiality of art.
>
> During the war I worked in the Office of War Information [OWI]. We were supplied with a constant stream of material, photographic and other kinds of documentation of the decimation within enemy territory. There were the secret confidential horrible facts of the cartloads of dead. . . . At that time I painted only one theme, "Europa," you might call it. Particularly I painted Italy as I lamented it, or feared that it might have become.[10]

In the 1940s, then, Shahn realized the possibility—indeed, the necessity—for an expressive art that captured the human heart as well as the head. Now seeking the interior life, he nevertheless rejected Surrealism, that extreme form of inner exploration. Unlike the Abstract Expressionists and others, he saw no use for the content of Surrealism as it was originally understood in America: the subconscious and the dream world. Shahn needed an art that would balance and unite the "subjective and objective." Surrealism, with its relinquishing of control, "led into that quagmire of the so-called automatic practices of art," as Shahn put it, "the biomorphic, the fecal, the natal, and the other absurdities."[11] For Shahn, Surrealism led the artist seeking historical relevance astray.

As one would expect, in Shahn's vision this new expressive art had to be more moving and evocative than ever before. "I think that at that time I was very little concerned with communication as a conscious objective," Shahn wrote. "Formulation itself was enough of a problem—to formulate into images, into painted surfaces, feelings, which, if obscure, were at least strongly felt." He felt liberated with the new emotional intensity of his images as he "became most conscious then that the emotional image is not necessarily of that event in the outside world which prompts our feeling; the emotional image is rather made up of the inner vestiges of many events."

Shahn recognized that this deep change in perception and feeling occurred during the latter years of the war: "I became increasingly preoccupied with the sense and the look, indeed, with the power of this newly emerging order of image." He mentioned a number of his paintings of the mid-1940s that expressed this new mode of perception, including *Liberation,* 1945 (plate 8), *The Red Stairway,* 1944 (plate 7), *Pacific Landscape,* 1945 (plate 9), *Cherubs and Children,* 1944 (fig. 35), and *Italian Landscape,* 1943–44 (plate 5). On the surface, they did not depart "sharply" from his previous style, but, Shahn noted, they had "become much more private and more inward-looking. A symbolism

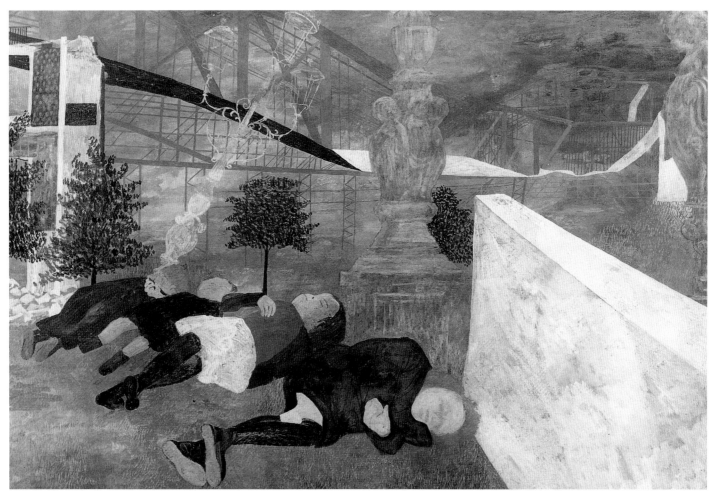

Figure 35
Cherubs and Children, 1944
Tempera on composition board,
15 × 22⅞ in. (38.1 × 58.1 cm)
Collection of Whitney Museum of American Art,
New York. Purchase

which I might once have considered cryptic now became the only means by which I could formulate the sense of emptiness and waste that the war gave me, and the sense of the littleness of people trying to live on through the enormity of war."

Furthermore, to address more than the subjective, the personal, and "the incidental, the individual, and the topical" as he had previously, meant for Shahn that the artist must address the "deeper source of meaning in art, a constant spring that would not run dry with the next change in political weather." That new depth of meaning would be expressed as the very opposite of the incidental, as "universal experience" that transcended the merely contingent, that is, as "timeless" experience. To express what was universal in experience, Shahn needed to create appropriate symbols. While he had always disliked generalities in art, he felt that the "universal" was not a generality, but rather a "unique thing which affirms the unique qualities of all things." As he put it in "The Biography of a Painting," "the universal experience is that private experience which illuminates the private and personal world in which each of us lives the major part of his life." For Shahn, the universal and personal were not op-

posites; rather, the universal reaffirmed the individual, and vice versa. Its expression was a way to create community.

A NEW PICTORIAL LANGUAGE: SYMBOL, ALLEGORY, AND MYTH

To formulate an art that expresses the universal required a new kind of pictorial language. Shahn now conceived of art as a symbol-making medium. He no longer had an interest only in selective reportage or advocacy. Instead, he sought to create a more symbolic art that could represent the depth of universal experience within individual consciousness: "In art, the symbol which has vast universality may be some figure drawn from the most remote and inward recesses of consciousness; for it is here that we are unique and sovereign and most wholly aware."

Shahn's essay "The Biography of a Painting" mentions several paintings of the later 1940s as representative of his new, increasingly symbolic style: *Brothers,* 1946 (see fig. 58), *Allegory,* 1948 (plate 14), and *The City of Dreadful Night,* 1951 (plate 16). While *Brothers* employs his realist figures, the latter two works embrace new forms drawn from myth and memory. With these new forms, Shahn began to work in an idiom—myth and allegory—that would characterize his work, and much of American art, during and in the wake of World War II. Shahn now used traditional imagery and forms to address the human turmoil, destruction, and other effects of the war. Whether drawing on ancient, biblical, classical, or Jewish traditions, Shahn sought to create symbolic images of the universal war experience, as did other American artists who took very different approaches in their work.

Shahn would thus infuse his topical and political subjects with larger meanings. In this he remained Shahn, a political artist, but his work was now endowed with greater resonance and associations as he moved toward a center approached by other artists as well. It should be remembered, however, that even with this change Shahn continued to make partisan political art. Shortly after he worked for the Office of War Information (OWI), he made graphics for the Congress of Industrial Organizations Political Action Committee (CIO-PAC) in 1943, and he had designed posters for Roosevelt's reelection in 1944, and again for the Wallace presidential campaign in 1948. He continued to create his political paintings during the rest of his career, for example, works such as *Defaced Portrait,* 1955, and the *Lucky Dragon* series (see plates 28–31, figs. 19–22, 36, 37, 66, 67). Even after the important shift in focus toward universal themes and images, Shahn never abandoned his political agenda. A distinctive

characteristic of his even more universalist work was that it had more of a political edge than the work of his contemporaries.

THE WAR PAINTINGS

Shahn thus reshaped his style with new subject matter, a more universal outlook, and a new artistic language of symbolic emotion. As an examination of the subjects, ideas, and forms of Shahn's art during this period reveals, his adoption of a new mythic and allegorical language was only one of the ways he contributed to the new American approach to art; particular expressive themes were another. Shahn wrote that he painted only one subject during the war years: his lamentation for "Europa." He represented the fate of Europe through the depiction of the fate of Italy. *Italian Landscape* (plate 5), *Italian Landscape II: Europa* (plate 6), *The Red Stairway* (plate 7), and *Liberation* (plate 8), all of 1943–45—at the height of America's participation in the war and the most terrible carnage in recorded human history—suggest a world of chaos, abandon, wildness, and destruction. In *Italian Landscape,* 1943–44, for example, the classical structure of broken aqueducts, a surviving link to the past, now pours forth rubble and the dead. In *Italian Landscape II: Europa,* 1944, a mother carrying a child inches her way over ground strewn with broken fragments of classical buildings and civilization. Behind this chaos and turmoil lies a battered building symbolic of all of Europe—a hotel unroofed, rent and shattered, its walls blown out. The image of the hotel was actually taken from a photo of a building in Warsaw that Shahn saw at OWI.[12]

A similar world is depicted in *Liberation,* 1945, in which three children circle a maypole in front of a rubble-strewn courtyard and a fragmented house, blasted open to reveal the remains of colorful wallpaper. Now the dark clouds that set the mood for the first two paintings have materialized as a shattered wooden roof. The children whirl round the pole in the foreground; yet the viewer is denied a sensation of stability because Shahn has not shown the children as tethered to the pole. At least one of the girls seems to be seeking her footing as she flies wildly by.

The Red Stairway, 1944 (plate 7), repeats these ideas but also offers the classic counter-image of the war and postwar years, one of reconstruction and bitter hope. Shahn again pictures a smashed, fragmented, open building encompassing a rubble-strewn ground. Outside the building, impossibly next to walls of traditionally arched windows, a brutally long stairway rises up, goes down, and up again. Part of the stairway becomes a large, jagged slide that must somehow be traversed; but Shahn gives no indication of how that could be done. Just begin-

ning this seemingly impossible journey is an old, crippled man on crutches, the war's classic "damaged man," with his head hung low. Shahn thus pictures the plight of Europe and its long road back. Battered, maimed, broken in body and soul, Europe faces a depressing, long struggle with its future far in the distance. Lest this fate be too despairing, however, Shahn also suggests hope, for to the right is a man buried up to his waist in the rubble—of the same white marble color and seemingly a part of it. Emerging from the depths of the destruction, he excavates the stone ruins of Europe and of civilization. To affirm this new work, just above the figure the bright light of a dawn breaks beneath a cloudy sky, a traditional natural symbol of the future. Reconstruction has begun.

In these paintings, Shahn portrays World War II in symbolic terms with images of destruction, chaos, ruin, loss, death, violence, injury, struggle, journey, and hope. The images are rendered in characteristically intelligible terms that convey a sense of dignity, restraint, rationality, and stability; that is, Shahn employs traditional, non-expressionist means of depicting space, figure, and form. As he himself noted, his work of this period looks much the same as before. Yet his images and themes are the fundamental subjects and ideas of almost all war art, whatever the style.

When the war ended, Shahn gradually ceased working with themes specific to the war, but he continued to address its lasting effects. As Shahn moved into the postwar years he developed further his new style of "universal" realism. Postwar subjects are to be found in a number of works. *Brothers,* 1946 (fig. 58), for example, suggests the reunion and reconciliation of millions formerly separated by the war. It shows a hoped-for but cautious concord, a postwar Brancusian *Kiss.*

Increasingly, nature was a favorite Shahn symbol. From the overcast days, vast empty wastelands, and new dawns of his works of the early 1940s, all of which reflected the depressed mood of isolation and loneliness typical of daily life during wartime, to the budding trees of *Brothers,* Shahn exploited traditional nature symbolism to comment on recent history.[13] *Spring,* 1947 (plate 12), for example, expresses the idea of new life with the daydreaming of a youthful couple lying on an exhilarating thrust of new grass. Nearby are an even younger boy and girl skipping rope. Spring, of course, is a traditional image of hope, rebirth, renewal. Shahn represented new beginnings here in figurative images with which all can identify.

Shahn returned to his use of symbolic architectural environments typical of the 1930s in his *Renascence,* 1946 (plate 10). Before a roughened wall is a freestanding classical column that strangely resembles an erect phallus, a traditional emblem of fecundity and creative force. This kind of symbol would be unusual

for Shahn, except that he places to the wall's left a shock of early spring grain and the figure of a woman, both, like the phallus, traditional symbols of fertility and new life. Shahn also makes clear the necessity for this renaissance: to the right of the wall is the twisted metal wreck of a building in Hiroshima, an image well-known at the time from news photographs. *Renascence* fuses historical, classical, and natural symbols to create a figurative allegory of contemporary history and need.

With *Allegory,* 1948 (plate 14), Shahn would seem to have returned at last to his domestic, Social Realist subject matter. He wrote, "the immediate source of the painting of the red beast was a Chicago fire in which a colored man had lost his four children."[14] Below the dominating red beast lies a pile of bodies of dead children. However, there are lasting effects from Shahn's war paintings that indicate the war's survival in the artist's thinking. The fierce animal is a development emerging from Shahn's recent symbol-making approach. In "The Biography of a Painting," the artist described the animal as "a huge Chimera-like beast," which he related to images of "Harpies, Furies, and other symbolic, semi-classic shapes and figures" that found their way into a number of paintings and further drawings. This mythical beast evoked "primitive terror" and cruelty.

But Shahn was well aware of the universal significance of the fire: "the implications of this event transcended the immediate story; there was a universality about man's dread of fire, . . . his sufferings from fire . . . [and] in the pity which such a disaster invokes." Shahn underscored this universality with a free association of personal memories: he remembered the burning of the Russian village in which his grandfather lived, which he witnessed, and the even more terrible fire in which his family's home went up in flames, and his father was badly burned saving the lives of Shahn and his siblings. In fact, Shahn noted in "The Biography of a Painting" that the children resembled his own brothers and sisters more than the children in the Chicago fire. Personal, too, is the image of the forest in *Allegory,* an oblique reference to his mother's "colorful tales about being pursued by wolves when . . . she went alone from her village to another one nearby." These associations together create an image not of a particular disaster alone, Shahn wrote, but the "emotional tone that surrounds disaster . . . inner disaster."

Allegory is not then just a topical work; it is also reflective of the new Shahn: symbolic; classically, that is, mythically, allusive; universalizing; distinctly emotional and responsive to memory. And it is a product of the artist's new way of thinking, for *Allegory* uses social and personal associations to convey even broader historical meaning. While allegedly commenting on the death of four black children as well as his own family history, the painting is also

an indirect expression of Shahn's reaction to the Holocaust: the pile of dead children is taken from a photo of dead children in Warsaw that he had seen at OWI.[15] (See also the essay by Frances Pohl in this book.) Shahn had used the image earlier in *Cherubs and Children,* 1944 (fig. 35), under the influence of John Heartfield's antifascist photomontages and Heartfield's use of the famous 1930s photograph of a crying Chinese child.[16] Shahn thus realized his idea of a symbolic universal implication through the particular event of a fire.[17] Interestingly, the Abstract Expressionists reversed this process by creating universal images that the viewer could make personally, and thus particularly, relevant.

Shahn continued to develop classical and other traditional references for the remainder of his career. While he continued to comment on immediate events and places in works such as *Sound in the Mulberry Tree,* 1948 (fig. 72), and *The City of Dreadful Night,* 1951 (plate 16), he developed his new symbolic visual language. In the latter painting, for example, Shahn used demonic Greek heads to anticipate the approaching dominance and mindlessness of television. *Harpy,* 1951 (plate 17), again represents the mythic beast and its terror (here beneath a calm exterior), as does Shahn's *Lucky Dragon* series of 1960–62 (plates 28–31, figs. 19–22, 36, 37, 66, 67), a series of paintings and drawings in which he explored the fate of Japanese fishermen caught up in the radiation cloud of a nuclear test in the Pacific; Shahn opposed nuclear testing. In particular paintings of the series such as *We Did Not Know What Happened to Us,* 1960 (fig. 66), Shahn again used a monstrous beast—this time in a form appropriated from Japanese legend—in a whirlwind chaos of crashing clouds to evoke primitive terror overwhelming man. (For other representations of the threat of the bestial whirlwind, see *Portrait of Dag Hammarskjöld,* 1962 [plate 32], and *That Friday: Yaizu,* 1961 [fig. 36]). Fortunately, the whirlwind is dispersed by the Japanese symbolic act of releasing white pigeons in *A Score of White Pigeons,* 1960 (plate 30).

When Shahn articulated his new themes of the 1950s—the city, the anxiety, the fear and doubt brought about by the war, the oppressive political climate, and the nuclear age—he continued to embrace the mythic approach. For example, *Detail No. 2: Labyrinth,* c. 1952 (fig. 38), suggests the unstable behavior and repeated conundrums posed by irrational acts: man's overreaching culminates in disaster. An undated work, *The Fall,* tells of the dangerous knowledge of the atom that, like the acts of Adam and Icarus, would bring about disaster, while a sense of existential anxiety in the face of unknown forces lies behind *Man,* 1952 (plate 19). Here, an evocative technological or atomic force in space (or "the void") frightens a man who lies cowering in terror. Shahn is not with-

Figure 36
That Friday: Yaizu,
from the *Lucky Dragon* series, 1961
Gouache on paper, 16¾ × 50¼ in.
(42.5 × 127.6 cm)
Private collection

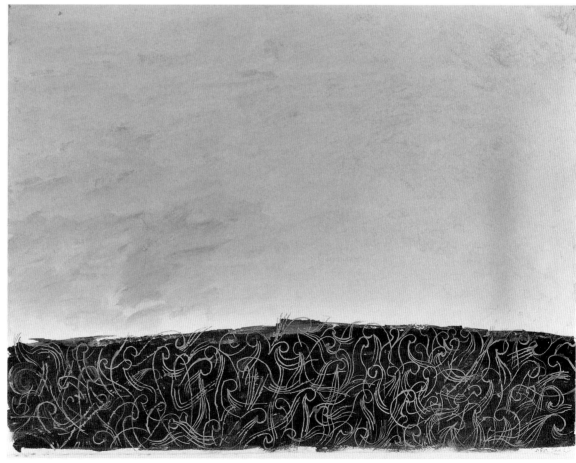

Figure 37
Desolation,
from the *Lucky Dragon* series, 1961
Gouache on paper, 20 × 26 in. (50.8 × 66 cm)
Terry Dintenfass, Inc., in association with
Salander-O'Reilly Galleries

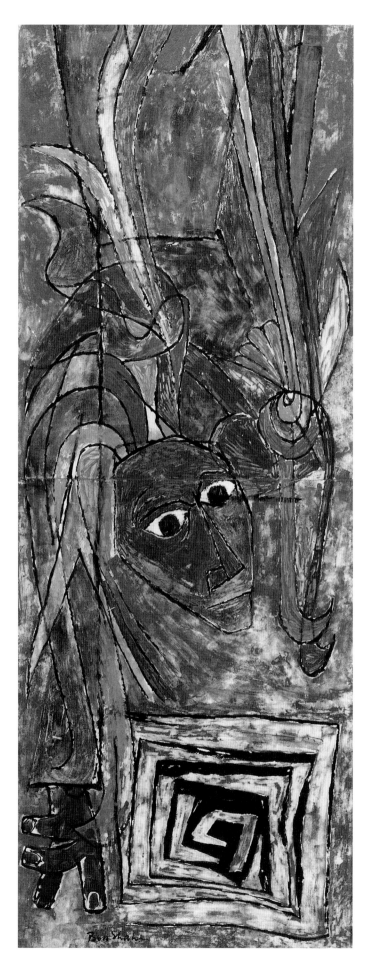

Figure 38

Detail No. 2: Labyrinth, c. 1952

Tempera on paper,

60¼ × 22¾ in. (153 × 57.8 cm)

Private collection

Figure 39

The Parable, 1958

Oil on canvas,

48 × 37¾ in. (121.9 × 95.9 cm)

Munson-Williams-Proctor Institute

Museum of Art, Utica, New York

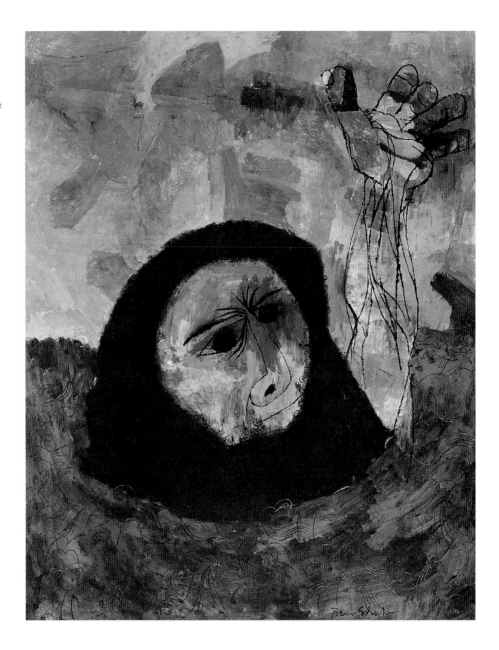

out his humor, however, even in this period. The title of the work on paper, *Age of Anxiety,* 1953 (plate 21), seems mostly to express that popular theme of the 1950s; yet the work also may comment on a woman's self-consciousness about her body, revealed at a swimming pool.

THE NEW RELEVANCE OF HERITAGE

Perhaps the climax of this new appreciation of mythic, ancient, and universal imagery as a means of representing human dilemmas that are both contemporary and timeless is Shahn's rediscovery of his Jewishness in his later years. For the first time since the 1930s, Shahn addressed his Jewish heritage in his art. With works such as *Sound in the Mulberry Tree,* 1948, with its Hebrew lettering

and biblical verse (see fig. 72), *Maimonides,* 1954 (plate 23), which evoked the medieval Jewish sage, *Third Allegory,* 1955 (plate 24) with its shofar and prayer shawl, and *The Parable,* 1958 (fig. 39), with its drowning or emerging patriarch, Shahn sought to address human needs through images of Jewish culture expanded to express universal truths. Yet, these works undoubtedly reflect Shahn's new appreciation for the heritage that he had restrained in his early work. The Holocaust brought forth a renewed identification with, and need for reaffirmation of, Shahn's Jewishness.

Shahn also took a renewed interest in Hebrew as a means of addressing foundationalist issues such as the origin of man. Beginning with his book *The Alphabet of Creation* of the early 1950s and then developed through different media, he re-created the origins of his Jewish identity through the use of the Hebrew language. This interest in Hebrew letters and text was perhaps also stimulated by the period's search for the sources and fecundity of visual and verbal language that arose in James Joyce and later in Abstract Expressionism; other examples are Theodore Stamos in *World Tablet* and *Saga of Alphabet,* both of the mid-1940s, and Adolph Gottlieb in letters and writing paintings such as *Inscription to a Friend,* 1948. Interestingly, Rico Lebrun also sought to depict as an alphabet a blueprint for man—not of creation, however, but, as he said, of "maliciousness."[18] And Morris Louis, the future color-field painter, also used Hebrew script to refer to the Holocaust in his *Charred Journal* series of 1951. In these works, he made oblique references to the Nazi book burnings and to the survival of the Jewish people in the wake of the Holocaust.[19]

Shahn also completed new editions of traditional Jewish texts as illustrator and scribe. Begun in 1931 but published in 1965, his *Haggadah for Passover* refers, of course, to the annual ritual narrative and prayers commemorating the Jewish flight from Egypt.[20] It thus addresses freedom from oppression in ancient form and ceremony. In 1967 in Paris, and in 1971 in the United States, Shahn illustrated and published *Ecclesiastes, or The Preacher.*[21]

NEW AFFINITIES

Shahn was not alone in developing mythic and allegorical language and ideas in the wake of World War II. In this respect, he joined the larger tide of American art during the 1940s and 1950s. For example, fellow radical painter Philip Evergood was also moved to depict the effects of the war in mythic and symbolic language. Evergood's *The New Lazarus,* 1927–54 (fig. 40), conflates his typical Social Realist edginess with a mythic biblical image of the evils of war and death, and the hope that these horrors will be redeemed by resurrection. Here

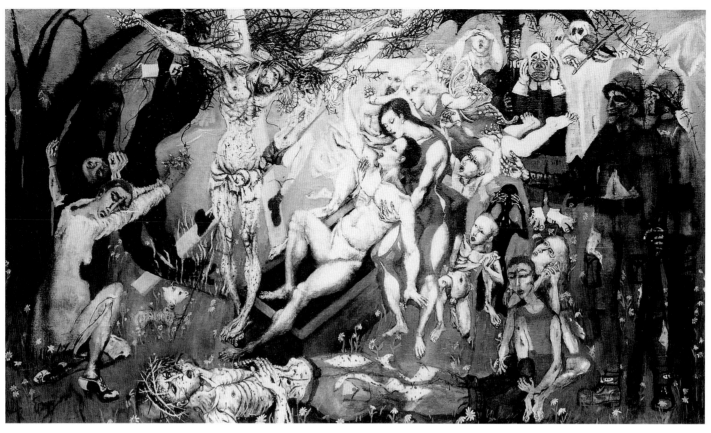

Figure 40
Philip Evergood
The New Lazarus, 1927–54
Oil on plywood, 48 × 83¼ in. (121.9 × 211.5 cm)
Collection of Whitney Museum of American Art,
New York. Gift of Joseph H. Hirshhorn

an American soldier lies crowned with thorns on the ground. Above him a nude Lazarus emerges from his coffin, aroused by the image of a Grunewald-like, crucified Christ and aided by fair angels. To the right are more American soldiers, one of whom receives the stigmata—mystic wounds that replicate the wounds of Christ. Behind the soldiers stand ghouls and clowns who hear, see, and speak no evil. Colorful flowers sprout around and from the body of the dead soldier. Using biblical and nature imagery, Evergood has fashioned an allegory of sorrow, suffering, death, and resurrection in the wake of the war. Much like Shahn, Evergood turned from Social Realism to create a symbolic history painting expressing the familiar and universalizing myth of redemption —even if it is represented in an almost gothic grotesque style.

Many other Social Realist artists of the 1930s, who had participated in the Works Progress Administration (WPA), took part in this major shift of subject and style. An example is the typical WPA artist Benton Murdoch Spruance, who is considered one of the finest printmakers of the war and postwar period. Spruance's *Souvenir of Lidice* won an award in the 1943 exhibition *America in the War,* sponsored by the Artists for Victory group. Like Shahn, he switched from a sociopolitical perspective to the mythic during the war.

Like many American artists in the 1930s, Spruance pictured the American

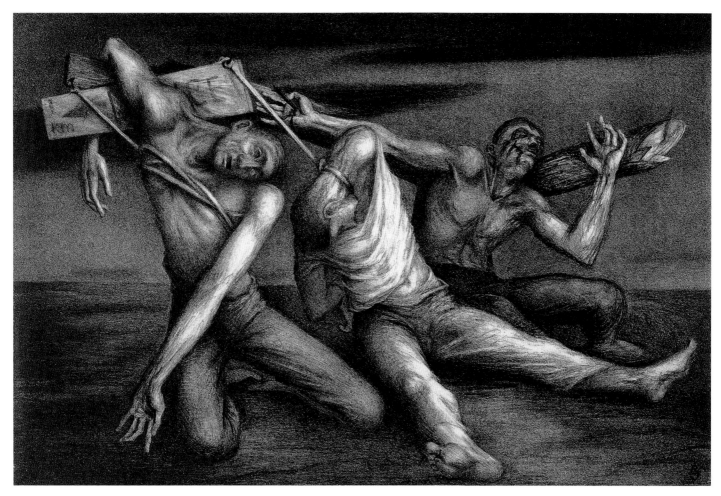

Figure 41
Benton Murdoch Spruance
Souvenir of Lidice, 1943
Lithograph, 12⅛ × 18¼ in. (31 × 46.4 cm)
Print Collection, Prints and Photographs Division,
Library of Congress, Washington, D.C.

social spectacle in a series illustrating America at work from morning to night and relaxing at football. By the early 1940s, he was representing World War II in prints, such as *Fathers and Sons,* 1943, that expressed his sorrow and bitterness about the human capacity for endless war and violence. During the war, he also came to employ religious symbolism to represent the universal significance of contemporary events.

Souvenir of Lidice (fig. 41), for example, depicts three men nailed to crosses—in other words, a modern Calvary. This contemporary crucifixion was inspired by the Nazi slaughter of the citizens of Lidice, Czechoslovakia, in retaliation for the assassination of a high Nazi official. Shahn had made a poster depicting the very same subject, but at the time he was not yet employing mythic language, as was Spruance.

Spruance followed his war work with a further use of this symbolic language. It is reflected in works of 1943 such as *Riders of the Apocalypse* with its air war; *Pietà—From the Sea* showing Christ as a dead seaman; and *Epiphany,* in which the stars of 1930s social reconstruction imagery—the doctor, teacher, and judge, offering the redeeming powers of health, education, and law—

appear in a new context. In the 1940s, they are shown before a mother and child seated in front of a ruin, faced with the tools and effects of war.

Spruance was not religious. A friend called him "more of a deist than theist."[22] Instead, he found the central truth of his generation: "He believed in the inherent worth and dignity of each individual while fully realizing that man had the capacity for evil as well as good. In the struggle to overcome the destructive forces in himself and in nature, man had to depend on his own reason and moral sense rather than the intervention of the supernatural. For Spruance, biblical events were more significant for what they had to say about the unfolding of the human drama."[23] The result was that after the war, like Shahn and other American artists, Spruance used biblical, religious, and other mythic imagery as malleable symbols to express his deeper insights about the human condition and its ageless dilemmas. Spruance, like Shahn, broadened his allusions to include not only the Bible but also mythology, ancient literature, and some modern classics. These references evoked not despair, nor the absurd, irrational, and valueless world, but rather a struggle between the forces of light and dark, life and death, in which human dignity and reason would ultimately prevail.[24] He remarked in 1955, "I do not think it sufficient to paint in innocent joy."[25]

Ironically, Thomas Hart Benton, much like Shahn, Evergood, and many WPA artists, also focused his art toward these themes at this time. And, as with the others, the shift has been virtually unnoticed in Benton's paintings. In the 1930s, of course, Benton championed the renewal of America through Regionalism, a reassertion of the successful populist past. But with the outbreak of war in Europe at the end of the decade, he began to lose absolute faith in the transformative power of past American patterns and values: "By the late autumn of 1941 my mind was so much on the international situation that I found it difficult to concentrate on painting. The American scene which had furnished the content and motivations of my work for some twenty years was outweighed by the world one. As I had no pictorial ideas applicable to this new scene, I was almost completely frustrated."[26]

With America's entry into the war, Benton altered his approach, now using biblical imagery to address America's political needs. In 1942, he produced a suite of paintings called the *Year of Peril.* These were crude propaganda works that traveled across the United States to explain the war and the nature of the threat to America. Although the figures were caricatures, the series narrated the war in terms of biblical images and themes. The first painting in the series, entitled *Again,* depicts the Axis powers attacking the crucified Christ. The word *again* captured Benton's belief and expressed an idea that was common

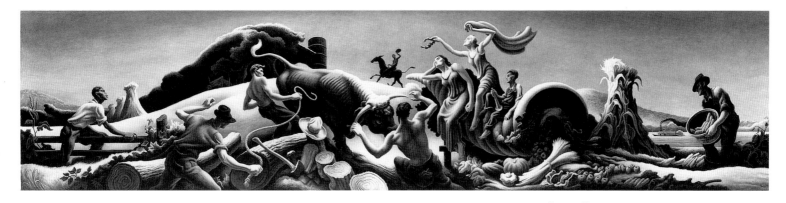

Figure 42

Thomas Hart Benton

Achelous and Hercules, 1947

Tempera and oil on canvas mounted on plywood,

$62\frac{7}{8} \times 264\frac{1}{8}$ in. (159.6 × 671 cm)

National Museum of American Art,

Smithsonian Institution, Washington, D.C.

Gift of Allied Stores Corporation, and museum

purchase through the Smithsonian Institution

Collections Acquisition Program

throughout the era—in Spruance's *Fathers and Sons,* for example—that the capacity for war was constant in human beings. *Again* was followed by the *Sower* (of death and destruction) and *Harvest* (of dead bodies), which developed other Christian themes.

Occasionally, Benton used myth for wry war humor, as in his 1943 pencil drawing *Mars and Venus,* which depicted a soldier and a waitress. But more often, his paintings philosophized about disaster and renewal symbolized in nature, as in *Achelous and Hercules,* 1947 (fig. 42). This long, splendid painting expresses contemporary historical themes of destruction and renewal by means of Greek myth in Benton's vernacular style. In the myth, a river god, who occasionally runs amok, destructively causing the river to overflow its banks, takes the form of the bull Achelous. Achelous fights with Hercules, who rips off one of the beast's horns, bringing forth a cornucopia of bounty and beauty from the earth. Thus disaster leads to a struggle of gods and heroes that ultimately gives rise to new life. In its way, Benton's *Achelous and Hercules* reiterates the vision, expressed in Shahn's 1946 *Renascence* (plate 10), of destruction followed by renewal as symbolized by woman and natural rebirth.

Along with Shahn's development of a language of myth that addressed the concerns of his time, his causes, themes, and ideas were also shared by many in American art. One such motif was the idea of lamentation, which Shahn said was the main theme of his early war work. Shahn "lamented" a shattered Europe and the destruction of European civilization, including that of the European Jews. This idea was, in fact, a standard theme of mourning in the art of both world wars.[27]

Most American Expressionists were affected by the war, either in their own flight from Europe to America or in their art. The Expressionist Abraham Rattner had been an artist of the School of Paris in his early career. When he fled to the United States in the late 1930s, his work took on a more grave character, and he painted the subject of lamentation several times. In his *Lamentation,*

Figure 43
Abraham Rattner
Pietà, 1949
Oil on canvas,
15 × 18 in. (38.1 × 45.7 cm)
Hirshhorn Museum and
Sculpture Garden,
Smithsonian Institution,
Washington, D.C.
Gift of Joseph H. Hirshhorn,
1966

1944, and *Pietàs,* 1945 and 1949, Rattner created a compact emblem of sorrow that, especially in the latter painting (fig. 43), was brilliantly colored and fragmented in imitation of stained glass and the work of Rouault. Although the war is not explicitly represented, it was implicitly understood in the frequent depictions of the crucifixion by Rattner and other artists. The apocalypse of history, with its 50 million dead, could be represented and distilled in the simple, culturally evocative image of the *Pietà* in the 1940s.

Lamentation was the formative idea of the Entombment paintings, the largest series in the early work of the Abstract Expressionist Mark Rothko.[28] Seeking an iconic, instantly communicative image that addressed modern tragedy, Rothko first painted the subject in surrealist, biomorphic forms, with quotations from Picasso and Ernst, before gradually moving toward abstraction, where the horizontal ideograph of the weeping Mary and prostrate Christ became an abstract emblem of sorrow. Rothko sought to find a modern pictorial form for tragedy, and the imagery of lamentation/pietà/entombment encapsulated his feelings toward modern history, just as Shahn's paintings and Rattner's

traditional icons had done. Similarly, the Abstract Expressionist sculptor Seymour Lipton reaffirmed the lament for Europe and mankind with his increasingly abstract sculptures, the *Pietàs,* 1946 and 1948.

The idea of bestiality dominates the art of the 1940s. In a world of epic, radical evil, it could be no other way. Artists represented this horrific force in the form of beasts. As we saw in *Allegory* (plate 14) and works such as *Harpy* (plate 17), Shahn would embody evil in the shape of an animal or chimerical creature. Although his images on the whole lack the overpowering feeling of evil so palpable in the bestial forms of Hyman Bloom (see fig. 44) and others, Shahn's *Harpy,* nevertheless, evokes a destructive force.

Other painters also made use of feral images to represent "primitive terrors" of their time, but without referring to the specific political source of the terror. The chimerical beast is a frequent image in Abstract Expressionism. For example, Adolph Gottlieb's works of the 1940s, the Pictographs, contain innumerable such creatures, and Gottlieb even called several works *Chimera.* Rattner's chimeras are human—beasts with bulbous noses, large teeth, and Boschian grimaces—and they are to be found throughout his work in the 1940s. Rico Lebrun employed bestial imagery when he represented the dumb soldiers surrounding Christ as horned and armored animals in *The Crucifixion,* 1950 (see fig. 49). Lebrun's forms are taken from the creatures he saw at the Natural History wing of the Los Angeles County Museum that he frequented at the time, much the same way that the Abstract Expressionists drew from remains of the dinosaurs and other biological epicenters of savagery they observed at the American Museum of Natural History in New York.

The broken and chaotic detritus of the war underlay Shahn's images. In most of his work of the mid-forties, he portrayed the fallen, fragmented, and rent symbols of order, civilization, and life in their state as wreckage. The exception was his whirlwind animal imagery, for example, in the *Lucky Dragon* series. Spruance also used whirlwind imagery to represent the intense movement and "restless motion"[29] of the human drama in works such as *The Vortex,* 1966, from the *Passion of Ahab* series. But in his representation of contemporary bestiality and chaos in works such as *Harpies,* 1947 (fig. 44), Bloom offers a more visibly gruesome vision of modern destruction.

Although a Jew from the Baltic like Shahn, the Expressionist Bloom was a Boston artist and much more devoted than Shahn to visionary, nightmarish imagery, born of the study of Dürer's allegories, and to the work of Rouault (like Rattner and Spruance), Bresdin, and Soutine. While at first Bloom's image of luminescent chandeliers and Christmas trees, archaeological riches, corpses and cadavers, dreamscapes, and Jewish rites would seem to be unrelated to the

Figure 44

Hyman Bloom

Harpies, 1947

Oil on canvas, 36 × 56 in. (91.4 × 142.2 cm)

Collection of Joseph Gropper

work of Shahn, many of the same themes also informed Bloom's work. In *Harpies,* swirling predators devour a barely visible body, creating "an allegory, enacted upon the body, of the psychic situation of man in the modern world: lacerated, devoured, and killed by a multitude of swooping evils."[30] The painting is all destructiveness, chaos, wildness, and despair—Shahn's whirlwind *redux*. Bloom would repeat these images throughout his career, for example, in the *Fish Skeletons* drawings of 1956 and the series *On the Astral Plane* of the 1960s, in which eyes, claws, fish, beasts, and monsters emerge from a dense nightmare of labyrinthine, tangled nature.

The image of the broken and chaotic whirlwind achieved an apotheosis in Abstract Expressionist art, although the motif is barely recognizable in popular interpretations that explain it in terms of Surrealist automatism, the artist's personal dream world, or gesture for the sake of gesture. The chaotic reigns, for example, in the work of Willem de Kooning. Although de Kooning virtually always represented a man or a woman, or parts of the human anatomy, the human being driven by destructive forces, and their fragmenting effects, are often his real subject. Beginning with his *Women* series in the early 1940s,

Figure 45

Willem de Kooning
Excavation, 1950
Oil on canvas,
81⅛ × 101¼ in. (206.2 × 257.3 cm)
The Art Institute of Chicago
Gift of Mr. and Mrs. Noah Goldowsky
and Edgar Kaufmann, Jr.;
Mr. and Mrs. Frank G. Logan Purchase Prize,
1952.1

de Kooning's expression of this subject reached a high point in perhaps his two greatest paintings, *Attic,* 1949, and *Excavation,* 1950.

The paintings seem to embody postwar feelings engendered by extreme horror. Indeed, excavations and attics—uncovering what was hidden behind facades or under ruins—are subtle war metaphors in play at this time. For example, Shahn's *The Red Stairway* (plate 7) depicts a man excavating the ruins of civilization. In Peter Blume's *The Rock,* 1948 (see fig. 46), that image is repeated, adapted from *The Excavation,* a painting Blume had done in 1945. Next to the excavator, in *The Rock,* barely stands the blitzed ruins of a building open through the attic, exposing as wreckage what was formerly behind its facade.

De Kooning's *Excavation* (fig. 45) is an intensified representation of similar chaotic ruin. Despite the doorway in the center of the painting, the work consists of mostly discontinuous pictorial vignettes with no continuous shapes or

Figure 46
Peter Blume
The Rock, 1948
Oil on canvas, 57³⁄₁₆ × 74³⁄₈ in.
(146.4 × 189 cm)
The Art Institute of Chicago
Gift of Edgar Kaufmann, Jr., 1956.338

complete and defined individuals—in other words, shattered form. The shapes have the same general character: mostly white with black demarcations, taut with sharp edges; free-floating and anonymous, with no consistent direction. The massed fragments of shapes and figures move randomly and violently without beginning or end, an endless waste and violation of meaning and coherence beyond the power of an individual to focus or alter. All is dissolution, flux, fragmentation, and corruption. The artist himself is the excavator, and the structure of the painting itself reenacts this theme, as does his style for the remainder of de Kooning's career—visionary, violent, dissolute.

Another theme of Shahn's war work was the cycle of reconstruction following destruction, particularly evident in *The Red Stairway* (plate 7). This cyclical pattern is typical of much of the art in the 1940s, for it expresses catastrophic contemporary history and suffering, but it also suggests redemption through the offer of new life. It is a practical but, ultimately, religious concept. Many post-

war artists approached this idea in the most personal of ways. Most common was the use of destruction/creation, death/rebirth, or, to borrow the metaphor of metamorphosis from *The Tempest,* "full fathom five" tropes. Shahn's *The Red Stairway* and other works utilize both destruction/creation and "full fathom five," the latter through an image of the light of a new dawn. The "full fathom five" effect evokes new life and splendor emerging from suffering and death.

The social Surrealist and former war artist Peter Blume said that he could not escape the natural cycle of destruction and rebirth. *The Rock,* 1948 (fig. 46), for example, represents a shattered rock as landscape, much as one sees in Flemish painting of the fourteenth century. "Though a skeleton lies adjacent to the rock, examples of life emerging from decay abound: the barren rock is coated with a crop of lichen; from a dead stump nearby erupts a bright red growth of fungus (life literally emerging from dead matter); and of course, a human counterpart to nature's renewal, the reconstruction of buildings."[31] A woman prays to the rock as if to a ritual idol. While scraps of old Italian buildings are tossed onto a fire, new materials are wrestled from the fertile earth itself to build a house in the New World (Frank Lloyd Wright's *Falling Water*). The painting as a whole is a sober celebration of the capacity of life and civilization to continue and to progress. However, the rock also assumes the form of a mushroom cloud, a product of an atomic explosion and a warning of man's precarious new circumstances.

Myths, religious symbols, and allegorical death/rebirth motifs predominate in Abraham Rattner's art. From *A Place Called Golgotha,* 1940, to *Darkness Fell Over All the Land,* 1942, to *Apocalypsion,* 1943, to the *Job* and *Gargoyle* series of the 1950s, Rattner narrated a Boschian world of mayhem, collapse, destruction, cruelty, and evil. Yet there is a possibility of redemption. In *Transcendence,* 1943 (fig. 47), for example, Rattner's image of metamorphosing figures flows from the dead Christ at the bottom of the image to an awakening and rising Christ who reaches out to touch the hand of His Father at the top. In this journey and process from death to rebirth, colors shift from dark to light and intensify as they do throughout Rattner's work. Often he will use a candle to suggest the light of illumination and of transformative ritual from death to physical and spiritual new life.

The themes of birth, life, death, metamorphosis, regeneration, and their ritual expression characterize much other Expressionist art, particularly that of Hyman Bloom.[32] In a series of famous, or infamous, works in the early 1940s, Bloom painted the decaying yet transcendent flesh of male and female corpses that he observed in the morgues of Boston hospitals. These rotting figures are at first repulsive—shattered fragments of mortality—yet their intense coloration

Figure 47

Abraham Rattner
Transcendence, 1943
Oil on canvas,
31⅞ x 39½ in. (81 x 100.3 cm)
The Brooklyn Museum of Art
Gift of Edith and Milton
Lowenthal Foundation, Inc.

creates a luminosity that suggests the emergence of new life. Indeed, with the naked, hideous, and Bacon-like *Female Corpse, Front View,* 1945 (fig. 48), the viewer, after being initially repulsed, perceives within the artist's seeming absorption in death and decay an image also of resurrection. Bloom notes the relative unimportance of fugitive flesh as opposed to the indestructibility of the spirit.[33] The ecstatic color is a metaphor of metamorphosis, the symbol of creative change during the 1930s and 1940s.[34] In Sydney Freedberg's words, "decay is transmuted into a living radiance, and the vital process, the endless mutation of matter, continues with a troubling beauty after death."[35]

Ironically, this very theme of death metamorphosed into new life is present in the poetry written following World War I. Richard Aldington's poem "Soliloquy #2" evokes the casualties of trench warfare:

> A dead English soldier,
> His head bloodily bandaged
> And his closed left hand touching the earth.

Figure 48

Hyman Bloom

Female Corpse, Front View, 1945

Oil on canvas, 70 × 42 in. (177.8 × 106.7 cm)

The Jewish Museum, New York

Gift of Kurt Delbanco and Romie Shapiro,

by exchange; and partial museum purchase

through the Kristie A. Jayne Fund, 1994-599

At the conclusion of the poem, out of this cadaver is born an almost redeeming
beauty:

More beautiful than one can tell

More subtly coloured than a perfect Goya,

And more austere and lovely in repose

Than Angelo's hand could ever carve in stone.[36]

Figure 49

Rico Lebrun

The Crucifixion, 1950

Duco on upson paper board,

16 × 26 ft. (488 × 792 cm)

Courtesy of the Syracuse University Art Collection

The theme of destruction followed by reconstruction, or death followed by rebirth, and the "full fathom five" effect—the emanation of splendor from destruction and decay—expressed in changes of light or color from dismal to dazzling appears even in abstract art. It is a commonplace in Abstract Expressionism. For example, the most important series of the Abstract Expressionist Barnett Newman, the *Stations of the Cross,* 1957–64, in the National Gallery in Washington, consists of fourteen black-and-white canvases followed by a fifteenth in orange, the color of a new sunlit world. The title of this fifteenth canvas, *Be II,* is Newman's exhortation after the universal Christ's death and resurrection. Since Picasso's *Guernica,* 1937, black-and-white, of course, had been the essential mode of commemorating the war dead during the 1940s.

In his intense work, Rico Lebrun also transcends disaster and cruelty with light and color. Lebrun was a well-known California artist in the 1950s, but he is virtually forgotten today. Yet his thought and evolution also focused on history as myth and allegory. Like Bloom and the Abstract Expressionists, Lebrun was a visionary artist who used "contemporary, universal, intelligible symbols to the purpose of depicting the general human condition."[37]

Figure 50
Rico Lebrun
Dachau, 1958
Ink, wax, and charcoal on canvas,
74¹³⁄₁₆ × 86⅝ in. (190 × 220 cm)
The Jewish Museum, New York
Gift of Constance Lebrun Crown,
1986-224

Lebrun's early work was typical social art of the 1930s—in his case, Region-
alist rather than Social Realist—expressed in such works as *Farm Machine, Yellow
Plow,* and *Vertical Composition* (of a wheel and a broken axle). But in 1945, the
war enveloped him, and the rest of his career reflects a coming to terms with
its facts. Like Shahn and other artists, he adapted tradition, myth, and ritual to
encompass, comprehend, and even transcend, contemporary history. Much of
his remaining twenty years were devoted to major statements of contemporary
thinking about the war in series such as *The Crucifixion, The Holocaust, Genesis,*
and *Dante's Inferno,* among others. In these works he related "the topical to the
traditional and to his own dream world."[38]

Lebrun painted more than three hundred works during the late 1940s as
studies and individual panels for the triptych mural *The Crucifixion* (fig. 49).
The series is a fusion of archaic myth and modern metaphor that addresses
modern history with images of reptilian soldiers, lurking sinister faces, broken
bodies, and bereaved women. And it is a pictorial fusion, too, reflecting mod-
ernist fragmentation, cubist overlapping, *Guernica*'s black and gray, and Abstract

Expressionist vitality and rent form. Yet even in the destruction symbolized by *The Crucifixion* there is an image of creation. In contrast, "a bright spotlight forms sharp, geometric planes of light and draws . . . attention to the left-hand panel; the sun disk has absorbed the crescent moon. An energetically crowing rooster . . . now joyfully heralds the new day, the brilliant dawn of the resurrection and of a new era. It is a sign of promise and of hope."[39]

So, too, *The Holocaust* paintings (see fig. 50) of the late 1950s, with their pits of death, are based on actual photographs: rows of scattered, brutal, and broken forms in dripped paint and black, yet with hints of transcending color. "In these awesome paintings, beautiful even with their deep, luminous colors and shattered forms [partially based on the Italian Gothic artist Francesco Traini's *The Triumph of Death,* from the Campo Santo in Pisa] the artist . . . has painted his 'form of remembrance and prayer . . . changing what is disfigured into what is transfigured.'"[40] W. R. Valentiner commented further: "These destroyed and destroying creatures form a beautiful abstract pattern in the moment of their change from life to death, reflecting glowingly the new life which generates out of the mortal agony. In these patterns of brilliant colors and transfiguring lights, the rays of a cosmic, a resurrected, world are caught. . . . Elements which can well be split apart by incredible forces . . . will always . . . [form] new configurations in an eternal chain . . . [corresponding] to the universe."[41] Lebrun thus trumps death with life, massacre with rebirth. His work recalls what he had learned at Naples Cathedral as a young boy, where people literally waited for annual miracles: "This collective and fierce will, convinced that it could change the inert into the alive, has never been to me a lost lesson. The miracle was that dead matter gave way to faith triumphant. Which goes for painting, also."[42] Only when an image is realized on canvas, says Lebrun, can the "redemptional element of gay color and splendor" be added.[43] Thematically, this pictorial triumph takes the form, typically, of new life, as in *Genesis,* at Pomona College in California.

In the art wars of his time, Lebrun's art was criticized for having content, for having subject matter, and thus being "literary." He had no problem with that characterization. But in a conversation with Selden Rodman, he declared his "literature" to be:

Full fathom five thy father lies;
Of his bones are coral made;
Those are pearls that were his eyes;
[Nothing of him that doth fade.
But doth suffer a sea-change

Figure 51

Jackson Pollock

Full Fathom Five, 1947

Oil on canvas, with nails, tacks, buttons, key,

coins, cigarettes, and matches,

50⅞ × 30⅛ in. (129.2 × 76.5 cm)

The Museum of Modern Art,

New York. Gift of Peggy Guggenheim

into something rich and strange.]

—Shakespeare, *The Tempest* (I.ii.397–402)[44]

Need one point out that *Full Fathom Five* (fig. 51) and *Sea Change,* both of 1947, are the titles of two of Jackson Pollock's first and most important poured paintings, works of transformative force and fecund flow in themselves?

Rebirth expressed through light or intense color can also be found in the work of other artists of this period. In the great mytho-ritual dances of Martha Graham such as *Rites of Spring,* she redeems the sacrifice of an innocent maiden

with the appearance of regenerative green in the cloak of the shaman, who had ordered the ceremony. Thus, from the darkness of death emerges new life for the polity.

Finally, an image of "transformation" or "transfiguration" can also be found in one of the most powerful historical dramas of recent memory—Steven Spielberg's motion picture *Schindler's List.* The narrative of the rescue of a thousand Jews by the German industrialist Oskar Schindler portrays their wartime suffering in black and white. At the end of the film, however, the appearance of some of the real survivors ritually commemorating Schindler in Israel is shown in the fullness of color. Although many would not impose any humanist meaning on the Holocaust, most survivors went on to build new lives and families; in a sense, those who survived the Holocaust were reborn from the ashes. It is also characteristic of rituals commemorating the Holocaust that the destruction of the European Jews is linked with the rebirth of Jewish life in the state of Israel, where, in the film, the Schindler survivors are shown in brilliant sunlight.

The heightened emotions expressed during the war extended well beyond it. Transformations brought about by the war led to intensified feelings that took years to retreat. Before this emotional intensity became almost a cliché that was later rejected by artists in the 1960s, it was embodied in the work of artists who painted intense emotional states to fully represent human possibility. Shahn presented this goal when he declared his artistic agenda as expressing "most important[ly] . . . a play back and forth, back and forth. Between the big and the little, the light and the dark, the smiling and the sad, the serious and the comic."[45] In works of the 1950s, he articulated these varied and opposite extremes of human life and feeling. The paintings *Anger, Discord,* and *Beatitude* (fig. 52), all of 1952–53, suggest distilled images of such opposite states of emotion. *Anger* and *Discord* seem to have evolved from earlier works such as *Trouble* (fig. 53) and *Laissez-Faire,* both of 1947, in which two men, apparently from different socioeconomic classes, battle with each other while a policeman looks away, the roller-coaster in the background symbolizing the turbulence of their relationship and environment. In *Anger* and *Discord,* however, the conflict is more abstract, less explicit.

The Abstract Expressionist William Baziotes also tried to represent the experience and sources of opposing emotional states in his work. In works such as *Dwarf,* 1947 (fig. 54), the teddy-bear figure with reptilian eye and teeth captures the human duality: both the childlike and the chilling aspects. Baziotes himself noted this duality in comparing the painter Pierre Bonnard and the writer Paul Verlaine: "Bonnard picks color in paint, as Verlaine in words . . . a little sadness,

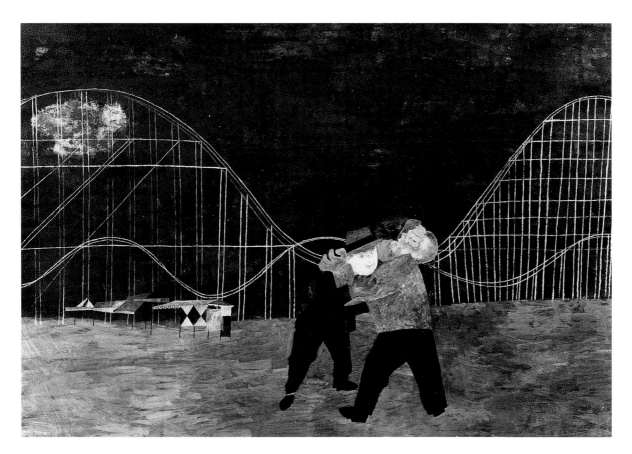

a little gaiety, and a little naughtiness. All under it, he is serious."[46] Similarly, Mark Rothko described his work, represented by intensely colored and expressive rising, falling, emerging, and sinking painterly forms, in these epic and opposite terms: "I'm interested only in expressing basic human emotions—tragedy, ecstasy, doom, and so on."[47] Benton Murdoch Spruance also referred to these epic polarities in his work. Deep sorrow is portrayed in *Dark Angel,* while "extreme ecstasy in the images of two cavorting angels" appears in the "lively and sunny" *Two Angels* (fig. 55), both of 1955.[48] And Adolph Gottlieb completed the era's complex view of the opposites of human life and destiny as distilled in emotion in his abstract works such as *Conflict* and *Transfiguration* of the late 1950s and 1960s.

Finally, as can be seen in the work of Ben Shahn during this period, the effects of Nazism, World War II, and the Holocaust led to the reaffirmation for Jewish artists of their cultural identity, heritage, and traditional practices. The secularist Shahn and others sought to find a place for these forms in the modern world, indeed, to reconceive the modern to allow for Jewish ritual to address succinctly timeless human needs. What was noted about Spruance could also be said of Shahn: "in these as in most of his later works, he clearly eschewed direct expression for the symbolic; by linking the present to familiar and parallel representations of the past he was able to emphasize the timelessness of human experience and, perhaps, to feel more confident about the significance of his own sentiments."[49] Spruance himself observed that "the dislocation of our old faith seems to call for a new coherence—expressed in myth."[50] For Shahn as well, myth and ritual expression were ways of reconceiving old verities for the new era.

Virtually all the other Jewish artists—Rattner, Bloom, and many Expressionists—used Jewish symbols to represent Jewish heroes and archetypes as universal themes. Bloom, for example, first in his *Synagogue* and then in *Rabbi, Younger Jew with Torah, Older Jew with Torah,* all of the early 1940s, and *The Bride,* 1943–45 (fig. 56), addressed the endurance of Jewish tradition as an exemplar of both ritual and survival. "In embracing these beliefs he could sense the existence of an order in which the individual was part of a larger, coherent whole, in harmony with a greater consciousness."[51] But in keeping with the remythification of modern life, Jewish symbols functioned as modes of expression of "the cosmic issues of life and death, illusion, mystery and metamorphosis."[52] *The Bride,* for example, represents a coloristically bejewelled woman whose wedding dress is covered with symbolic forms of life and death.

During the war, Abraham Rattner denounced reason, saying that "the war

was the culmination of the worship of reason by man. . . . We have to try for an understanding that surpasses reason. We cannot understand without faith—in revelation."[53] Rattner required a spiritual purpose for art, rejecting both modernism for its own sake and materialism. The art critic, and later dealer, Samuel Kootz admired Rattner for illuminating his and other artists' use of mythic and ritual forms. In *New Frontiers in American Painting,* Kootz wrote that Rattner was possessed by "a deeply religious ethical inwardness. He suffers a profound pain—not self-torment—at the injustices of the world, an almost

Biblical anguish at war and its causes. He is morally implicated in everything he does."[54]

To be sure, for this generation, interest in the mythic grew partly out of the American interest, during the 1930s, in custom, ritual, and tradition. From John Steuart Curry's *Baptism in Kansas,* 1928, to the American archetypes in Grant Wood's *American Gothic,* 1930, to the urban, ethnic Christian, funeral procession in Shahn's *Ave,* 1950, American artists had sought to articulate identities, heritages, and communities through awareness of the common rituals, legends, and histories that defined them. In the 1940s, in particular, ethnic heritage became part of the mix. For example, among the Abstract Expressionists, the Armenian-American Arshile Gorky fused the ancient past of his ancestors with modernism to produce a new cultural hybrid embodied, for example, in *The Plough and the Song* series of the mid-1940s. The same was true of the Greek-Americans William Baziotes and Theodore Stamos, who did likewise while the Jewish-American Seymour Lipton expressed his heritage in the new forms of metal sculpture. In the end, these artists infused modernism with the particular and universal to inform the new with knowledge and wisdom gleaned from the past, especially from a particular ethnic heritage.

There are many more works that could be cited to add to the list of correspondences noted here. From Newman's *Concord,* 1949 (fig. 57), and *Prometheus Bound,* 1951—his version of Shahn's *Brothers* (fig. 58) and *Prometheus* (fig. 59), 1956—to Gottlieb's *Incubus,* 1946, and *Ashes of Phoenix,* 1942—his version of Shahn's *Incubus,* 1954 (fig. 11), and *Phoenix,* respectively—to Spruance's *Clue to the Labyrinth,* 1953, and *I Lazarus,* 1961, among others, there are innumerable connections between different artists, different approaches, different heritages, and universal humanity.

During the 1940s and 1950s, many artists were engaged in representing their personal responses to history.[55] They also participated in shifting the frame of reference, the tangible consciousness that defines a period. Shahn joined these artists in coming to terms with history through allegory, myth, and tradition. His art of protest was joined by his fellow artists' art of vehemence when the challenge of radical evil supplanted socioeconomic ills as the central crisis of contemporary history.

Shahn is a realist artist who continually violates the realist tradition. He is associated with other artists who represent even more hallucinatory "visions" that end in abstraction. What underlies much American art of the war and postwar years is a shared experience—of incoherence, violence, and hope for redemption—that altered the artistic imagination. For no one thinking about history, culture, or civilization could escape its effects. Shahn and other artists

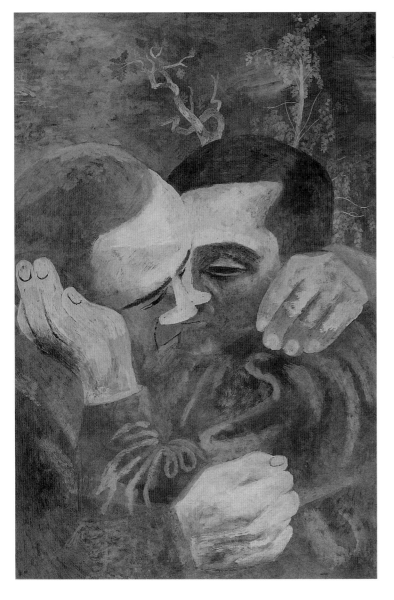

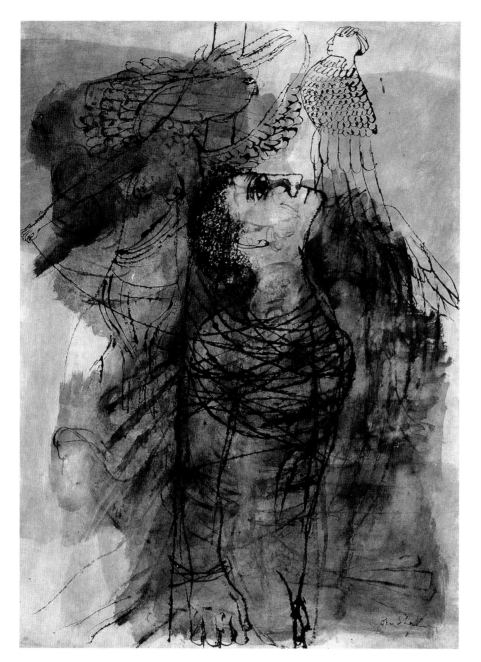

Figure 59

Prometheus, 1956

Wash drawing on paper,

33 × 24 in. (83.8 × 61.0 cm)

Samuel S. Fleisher Art Memorial,

Philadelphia Museum of Art

repudiated convention, but they also embraced and extended traditional images
and ideas to encompass modern reality (see fig. 60).

Perhaps the shared tendency that courses through artists very different in
style and conception can be summed up in Shahn's watercolor *Apotheosis,* 1956
(fig. 61), a study for a mural for the William E. Grady Vocational High School
in New York. This work and Shahn's description of it reveal an integration
of art, history, and hope. The mural form consists of the epic, sequential panel
images of the 1930s, infused with the subject matter and thought of the 1940s
and 1950s. On the left are several panels reprising the wrecked Hiroshima build-
ing from Shahn's *Renascence* (plate 10), which weighs on a prostrate man joined
by another in a free fall. These images represent the limits of science and tech-

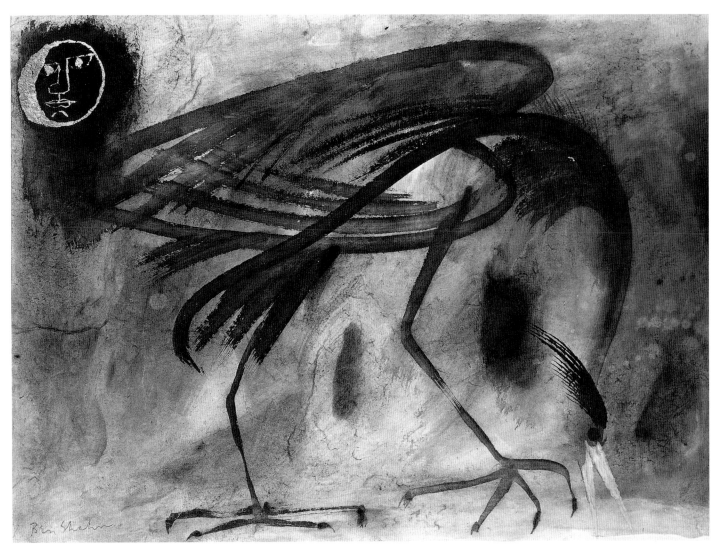

Figure 60

The Heron of Calvary No. 1, 1962
Watercolor and gouache on paper,
23½ x 32 in. (59.7 x 81.3 cm)
Collection of Mr. and Mrs. Maurice
G. Levine

nology, the liberational forces of the 1930s that ended up as instruments of war. In the center, rising from the flames, is the mythological Phoenix, "symbolizing man's power of self-regeneration" according to Shahn. To its right are the forms of the ancient cosmic constellations and symbols of new mathematical understanding. The last section shows the creative figures of the thoughtful architect, the musician, and the philosopher Maimonides, who is surrounded by emergent, fair nature and holds a book opened to words entreating humility as a condition of human progress. These three figures, Shahn noted, "symbolize the intellectual-spiritual pursuits of man, through which he creates civilizations and is saved from self-destruction." The epic format of the thirties, which formerly represented social and economic suffering, in this work houses the effects of the war, which, nevertheless, are redeemed by humanity's tireless capacity for creativity, reflected in ancient wisdom and modern understandings.

Apotheosis is Shahn's and his generation's statement about history and its antidote—death and destruction followed by rebirth and renewal. At the time

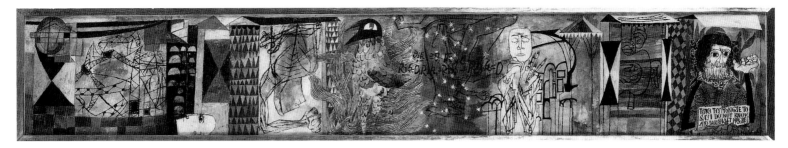

Figure 61

Apotheosis (Study for William E. Grady Mural), 1956
Watercolor, gouache, and ink on paper,
7½ × 48¼ in. (19.1 × 122.6 cm)
Collection of Irene and Mark Kauffman

that he painted this work, the experience and defiance of Shahn and his generation were put into words by W. H. Auden in an appraisal of the French diplomat and contemporary poet Saint-John Perse, who fled the Nazis to settle in the United States and whose symbolic writings on the epic material and moral struggles of man throughout time won him the Nobel Prize for literature in 1960. Perse was a favorite poet of many in Shahn's generation, from Martha Graham to Spruance. As Auden put it, Perse celebrated "not the refusal of the noble individual to live at any price, but the inexhaustible power of life to renew itself and triumph over every disaster."[56]

Notes

1. See Stephen Polcari, *Abstract Expressionism and the Modern Experience* (New York: Cambridge University Press, 1991), 133; and Mona Hadler and Joan Marter, "Sculpture in Postwar Europe and America, 1945–59," *Art Journal* 53, no. 4 (Winter 1994).

2. Piri Halasz, *The Expressionist Vision: A Central Theme in New York in the 1940s,* exh. cat. (Greenvale, N.Y.: Hillwood Art Gallery, C. W. Post Center, Long Island University, 1984), 23.

3. Ibid.

4. Elaine de Kooning, "Hyman Bloom Paints a Picture," *Art News* (January 1950): 30–34.

5. George Biddle, *The Yes and No,* p. 93, cited in Greta Berman and Jeffrey Wechsler, *Realism and Realities: The Other Side of American Painting 1940–1960* (New Brunswick, N.J.: Rutgers University Art Gallery, 1981), 50.

6. Ibid.

7. Ibid.

8. Excerpts are taken from Ben Shahn, "The Biography of a Painting," in *The Shape of Content* (Cambridge: Harvard University Press, 1957), 25–52.

9. Interview with Thomas Hart Benton, *New York Herald Tribune,* April 1935, cited in Henry Adams, *Thomas Hart Benton: An American Original* (New York: Knopf, 1989), 233.

10. Shahn, "The Biography of a Painting," 41–42.

11. Ibid., 25–52. Quotations are taken from Shahn's essay.

12. Ziva Amishai-Maisels, "Ben Shahn and the Problem of Jewish Identity," *Jewish Art* 12–13 (1986–87): 309.

13. Shahn shared this depressive mood with other American artists, such as Raphael Soyer and Yasuo Kuniyoshi. See Berman and Wechsler, *Realism and Realities,* 49.

14. Shahn, "The Biography of a Painting," 26. Comments on *Allegory* are taken from this source.

15. Amishai-Maisels, "Ben Shahn and the Problem of Jewish Identity," 307.

16. Ibid., 308.

17. Not all of Shahn's mythic imagery is related to the war. In 1949, for Curt Valentin, and then in 1951, for the Museum of Modern Art in New York, Shahn published *A Partridge in a Pear Tree,* consisting of graphic illustrations of the Christmas song.

18. Selden Rodman, "Rico Lebrun," in *Conversations with Artists* (New York: Capricorn, 1961), 34.

19. The *Charred Journal* series was the subject of an exhibition at The Jewish Museum, January 19 to April 13, 1997.

20. *Haggadah for Passover,* copied and illustrated by Ben Shahn, with a translation, introduction and historical notes by Cecil Roth (Boston: Little, Brown, and Co.; Paris: Trianon Press, 1965).

21. *Ecclesiastes, or The Preacher,* illustrated by Ben Shahn (Paris: Trianon Press, 1967; New York: Grossman, 1971).

22. Lloyd M. Abernethy, *Benton Spruance: The Artist and the Man* (Philadelphia: The Art Alliance Press; London and Toronto: Associated University Presses, 1988), 76.

23. Ibid.

24. Ibid., 77–79.

25. Ibid., 79.

26. Thomas Hart Benton, *An Artist in America,* 3rd ed. (Columbia: University of Missouri Press, 1968), 297.

27. See Jay Winter, *Sites of Memory Sites of Mourning* (Cambridge: Cambridge University Press, 1995) for a discussion of biblical, classical, and archaic themes in the arts in the aftermath of World War I.

28. See Polcari, *Abstract Expressionism,* 133.

29. Abernethy, *Benton Spruance,* 85.

30. Sydney Freedberg, "Hyman Bloom," *Perspectives: USA* 6 (Winter 1954): 53.

31. Remarks are taken from Berman and Wechsler, *Realism and Realities,* 56.

32. Piri Halasz, "Figuration in the '40s: The Other Expressionism," *Art in America* (December 1982): 145. See also Halasz, *The Expressionist Vision,* 29.

33. Joe Gibbs, *Art Digest,* cited in Dorothy A. Thompson, *Hyman Bloom: The Spirits of Hyman Bloom* (New York: Chameleon Books, 1996), 41.

34. Thompson, *Hyman Bloom,* 28.

35. Freedberg, "Hyman Bloom," 53. Interestingly, Bloom extended his eschatological thinking and that of others to the primal past. *Treasure Map,* for example, would seem at first to be simply an archaeologist's map of an ancient Mesopotamian city and thus a symbol of the prehistory and origins of man. Those beginnings are then transformed—or transfigured— in *Archaeological Treasure,* whose rich colors suggest "jumbles of precious stones." See Halasz, "Figuration in the '40s," 145. The emergence of new splendor from dark origins, or the "full fathom five" effect, was also noted in a discussion of Bloom's cadavers in *Time* magazine in 1948. There a Mohammed legend about Jesus was cited to the effect that in noticing a dead dog that stank, Jesus was purported to have said: "How whiter than any pearls are the teeth." See "The Pessimistic View," *Time,* March 14, 1949, 69, cited in Halasz, 145.

36. Cited in Paul Fussell, "Modernism, Adversary Culture, and Edmund Blunden," in *Thank God for the Atom Bomb and Other Essays* (New York: Ballantine, 1990), 227.

37. See "Statement of Views of the Artist Himself," in *Rico Lebrun* (Philadelphia: Art Alliance,

1950), n.p. Lebrun's series of Holocaust paintings was shown at The Jewish Museum from January 19 to April 13, 1997.

38. Rodman, "Rico Lebrun," 34.

39. Ellen Oppler, *Transformations/Transfigurations* (Syracuse, N.Y.: Lowe Art Gallery, 1953), 8.

40. Ibid., 10.

41. W. R. Valentiner, *Nine Paintings by Rico Lebrun* (New York: Jacques Seligmann, 1950), n.p.

42. Rico Lebrun, *Drawings* (Berkeley: University of California Press, 1961), 8.

43. Rodman, "Rico Lebrun," 35.

44. Ibid., 41.

45. James Thrall Soby, *Ben Shahn: His Graphic Art* (New York: George Braziller, 1957), 19.

46. William Baziotes to Byron Vazakis, April 2, 1934.

47. Rodman, "Mark Rothko," in *Conversations with Artists,* 93.

48. Abernethy, *Benton Spruance,* 102.

49. Ibid., 101.

50. Ibid., 125. This comment, by the way, indicates how the search for a unifying myth during the 1930s continued in the 1940s. It also indicates how the supposedly unique Abstract Expressionist quest for a myth by a "small band of myth-makers," in Rothko's words, was common coin. Neither Rothko nor the critics of Abstract Expressionism have acknowledged the extent to which their thinking was shared by other artists of the period.

51. Thompson, *Hyman Bloom,* 27.

52. Ibid., 49.

53. Abraham Rattner Papers, Archives of American Art, New York, microfilm roll D204, frames 0236–37.

54. Samuel Kootz, *New Frontiers in American Painting* (New York: Hastings House, 1943), 36.

55. See, for example, Halasz, *The Expressionist Vision,* and Berman and Wechsler, *Realism and Realities,* for more examples.

56. *New York Times,* July 27, 1958, cited in Abernethy, *Benton Spruance,* 105.

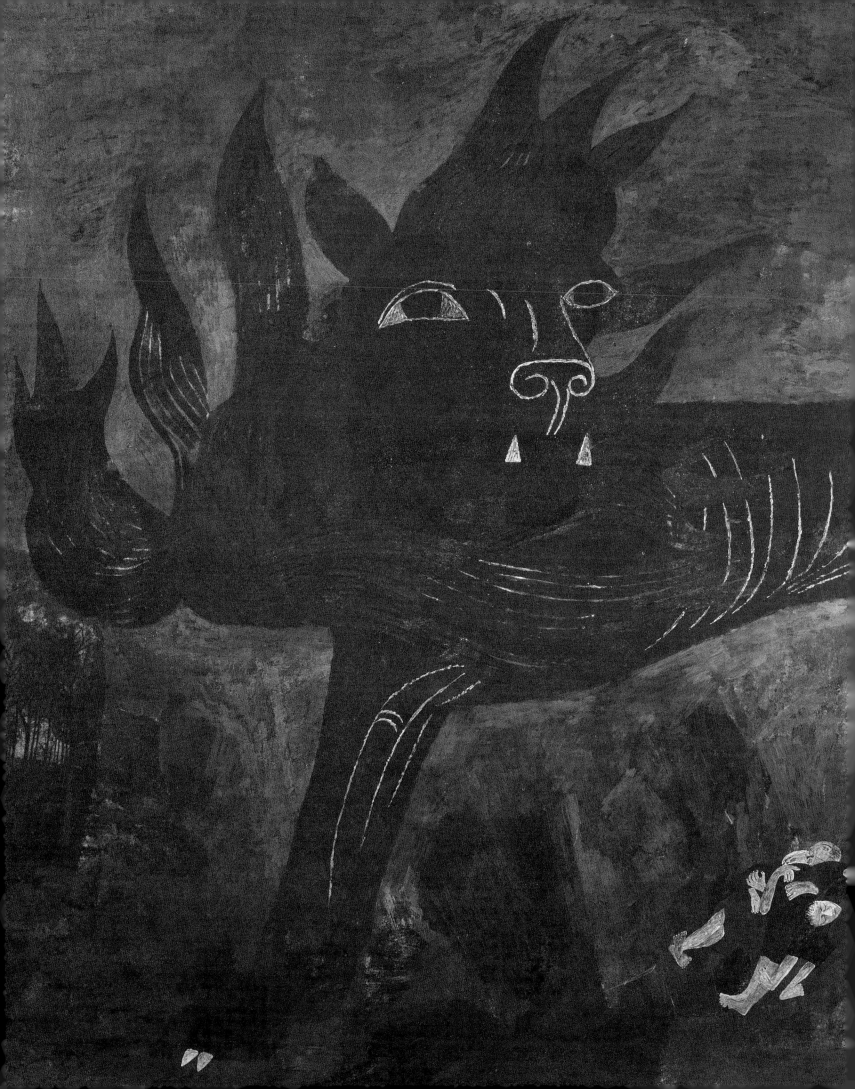

Allegory in the Work of Ben Shahn

Frances K. Pohl

Allegory: *An extended metaphor, usually in the form of a narrative,*
portraying abstract ideas in symbolic guise.
—Encyclopaedia Judaica

Allegorical Interpretation: *That explanation of a Scripture passage*
which is based upon the supposition that its author, whether God or man,
intended something 'other' . . . than what is literally expressed.
—Jewish Encyclopedia[1]

Ben Shahn used allegory extensively in the work he produced after World War II, as did many American artists.[2] One of his reasons for doing so can be found in a passage in his well-known essay "The Biography of a Painting":

> The change in art, mine included, was accomplished during World War II. . . . During the war I worked in the Office of War Information. We were supplied with a constant stream of material, photographic and other kinds of documentation of the decimation within enemy territory. There were the secret confidential horrible facts of the cartloads of dead; Greece, India, Poland. There were the blurred pictures of bombed-out places, so many of which I knew well and cherished. . . .
>
> I had once believed that the incidental, the individual, and the topical were enough; that in such instances of life all of life could be implied.
>
> But then I came to feel that that was not enough. I wanted to reach farther, to tap some sort of universal quality. . . . A symbolism which I might once have considered cryptic now became the only means by which I could formulate the sense of emptiness and waste that the war gave me, and the sense of the littleness of people trying to live on through the enormity of war.[3]

For Shahn, another language, one different from the realism of his prewar paintings, was necessary to convey the horror and shattered dreams that accompanied World War II.

While many artists chose an abstract language to present their abstract ideas, Shahn clung to the narrative that informed his earlier work. He also returned to the biblical literature he had studied so well in his early years for the symbols that he used to construct many of his allegorical narratives. Yet the abstract truths expressed through such allegories were also grounded in the particular details of Shahn's own time. In creating a universal language Shahn did not simply want to retreat into the realm of the generalized and the abstract. Rather, he wanted his painting to be both topical and universal. He argued that "the universal is that unique thing which affirms the unique qualities of all things. The universal experience is that private experience which illuminates the private and personal world in which each of us lives the major part of his life."[4]

This essay focuses on three of Shahn's paintings, fittingly entitled *Allegory,* 1948 (plate 14, fig. 62), *Second Allegory,* 1953 (plate 20, fig. 65), and *Third Allegory,* 1955 (plate 24, fig. 70). Each work combined the particular and the general, the detail drawn from daily life and the larger fears and hopes that were shared across generations, if not across nations and continents. A key to understanding the melding of the personal and historical incident and the universal experience within these three paintings can be found in another passage by Shahn, taken from his book *Love and Joy about Letters,* published in 1963. Here Shahn wrote about his early years in Vilkomir, Lithuania; of his long days in school studying the Bible; of how the world of his immediate family seemed to blend imperceptibly into biblical times: "At that time I went to school for nine hours a day, and all nine hours were devoted to learning the true history of things, which was the Bible; to lettering its words, to learning its prayers and its psalms, which were my first music, my first memorized verse. Time was to me, then, in some curious way, timeless. All the events of the Bible were, relatively, part of the present. Abraham, Isaac, and Jacob were "our" parents—certainly my mother's and father's, my grandmother's and my grandfather's, but mine as well. I had no sense of imminent time and time's passing."[5]

Such a blurring of boundaries between the present and the past, the worldly and the otherworldly, was, according to historian Irving Howe, an integral part of Jewish life in the Pale of Settlement, that circumscribed territory stretching from the Baltic Sea to the Black Sea where Russian Jews were legally authorized to settle and where Shahn spent his first eight years. Irving Howe writes that for much of the nineteenth century this closely bound, impoverished and imperiled society nourished a culture that essentially rejected the distinction between the worldly and otherworldly. There was little sense of history. Life was marked, instead, by a timeless proximity to the mythical past and the redeeming future.[6]

Shahn entered this world, however, at the moment when its insularity was beginning to crack. Physical attacks by czarist forces increased during the final decades of the nineteenth century and the first decades of the twentieth, while new ideas contained in secular books from the West challenged the old ways of viewing the world. According to Howe, the communal and political movements that arose in the Pale during the last two decades of the nineteenth century, as well as the flowering of Yiddish poetry and fiction, were fueled by the desire of a younger generation to revitalize Jewish culture and society and take part in the twentieth century. Shahn began to sense this change through the writing and political actions of his father, who fits Howe's description of the new social type that emerged from these struggles: the self-educated worker-intellectual, schooled in both Talmud and Karl Marx, and committed to a vision of a universal humanist culture.

The involvement of Shahn's father in anti-czarist activities forced him to leave Lithuania for South Africa. From there he continued on to the United States, and in 1906 he sent for his family. Upon his arrival in New York at the age of eight, Ben Shahn was jolted out of the timelessness of the Pale and experienced an acute sense of historical consciousness: "the immigration to America worked a cataclysmic change. All the secure and settled things were not settled at all. I learned that there was a history quite apart from the intimate Biblical legends; there was an American history and a world history that were remote and unreal and concerned people who were strange to me and had nothing to do with Abraham, Isaac, and Jacob. Time was moving toward me, and time was passing away."[7]

In Shahn's three allegory paintings, American history and world history are intertwined with biblical stories and Lithuanian folktales. World War II forced Shahn to rethink the very meaning of history. It forced him to reexamine assumptions that political reform and technological progress could bring about a free and just society, assumptions that had been so dear to him during the New Deal era of the 1930s.[8]

ALLEGORY

Shahn's painting *Allegory* (plate 14, fig. 62) was included in the Whitney Museum's 1948 Annual Exhibition of Contemporary American Painting, which opened November 13. The work is dominated by a large red beast, with flaming mane, which stands guard over four small figures lying in a heap beneath its belly. The beast and human figures float in an indeterminate space. Red underpainting shows through the blues and purples of the surface layers of paint,

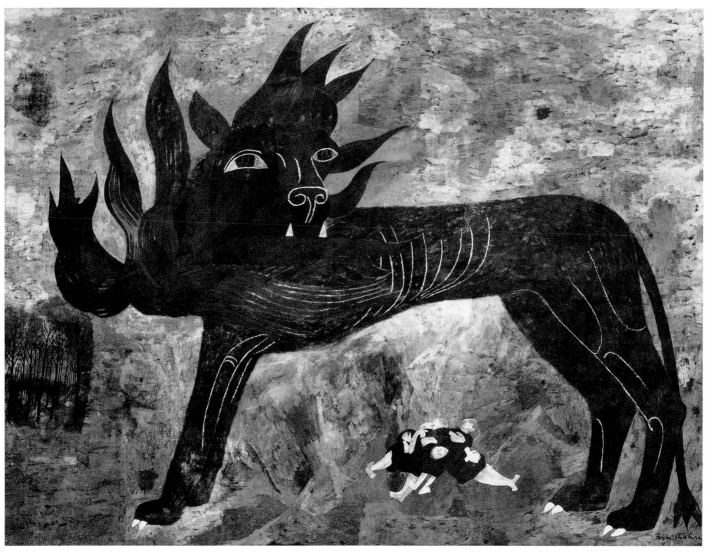

Figure 62

Allegory, 1948

Tempera on panel,

36⅛ x 48⅛ in. (91.8 x 122.2 cm)

Collection of the Modern Art Museum

of Fort Worth

Gift of Mr. W. P. Bomar, Jr.,

in Memory of Mrs. Jewel Bomar

and Mr. Andrew Chilton Phillips

suggesting the glow of a rising sun cutting through a morning fog or of a fire behind clouds of smoke. In the lower-left-hand corner, a small, precisely rendered scene of barren red trees in front of a green backdrop contrasts sharply with the absence of detail in the rest of the background. The mood is one of vigilance in the face of danger.

Henry McBride, art critic for the *New York Sun,* singled out *Allegory* and subjected it to what Shahn's biographer Selden Rodman described as "a curiously McCarthian analysis."[9] McBride admired Shahn's skill as a painter but was troubled by the politics of this painting. He claimed to discern in the bright red coloring of the beast a "subtle tribute to our quondam friend but present enemy, the Soviet Republic," and went on to comment that he had always thought the political implications in Shahn's work to be "of the shadiest. The shade often is red, and it is this time." McBride hoped that the attention of the public would focus on "the art rather than the insinuation," as he would

"certainly hate to see Ben Shahn boxed up with the Dean of Canterbury and sent away to wherever it is they send disturbers of the peace."[10]

Such attacks on art as communistic were not unusual in the 1940s and early 1950s, particularly after the cancellation of the exhibition *Advancing American Art* in April 1947. This two-part exhibition had been organized the previous year by the U.S. State Department in response to the requests of a number of foreign countries, and was traveling in Europe and Latin America at the time of the cancellation. Its recall was part of a larger attack on the entire Cultural and Information Division of the State Department by conservative congressmen such as Republican Representative Fred Buseby of Illinois. Buseby claimed that "more than twenty of the forty-five artists were definitely New Deal in various shades of communism," and cited, among others, Milton Avery, Stuart Davis, Philip Evergood, and Shahn. The fact that Shahn's painting *Hunger* (see fig. 6), included in the exhibition, had been reproduced as a poster for the Congress of Industrial Organizations' anti-Republican congressional campaign of 1946 *after* it had been purchased by the State Department further angered Republican congressional representatives. Republican congressman John Taber of New York used his position as Chair of the House Committee on Appropriations to destroy most of the State Department's cultural program by cutting the Cultural and Information Division's budget 48 percent and scuttling the entire art project.[11]

Thus, while Shahn was not unaccustomed to being labeled a "New Dealer in various shades of communism" by conservative politicians, he did not expect a similar attack from McBride, whom he had considered a friend. Eight years later, Shahn cited McBride's review and the concern it had caused him, in the opening of a lecture at Harvard in which he described in detail the origins of the painting *Allegory*. The lecture, "The Biography of a Painting," was later published in a collection of essays entitled *The Shape of Content*.[12] According to Shahn, the immediate source of *Allegory* was a Chicago tenement fire in which a black man, John Hickman, lost four of his children. The man later shot and killed the tenement landlord, whom he felt was responsible for setting the fire. A defense committee was organized by Mike Bartell of the Socialist Workers Party, Willoughby Abner, and Charles Chiakulas. Hickman pleaded innocent by reason of temporary insanity and was found guilty of manslaughter. He received two years probation.

In 1948, Shahn was commissioned to create a series of drawings to accompany an article on the Hickman case written by John Bartlow Martin for *Harper's* magazine.[13] He began by examining the factual and visual material surrounding the story, where he perceived themes of broad significance—the universal human fear of fire, pity and compassion evoked by victims of disaster,

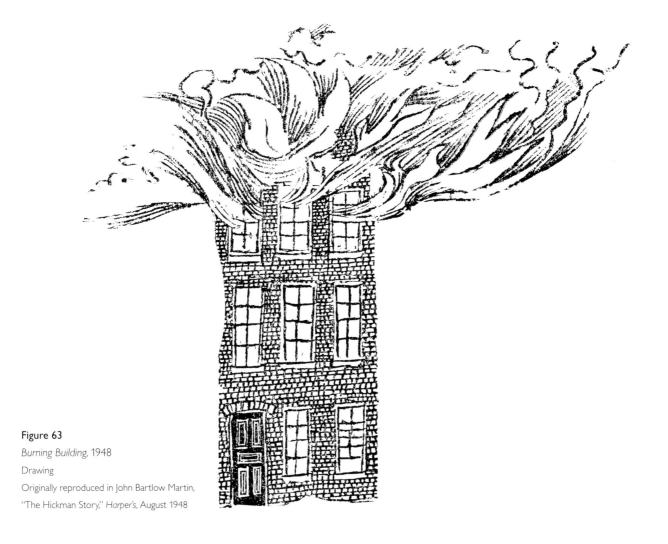

Figure 63

Burning Building, 1948

Drawing

Originally reproduced in John Bartlow Martin,

"The Hickman Story," *Harper's,* August 1948

especially children, racial injustice, poverty. Such themes, he felt, required a symbolic rather than factual representation. Yet, ultimately, he rejected this symbolic approach, for "in the abstracting of an idea one may lose the very intimate humanity of it, and this deep and common tragedy was above all things human." Shahn returned, therefore, to the familiar aspects of family life —the Hickman clothes and furniture—and on that level made his "bid for universality and for the compassion that [he] hoped and believed the narrative would arouse."[14] His drawings included the small wooden shack in Mississippi that was the Hickman home before the family moved to Chicago, a chest of drawers, and the Chicago tenement house. The drawings also included, however, one of Shahn's earlier symbolic images, a highly formalized wreath of flames that crowned the burning tenement building (fig. 63). It was this wreath of flames that evolved into the red beast of *Allegory.*

After the completion of the *Harper's* commission, Shahn wrote, the Hickman fire continued to haunt him. First, "there were the half-realized, the only intimated drawings in a symbolic direction which were lying around my stu-

dio." Second, "I had some curious sense of responsibility about it, a sort of personal involvement. I had still not fully expressed my sense of the enormity of the Hickman fire; I had not formulated it in its full proportions; perhaps it was that I felt that I owed something more to the victim himself."[15] This sense of personal involvement may have come from Shahn's own intimate experience of fire, which he acknowledged was embedded in the painting, if not also in the drawings for the *Harper's* article:

> The narrative of the fire had aroused in me a chain of personal memories. There were two great fires in my own childhood, one only colorful, the other disastrous and unforgettable. Of the first I remember only that the little Russian village in which my grandfather lived burned, and I was there. I remember the excitement, the flames breaking out everywhere, the lines of men passing buckets to and from the river which ran through the town, the madwoman who had escaped from someone's house during the confusion, and whose face I saw, dead-white in all the reflected color.
>
> The other fire left its mark upon me and all my family, and left its scars on my father's hands and face, for he had clambered up a drainpipe and taken each one of my brothers and sisters and me out of the house one by one, burning himself painfully in the process. Meanwhile our house and all our belongings were consumed, and my parents stricken beyond their power to recover.[16]

According to Rodman, the village in which his grandfather lived—Vilkomir—was also the one in which Shahn lived. And the madwoman who had escaped was his father's stepsister. Most of the village was destroyed, but the Shahn family home, located on the outskirts, was saved.[17] Although references to this early fire did not appear in the Hickman illustrations, Shahn's drawing of the tenement house topped with flames in the *Harper's* article closely resembles the Brooklyn tenement building from which he and his siblings were rescued by their father. What compelled Shahn to create *Allegory,* therefore, was not only a desire to convey in symbolic terms themes of universal significance, but also a need to grapple with his own personal fears and memories grounded in the distant past of Vilkomir and Brooklyn. The small scene of barren trees in the lower-left-hand corner of *Allegory* may well be a reference to the fires of Vilkomir, a scene clearly stamped on the impressionable mind of a child and present as a vivid memory years later.

The connection between fire and persecution is given further meaning by Shahn's use of the fire-wreath in the illustrations he created for Daniel S. Gillmor's article "Guilt by Gossip," published in the May 31, 1948, issue of the *New Republic.* Shahn illustrated this article, which discussed the threats to individual civil liberties posed by the current security mania, with an image of

a branding iron surrounded by a wreath of fire on which is printed the word "subversive."[18] Thus, McBride was not totally mistaken in discerning in the symbolic language of the painting *Allegory* a reference to the atmosphere of persecution and paranoia that was spreading throughout the nation.

Shahn's fear of wolves was another personal association embedded in the beast image in *Allegory*. "To me," Shahn writes, "the wolf is perhaps the most paralyzingly dreadful of beasts, whether symbolic or real. . . . Is my fear some instinctive strain out of my Russian background? I don't know. Is it merely the product of some of my mother's colorful tales about being pursued by wolves when she was with a wedding party, or again when she went alone from her village to another one nearby? Does it come from reading Gogol? Whatever its source, my sense of panic concerning the wolf is real. I sought to implant, or, better, I recognized something of that sense within my allegorical beast."[19]

The wolf was also associated in Shahn's mind with the well-known sculpture of the mythical founders of Rome, Romulus and Remus, being suckled by a she-wolf, which Shahn found "disconcerting" and "irritating":

> Now I found that, whether by coincidence or not I am unable to say, the stance of my imaginary beast was just that of the great Roman wolf, and that the children under its belly might also be a realization of my vague fears that, instead of suckling the children, the wolf would most certainly destroy them. But the children, in their play-clothes of 1908, are not Roman, nor are they the children of the Hickman fire; they resemble much more closely my own brothers and sisters.[20]

This combination of nurture and destructiveness in an animal who resembles both a wolf and a lion can be traced also to another aspect of Shahn's Lithuanian past. Shahn's grandfather's name was Wolf-Leyb, the Yiddish for Wolf-Lion. He was a man the young Shahn both feared and loved.

There is one other possible source for the children arranged beneath the belly of the lion-beast in *Allegory* that Shahn does not include in his essay, but which is explored by Ziva Amishai-Maisels in her article "Ben Shahn and the Problem of Jewish Identity." Amishai-Maisels has traced the children in the painting to an official United States Office of War Information (OWI) photograph of Holocaust victims (fig. 64).[21] This association adds another level of meaning to the painting, further explaining why Shahn may have felt a "curious sense of responsibility" and "personal involvement" in the Hickman story. The fire in Russia—perhaps the result of one of the many attacks on Jewish villages by Russian soldiers—the fire in Brooklyn, the fires in the crematoria of the concentration camps, and the fire in the Chicago tenement building all threaten or take the lives of innocent children and all are the result of prejudice

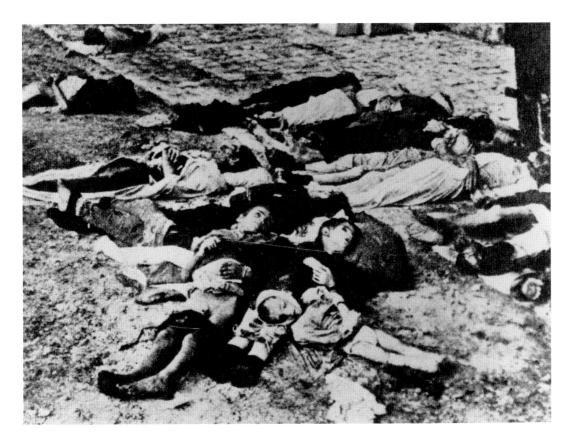

Figure 64
Photograph of Holocaust victims,
c. 1939–44

or injustice—enforced poverty, anti-Semitism, racism, genocide. *Allegory* is one
of many wartime and postwar paintings by Shahn that comment on injustice
and the destruction of war through images of children—for example, *Boy,* 1944,
Cherubs and Children, 1944 (fig. 35), and *Liberation,* 1945 (plate 8)—as well as
through the eyes of a child: much of the emotional impact of this painting relies
on the intensity of Shahn's childhood memories.

Amishai-Maisels criticizes Shahn for failing to include direct references
to the Holocaust in his postwar work. Yet she also recognizes that Shahn was
one of many artists who did not intend to depict the actual horrors of the
war and the Holocaust. Shahn wrote in "The Biography of a Painting" that
he was not seeking to create an image of a particular disaster, but rather of
"the emotional tone that surrounds disaster; you might call it the inner disas-
ter."[22] The Holocaust was certainly an "inner disaster" for all Jews, requiring
of the survivors a reservoir of spiritual strength often sustained by a return
to the ritual and lore of Judaism. According to Amishai-Maisels, the Hickman
fire awoke in Shahn "an echo of his own childhood which was itself a foretaste
of the Holocaust." It also "allowed Shahn to crystallize all his ideas on children
as innocent victims of racial oppression, and released him from the pressure
the Holocaust had placed on him." Of course, this was not a total release but
only the beginning of an attempt to come to terms not only with the fires

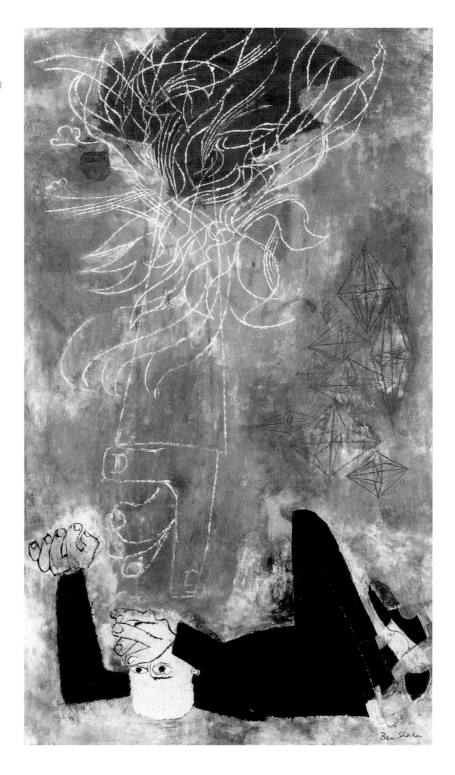

of the past but also those of the present and future. *Second Allegory* would continue these efforts.

SECOND ALLEGORY

The wolf-lion of *Allegory,* 1948 (plate 14, fig. 62), is absent in *Second Allegory,* 1953 (plate 20, fig. 65), but the fire-wreath remains, positioned in the top half

of the painting. From the center of the wreath descends a large arm and hand, the index finger pointing at and almost touching the figure of a man who lies on his back at the bottom of the painting, one arm covering his face, the other reaching upward. The fire-wreath and arm are sketchily outlined against a mottled surface of reddish-oranges of varied intensities. The transparency of the arm and wreath contrast with the solid black of the man's suit and the jagged but firm outline of his hands. Above the man's raised knee is a group of ten stereometrically drawn crystalline shapes, which appear to float in the variegated background of blues, reds, and oranges.

Shahn did not describe in writing the sources of this painting, as he had for *Allegory,* but it is possible to make a number of observations on the basis of his later works and events that took place in 1952 and 1953. Just as the fire-wreath symbolized injustice and the destructive power of fire in the first allegory painting, so, too, did it come to symbolize the destructive power and unjust use of another cataclysmic "fire"—nuclear weapons—in his later work. This association is clarified if one moves forward in time to 1960–61 and a series of paintings (plates 28–31, figs. 19–22, 36, 37, 66, 67) Shahn executed on the tragic fate of the Japanese fishing boat *The Lucky Dragon,* which in 1954 wandered into the area of the Bikini atoll where the American government was testing its new hydrogen bomb. A much more stylized fire-wreath, now containing a face with bared teeth and claws, appears a number of times in this series, which was, again, inspired by a group of drawings Shahn prepared for several articles in *Harper's* on the *Lucky Dragon* episode.[23] One of the paintings, *We Did Not Know What Happened to Us,* 1960 (fig. 66), includes not only the fire-wreath, but also the head and upraised arms of the figure in *Second Allegory.*

The fire-wreath in *Second Allegory,* therefore, could represent the destructiveness and evil of nuclear weapons. The crystalline shapes floating in space support this interpretation in several ways. Shahn often used crystalline or molecular shapes in later paintings as symbols of science or scientific research, as in *The Physicist* of 1961 (fig. 67, see also plate 25).[24] In a smaller watercolor version of *Second Allegory,* c. 1953, however, the crystalline forms are given a more specific identification (fig. 68). There are only six crystalline forms in this watercolor, and they are labeled and numbered as follows: (1) Isometric System; (2) Tetragonal System; (3) Hexagonal System; (4) Orthorhombic System; (5) Monoclinic System; and (6) Triclinic System. This labeling and numbering indicates that Shahn did not simply produce a random set of shapes, but was aware of and referring to what are known in physical chemistry as the fourteen Bravais lattices, unit cells that "generate all the possible three-dimensional crystal lattices," which, in turn, are the basis of almost every solid

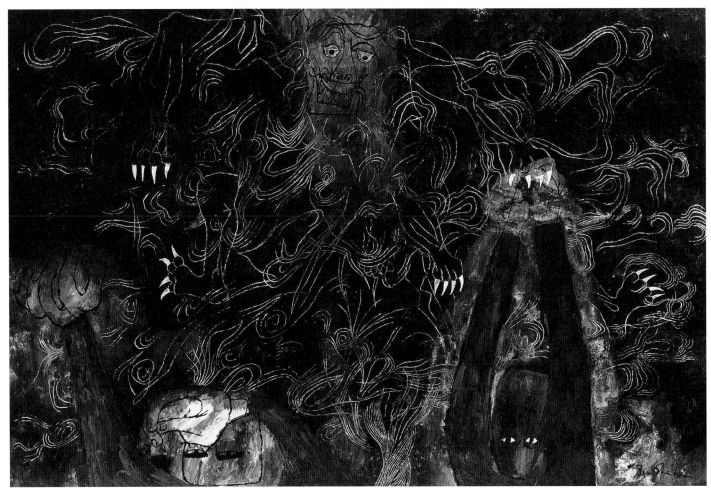

Figure 66

We Did Not Know What Happened to Us,
from the *Lucky Dragon* series, 1960
Tempera on wood,
48 × 72⅛ in. (121.9 × 183.2 cm)
National Museum of American Art,
Smithsonian Institution, Washington, D.C.
Gift of S. C. Johnson & Son, Inc.

form on earth.[25] These fourteen lattices are organized into seven classes: triclinic, monoclinic, orthorhombic, tetragonal, hexagonal, trigonal, and cubic.

While there is no obvious direct connection between Bravais lattices and nuclear research, they do represent, in broader terms, the symmetry and balance found in the solid forms of the natural world. They are the building blocks of matter, the basic units, the universal language. They represent what is destroyed by atomic and hydrogen bombs. In the tempera painting, Shahn removed the labels found in the watercolor, but retained the symmetry and rectilinearity of the shapes, which contrast with the curvilinear, chaotic lines of the firewreath. The natural order of the world revealed through the abstract language of science is thus contrasted in this work with the disorder or chaos caused by that same science.

The fire-enshrouded arm could also signify aspects of the spiritual rather than the material world. Bernarda Bryson Shahn suggests that the flames in this image represent the fires of hell.[26] Yet, in discussing a later work by Shahn that also depicts a hand emerging from a wreath of flames, Avram Kampf notes that the fire "symbolizes the presence of the Lord while the hand refers to His

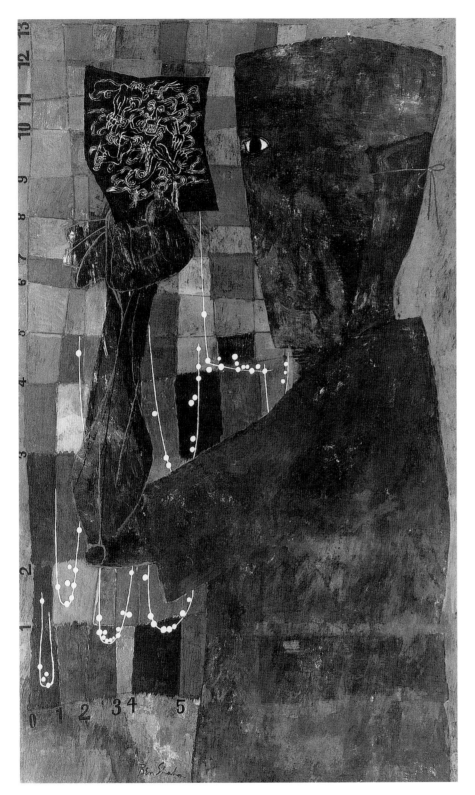

Figure 67
The Physicist,
from the *Lucky Dragon* series, 1961
Tempera on panel,
52 × 31 in. (132.1 × 78.7 cm)
Private collection

creative power and His intervention in the affairs of man."²⁷ Certainly, many
European artists during the sixteenth and seventeenth centuries used the image
of a hand emerging from the clouds to represent the presence of God. Shahn
himself portrayed the hand of God in the series of Haggadah illustrations he
produced in 1931. The fire-wreath is not present in the watercolor version of

Figure 68

Second Allegory, c. 1953
Watercolor on paper,
22¾ × 15 in. (57.9 × 38.1 cm)
Private collection

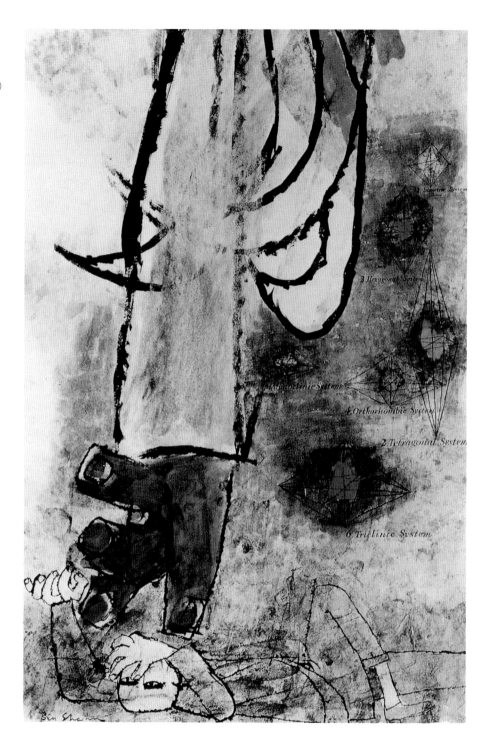

Second Allegory (fig. 68); instead, feather shapes descend along the arm, suggesting the wings of an angel. In the tempera painting, however, Shahn rejected the angel association in favor of the more all-encompassing fire of God (fig. 65).

The pointed finger also carries with it the association of condemnation or judgment. In response to the third plague—that of gnats—visited on Egypt by God because of the Pharaoh's refusal to release Israel from bondage, Pharaoh's magicians said to him: "This is the finger of God" (Exodus 8:19). This theme of judgment could easily have had secular connotations in the early 1950s. In 1952,

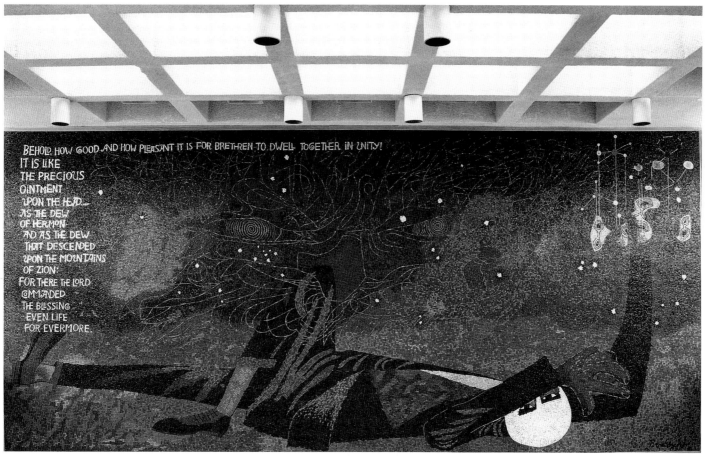

The mural text reads:

BEHOLD, HOW GOOD AND HOW PLEASANT IT IS FOR BRETHREN TO DWELL TOGETHER IN UNITY!
IT IS LIKE
THE PRECIOUS
OINTMENT
UPON THE HEAD...
AS THE DEW
OF HERMON
AND AS THE DEW
THAT DESCENDED
UPON THE MOUNTAINS
OF ZION:
FOR THERE THE LORD
COMMANDED
THE BLESSING
EVEN LIFE
FOR EVERMORE.

Figure 69
Alternatives, 1963
Mosaic mural
Hollis F. Price Library,
LeMoyne-Owen College, Memphis, Tennessee

Shahn signed a petition protesting the conviction of the leaders of the American Communist Party. During the same year, he designed the program booklet for the off-Broadway play *The World of Sholom Aleichem,* which provided employment for some of the hundreds of people "fingered" by Senator Joseph McCarthy's House Committee on Un-American Activities. On February 27, 1953, Shahn and his wife Bernarda were interviewed by two FBI agents who questioned them about their alleged communist sympathies and Communist Party activities in New Jersey.[28] The hand, therefore, could represent McCarthy or his committee "fingering" an alleged Communist, and the figure on the ground their hapless victim. If, however, the hand is that of God, then the figure being condemned could be McCarthy himself, or others who promoted the Red Scare hysteria of the 1950s. Thus, the force of spiritual authority intervenes to redirect the processes of both politics and science toward more just ends—or, at the very least, to punish those who fail to follow this path.

In a later mosaic mural titled *Alternatives,* installed in 1963 in the Hollis F. Price Library of LeMoyne College in Memphis, Tennessee (fig. 69), Shahn repeated the figure from *Second Allegory,* positioning him in reverse, with his hand clutching a complex molecular structure (see also plate 19). The fire-

wreath and hand are replaced by the intense eyes of an all-powerful being or force, surrounded by flames. An abbreviated version of Psalm 133 appears in the upper-left portion of the painting, beginning with the words "Behold how good and how pleasant it is for brethren to dwell together in unity!" This message of integration was certainly taken to heart by LeMoyne College's African-American students and by all those who, like Shahn, supported the civil rights movement. The knitted brow and staring eyes contrast with the biblical verse envisioning harmony among brothers, suggesting the struggles involved in achieving and maintaining integration, or the wrath that would be incurred if such struggles were not undertaken.

If the all-powerful force represented by the face in the mural is that of God, then its positioning next to the molecular structure suggests the relationship between the material and the spiritual. But, as in *Second Allegory,* it is not clear exactly how Shahn is defining this relationship. The ambiguity implicit in the mural is echoed in a passage from Shahn's small book *Paragraphs on Art,* published in 1952. Shahn wrote that he had "no quarrel with scientific skepticism as an attitude," for it provided "a healthy antidote to fanaticism of all kinds."

> But as a philosophy or a way of life it is only negative. It is suspicious of belief. It negates positive values. Aesthetically, it refuses to commit itself.
>
> For society cannot grow upon negatives. If man has lost his Jehovah, his Buddha, his Holy Family, he must have new, perhaps more scientifically tenable beliefs, to which he may attach his affections. Perhaps Humanism and Individualism are the logical heirs to our earlier, more mystical beliefs. . . . But in any case, if we are to have values, a spiritual life, a culture, these things must find their imagery and their interpretation through the art.[29]

Second Allegory and the LeMoyne College mural can be seen as expressions of Shahn's search for "more scientifically tenable beliefs," for a more individualistic or humanistic spirituality.

Shahn was certainly not alone in such a search. In 1950, the leftist journal *Partisan Review* published a four-part symposium entitled "Religion and the Intellectuals." "One of the most significant tendencies of our time," wrote the editors William Phillips and Philip Rahv, "especially in this decade, has been the turn toward religion among intellectuals and the growing disfavor with which secular attitudes and perspectives are now regarded in not a few circles that lay claim to the leadership of culture."[30] One of the contributors to this symposium, the art historian Meyer Schapiro, observed that "with the immense accomplishment of science and technology, social life is full of profound anxieties. The chief carriers of assurance—industry and the state—are among the

greatest source of fear. The fact that freedom and security were passionately expected and not achieved has made the reaction against the disappointing ideologies of progress all the more bitter."[31] Schapiro, like the majority of participants in the *Partisan Review* symposium, saw the turn to religion that resulted from these profound social anxieties as a mistake. Those who hoped to find a source of moral order within organized religion were deluding themselves, they believed, for organized religion had just as often been the source of wars and massacres as of peace and well-being. "We are therefore confident," writes Schapiro, "that all who are genuinely concerned with the liberty of the individual and the achievement of a humane life for the entire community will sooner find the means through a socialist outlook than through religion."[32]

For Shahn, socialism was not a realistic option for the United States in the early 1950s. As late as 1948 he still hoped that Roosevelt's social reform ideals could be revived under Henry Wallace and the Progressive Party. But the anti-communist hysteria of the period ensured the defeat of Wallace and the removal of the Progressive Party as a viable political alternative. Shahn then returned to the Democratic Party, supporting Adlai Stevenson in the 1952 presidential campaign.[33]

Shahn's renewed interest in religious symbols and questions of spirituality did not manifest itself in a return to the synagogue or other organized religious practice. Instead, this interest was, according to Shahn's widow Bernarda Bryson Shahn, "curiously unparochial; he still rejected all personal identification with sect or creed. He deeply appreciated the observances, the ritual and lore of his inherited Judaism but also was profoundly moved by the sonorous Masses of Catholicism and, again, by the tough spirit of early Protestantism."[34] But this general interest in religion can also be seen as part of a larger attempt by American Jews to come to terms with the annihilation of European Jewry. Barbara Kirshenblatt-Gimblett writes that during and after World War II American Jews, faced with the fact that efforts to assimilate had failed to stem anti-Semitism, began to celebrate the distinctiveness of Jewish life, particularly in the East European culture from which most American Jews stemmed. Maurice Samuel's 1943 publication *The World of Sholom Aleichem* was one such celebration. *Life Is with People: The Culture of the Shtetl* by Mark Zborowski and Elizabeth Herzog, published in 1952, the same year as the off-Broadway production of *The World of Sholom Aleichem,* was another. These and other books and plays took part in the creation of what Kirshenblatt-Gimblett calls "Holocaust memory." They portrayed not the horrors of the Holocaust, but the world that had been destroyed. They spoke, as did Shahn in *Love and Joy about Letters,* of a set of daily rituals and an inner life that together constituted an historically distinc-

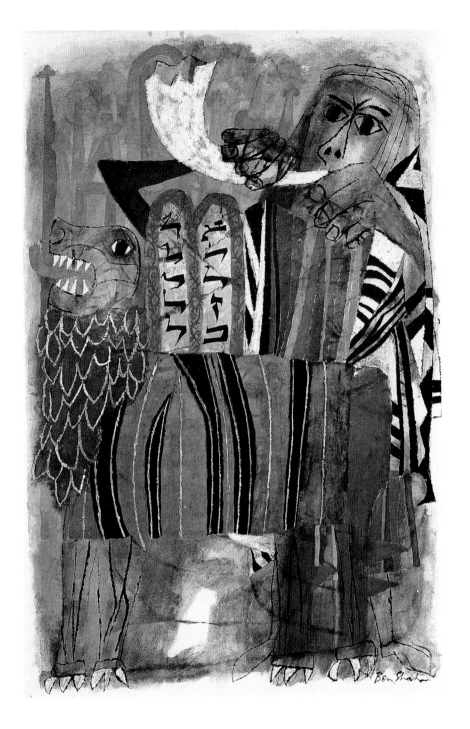

tive Jewish culture. Shahn's visual explorations of Judaism can also be seen as attempts to recover and commemorate the world that was lost. "[I]t was now a moral requirement," writes Kirshenblatt-Gimblett, "that this world [of six million Jews] not suffer a double death, first by disappearing with its creators and then by fading from the memory of those who survived."[35]

In the face of the Holocaust—and of Hiroshima and Nagasaki—Shahn attempted to maintain a political and artistic practice that refused to give in to either blind faith or scientific skepticism, one that acknowledged the complexity of the contemporary world and the enormity of genocide and loss of life

during World War II without being immobilized by that complexity and loss. Such concerns informed Shahn's final allegory painting.

THIRD ALLEGORY

In *Third Allegory,* 1955 (plate 24, fig. 70), a figure with furrowed brow, draped in a prayer shawl, blows a ram's horn, or shofar. In front of him stands a lion-like beast, reminiscent of the beast in *Allegory.* Although the fire-wreath is absent, the beast's rear legs are marked by flamelike projections. Its teeth are bared, and on its back rest the two arched tablets of Moses with their two columns of Hebrew. The letters on the right tablet are the initial letters of the first five commandments; those on the left are variations of the same letter, *lamed,* which represents the Hebrew word *lo,* or "thou shalt not," the intro-ductory phrase of the last five commandments. The man and beast assume an aggressive posture, suggesting a defiant declaration and defense of the laws of Moses by the Jewish people. While the shofar is used in religious ceremonies, it also had a secular use—to sound a warning of invading forces, to call the people to assembly, or to assemble Jewish soldiers for an attack on their ene-mies. The aggressive posture could therefore signify a defense of physical place —represented perhaps by the golden towers of Jerusalem—or, more generally, the defense of the nation or people.

In a 1955 letter to Shahn regarding the purchase of *Third Allegory* for the Jewish Center of Buffalo, Kathryn Yochelson refers to it as the painting "show-ing the arc [*sic*] brought by oxen into the tabernacle."[36] Shahn himself con-firmed this identification of the subject matter in a note penciled on a letter from J. Strassberg of *Wisdom* magazine the following year.[37] For Shahn, the story of the transport of the ark had a special personal meaning. In an interview with the art critic John D. Morse in 1944, Shahn stated:

> In Russia I went to a Jewish school, of course, where we really read the Old Testament. That story was about the ark being brought into the temple, hauled by six white oxen, and balanced on a single pole. The Lord knew that the people would worry about the ark's falling off the pole, so to test their faith He gave orders that no one was to touch it, no matter what happened. One man saw it beginning to totter, and he rushed to help. He was struck dead. I refused to go to school for a week after we read that story. It seemed so damn unfair. And it still does.[38]

The event described by Shahn is a slightly altered version of a passage found in II Samuel 6:1–15, which relates an attempt by David to bring the ark to his city in a cart pulled by oxen and driven by Uzzah and Ahi'o, the sons of Abin'adab.

When the oxen stumbled, Uzzah put out his hand to steady the ark and was struck dead. The Levites later carried the ark successfully on their shoulders to Jerusalem. The Lord had designated the tribe of Levi to carry the ark (Deuteronomy 10:8); thus, no others were to touch it "lest they die" (Numbers 4:15). Such an explanation was obviously insufficient for the young Shahn, who saw only injustice in the death of Uzzah. (David was also both angered and frightened by Uzzah's death.) The tall pole appears to have come from I Kings 8:8, where, in a description of how the ark was carried into the Temple of Solomon, we are told that the poles of the ark "were so long that the ends of the poles were seen from the holy place before the inner sanctuary; but they could not be seen from outside."

Although the biblical narratives of the ark's transport, as interpreted by the impressionable young Shahn, evoked for him the themes of injustice and death, the absence in *Third Allegory* of specific symbols such as the fire-wreath of *Allegory* and *Second Allegory* produces a lesser visual emphasis on destruction and condemnation. Even the deep red of the lion-beast is subdued by the blue and black blanket thrown across its back.[39] What dominate, instead, are the bright colors and patterns of the robe and blanket, the golden glow of the arches and trefoils, the vibrant energy of the tablets' curvilinear red borders, and the play of sharply incised lines and textile patterns. The golden towers could well be a reference to Jerusalem, or more particularly the Temple of Solomon, whose entire inner sanctuary was both overlaid with and filled by gold (I Kings 6:20–32), an echo of the gold-covered ark itself (Exodus 25:11–13).

While Shahn claims *Third Allegory* is about the transport of the ark into the temple, he has obviously not presented a literal image of this event. The animal resembles a lion rather than an ox. The object on its back is not the ark, which contained the tablets of Moses, but the tablets themselves. How, therefore, are we to read this painting? What, in fact, is the "something 'other'" intended by Shahn's allegory? Perhaps the meaning of this painting can be discerned in the intersection of the spiritual and the political, specifically in the founding of the state of Israel.

In November 1947, the United Nations divided the territory then known as Palestine, controlled by the British, into Jewish and Arab states. By May of the following year, the British had withdrawn, and on May 14, 1948, the state of Israel was proclaimed. War soon erupted between Israel and its Arab neighbors, and it was waged both on the battlefield and in the marketplace. The Arab economic blockade and Egypt's refusal to allow ships carrying Israeli goods to pass through the Suez Canal increased Israeli dependence on outside aid, in particular from the United States. In 1951, Shahn illustrated an ad in the February 5

issue of *Time* magazine entitled "Wine, diamonds, ships, prayer shawls and you," encouraging investment by individuals and corporations in the state of Israel (fig. 71).[40] The text of the ad emphasized the "vibrant sense of work and hope" of the new state and listed its agricultural and industrial accomplishments. The manufacture of prayer shawls received particular attention:

> Ponder this latter item—Prayer Shawls—and regard it as the imponderable item in the modern miracle of Israel! For in a material world, in a world of technological fantasies, these Prayer Shawls are not merely religious symbols, but the symbols of a great spiritual heritage . . . the indestructible substance which has defied the fires of history for over twenty centuries.

In the ad, Shahn depicted a prayer shawl draped over the back of a chair.

The symbolism of the prayer shawl articulated in this ad for the state of Israel may well have struck a chord with Shahn. Nationhood—community—required more than material goods or "technological fantasies." It required a spiritual heritage embodied in objects such as the prayer shawl and able to "defy the fires of history." (Few would have missed the reference to the Holo-

caust, one of the most devastating fires in Jewish history, or to Israel's recent War of Independence.) Such a prayer shawl, marker of "a great spiritual heritage [and] indestructible substance," subsequently finds its way into *Third Allegory,* draped over the head and shoulders of the standing figure. As he did in *Allegory* and *Second Allegory,* Shahn has taken an image developed for a commercial assignment relating to a specific historical situation and abstracted it from that history, placing it in a painting in which references to specific events are absent or ambiguous. The viewer is left with the emotional tone of the painting and with a desire to unearth the allegorical meaning evoked by its title.

There is little evidence recording Shahn's attitude toward Israel. Although he contributed drawings to this and other Israeli ad campaigns,[41] he never visited the country, despite an offer of free passage on the Israeli luxury liner for which he executed two large mosaic murals in 1963–64.[42] Also, he did not discuss Israel in his many published books and articles. Yet he could not have been unaware of the debates that arose in the United States as a result of the founding of Israel. He lived in Roosevelt, New Jersey, a predominantly Jewish community where the political and religious allegiances of residents ranged from Orthodox to communist, and where heated discussions about Israel undoubtedly took place—whether it should exist at all; whether it should be a binational state of Jews and Palestinians; to what extent American Jews should support or pledge loyalty to the new nation.[43] Shahn also probably knew of art critic Clement Greenberg's 1950 article "Self-Hatred and Jewish Chauvinism." While Greenberg opposed Jewish chauvinism and nationalism, he claimed to understand why they existed. The Holocaust certainly justified a desire on the part of Jews to have nothing to do with Gentiles. Yet, "not all Gentiles are anti-Semites," Greenberg writes. "No matter how necessary it may be to indulge our feelings about Auschwitz, we can do so only temporarily and privately; we certainly cannot let them determine Jewish policy either in Israel or outside it."[44]

Ziva Amishai-Maisels identifies at least one painting by Shahn that, she believes, includes a reference, although indirect, to Israel—*Sound in the Mulberry Tree,* 1948 (fig. 72), executed in the same year as *Allegory,* also the year that the state of Israel was officially proclaimed. *Sound in the Mulberry Tree* was one of Shahn's first postwar paintings to feature Hebrew letters in a prominent position. The painting appears, at first glance, to be a colorful memory of childhood life in the city. Yet the Hebrew scroll read by the young girl contributes another level of meaning to the work. The inscription is taken from II Samuel 5:24, which recounts David's final defeat of the Philistines after being crowned king: "And let it be, when thou hearest the sound of a going in the tops of the

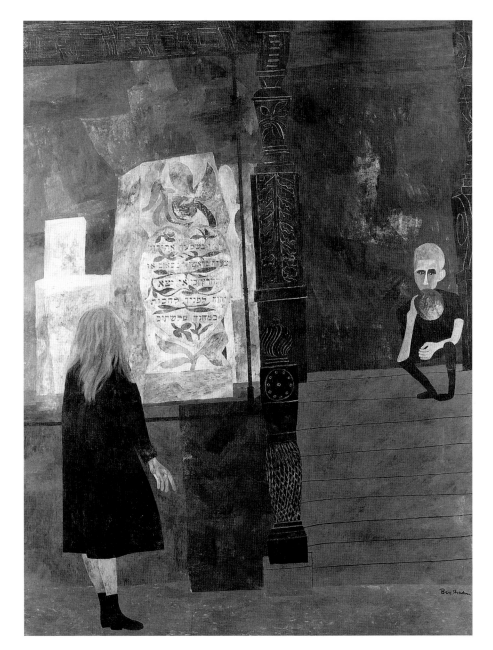

Figure 72

Sound in the Mulberry Tree, 1948
Tempera on canvas on panel,
48 × 36 in. (121.9 × 91.4 cm)
Smith College Museum of Art,
Northampton, Massachusetts
Purchased 1948

mulberry trees, that thou shalt bestir thyself: for then shall the Lord go out be-
fore thee, to smite the host of the Philistines." The art critic and curator James
Thrall Soby interpreted the painting as a call to arms against Republican Repre-
sentative George Dondero of Michigan and his "philistine" attacks on modern
art as communistic.[45] But Amishai-Maisels sees the text, with its prominent
Hebrew letters, as a reference to the recently founded state of Israel and its
War of Independence.

The passage from II Samuel in *Sound in the Mulberry Tree* immediately pre-
cedes the description of the transport of the ark and the death of Uzzah that
had so upset the young Shahn. There is, then, at least a textual connection be-
tween this 1948 painting and *Third Allegory,* and a strong possibility that both

paintings comment in allegorical terms on the birth of the modern state of Israel. There is also another passage from the Bible, Joshua 6:12–14, in which the shofar and the ark are specifically associated with the attack on the city of Jericho by Joshua and his army: "Then Joshua rose early in the morning, and the priests took up the ark of the LORD. And the seven priests bearing the seven trumpets of rams' horns before the ark of the LORD passed on, blowing the trumpets continually; and the armed men went before them, and the rear guard came after the ark of the LORD, while the trumpets blew continually."

Shahn's early years of Bible study and his renewed interest in biblical texts in the late 1940s—he was given the fourteen-volume Soncino Bible in the early 1950s by his friend Morris [Moishe] Bressler[46]—would certainly suggest he was familiar with this and other passages that refer to the ark and shofar.

Herbert May and Bruce Metzger note in their discussion of II Samuel 6:1–15 in *The Oxford Annotated Bible* that "David wished to add to the prestige of Jerusalem by making it a religious, as well as a political and military center. Hence it was particularly appropriate for him to bring there the ark, the sacred object of the northern tribes, and now the symbol of the national God."[47] The ark, like the prayer shawl and golden towers of Jerusalem, symbolizes both nation and religion. That Shahn uses a lion, emblem of the tribe of Judah and thus by implication the state of Israel, rather than the ox, adds to the nationalist iconography.

The significance of the ark of the covenant in Jewish history cannot be underestimated. "The worship of the nation," write May and Metzger, "revolved around the ark of the covenant, which was the monument of God's presence among his people."[48] The ark's power to create fear in the enemies of Israel is evident throughout the Bible:

> And whenever the ark set out, Moses said, "Arise, O LORD, and let thy enemies be scattered; and let them that hate thee flee before thee." (Numbers 10:35)

> When the ark of the covenant of the LORD came into the camp, all Israel gave a mighty shout, so that the earth resounded. And when the Philistines heard the noise of the shouting, they said, "What does this great shouting in the camp of Hebrews mean?" and when they learned that the ark of the LORD had come to the camp, the Philistines were afraid; for they said, "A god has come into the camp." (I Samuel 4:5–7)

Third Allegory (plate 24, fig. 70) certainly conveys the challenge of the words of Numbers 10:35 and the sense of a journey about to be undertaken. The state of Israel represented the beginning of a new era for the Jewish people, the first time in two thousand years that they were able to constitute themselves as a

sovereign nation. This sense of a new beginning is also embodied in the shofar, which plays a key role in the ceremonies surrounding Rosh Hashanah, the Jewish New Year. The shofar is sounded every day during the month prior to Rosh Hashanah and one hundred times in traditional Rosh Hashanah services, with one long blast at the end of Yom Kippur, the Day of Atonement.[49]

According to the medieval Jewish sage Maimonides, these blasts on the shofar are moral wake-up calls for Jews who, during the High Holy Days, are encouraged to seek forgiveness from those they have wronged (*Mishneh Torah, Yad Teshuvah* 3:4). Thus the shofar signifies, within the High Holy Days tradition, repentance and forgiveness. It would not be unlike Shahn to feel conflicted about the actions of Israel, to recognize the need for a Jewish state but also to acknowledge the pain and loss of the Palestinian people. The Lord who guides the Jews to Canaan is also the Lord who strikes Uzzah dead.

EPILOGUE: THIRD ALLEGORY AND THE VATICAN

From April 1983 through February 1984, the exhibition *The Vatican Collections: The Papacy and Art* toured the United States, opening in New York, then traveling to Chicago and San Francisco. The works in the exhibition were grouped in the order in which they were commissioned or collected, rather than chronologically, thus providing a history of papal patronage. Included in the section representing the most recent addition to the Vatican Museums—the collection of contemporary religious art—was the painting *Third Allegory* (plate 24), the only work by an American artist in the entire exhibition.

The Museum of Contemporary Religious Art was opened on June 23, 1973, by Pope Paul VI. Its organization actually began, however, on May 7, 1964, when this same pope called a meeting of artists in the Sistine Chapel and appealed to them to help reestablish the fruitful collaboration between artists and the Church that had marked earlier times. There was a need, the Pope felt, to cast off rules that had been imposed on artists over the years, and that had resulted in tired repetitions of the past rather than free inventiveness.[50]

This call for a casting off of old rules was issued in the spirit of the Second Vatican Council, convened by Pope John XXIII in October 1962 and sustained under his successor Pope Paul VI through December 1965. The purpose of the Council, according to Pope John XXIII, was not only to preserve the deposit of faith inherited from the past, but also to adapt the Church to present-day needs and to work actively toward "the fulfillment of the mystery of unity" with other Christians and non-Christians.[51] With regard to the latter, the Council issued a declaration affirming the Church's roots in the Hebrew Bible

and its ties to the Jewish people, affirming that what happened in Christ's Passion cannot be charged against all Jews then alive or against Jews today, and that all displays of anti-Semitism are to be deplored.[52]

Third Allegory is one of several works by Shahn in the Vatican Museum. Their presence can be explained, in part, by the fact that Lawrence Fleischman, director of New York's Kennedy Galleries and the dealer for the Shahn estate during the 1970s, was vice-president of the Committee of Religion and Art in America. Headed by Terence Cardinal Cooke, the Committee was founded as a tax-exempt organization in 1971 to select art for the new Vatican collection. In an article in *Art News* in 1974, Fleischman recalled that on their first visit to the United States in 1971, the Pope's representatives Monsignor Pasquale Macchi and Bishop Paul Marcinkus took an interest in the work of Shahn and Leonard Baskin on a visit to the Museum of Modern Art, which then led them to him.[53] They undoubtedly would have known of Shahn prior to their visit to the United States, for he was an extremely popular artist in Italy during this time, with a major retrospective exhibition at the National Gallery of Modern Art in Rome in the spring of 1962. In the introductory essay to the catalogue, Maurizio Calvesi, curator of the exhibition, presented Shahn in terms well suited to the call for unity being issued at the same time by Pope John XXIII. The message of Shahn, according to Calvesi, was a message of love, brotherhood, and peace, one that recalled the message of Christ. The art of Ben Shahn plants its roots not in recent history but in the older Jewish and Christian civilizations: "Ben Shahn has the Bible in his mind and the Gospel in his heart."[54]

The inclusion of Shahn's stylistically modern and thematically Jewish painting *Third Allegory* in the Vatican exhibition thus can be understood in the context of the Catholic Church's reevaluation of Church doctrine. Shahn also issued his own calls for unity in several of the works he created during the last decade of his life. In his 1959 mosaic mural *The Call of the Shofar* (fig. 73), which includes a version of the figure blowing the shofar from *Third Allegory,* Shahn inserted a passage from Malachi 2:10 running in Hebrew letters across the top of the composition: "Have we not all one father? Hath not one God created us? Why do we deal treacherously every man against his brother, to profane the covenant of our father?" Beneath the shofar are five profile heads marked by different skin tones and representing the peoples of the world (see also plate 26). In 1963, the year immediately following the opening of Vatican II, Shahn included in his mural *The Tree of Life,* for the Israeli luxury liner SS *Shalom,* a quote from the writings of the second-century Greek scholar Maximus of Tyre: "Let men know what is divine. Let them know. That is all. If a Greek is stirred to the remembrance of God by the art of Pheidias, an

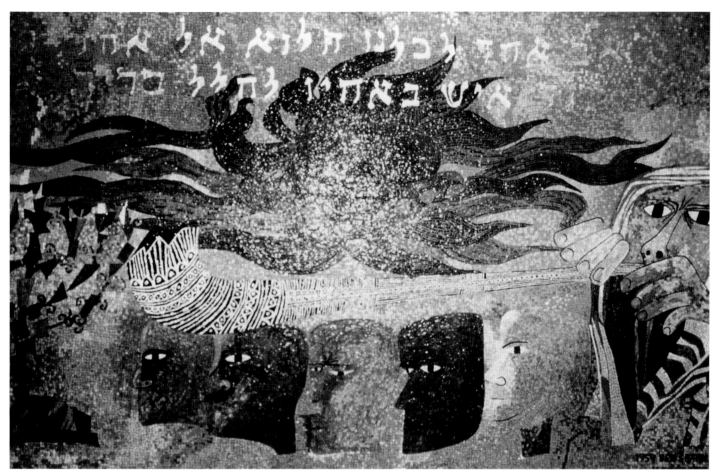

Figure 73
The Call of the Shofar, 1959
Mosaic mural
Vestibule, The Temple Congregation
Ohabai Sholom,
Nashville, Tennessee

Egyptian by paying worship to animals, another man by a river, another by fire, have no anger for their divergences. Only let them know. Let them love. Let them remember."

By the early 1960s, Shahn had seen a world torn apart by World War II and the Holocaust, and a nation torn apart by the Cold War and the civil rights movement. He also watched with trepidation the escalation of the war in Vietnam. He responded on the one hand with contributions of time and money to political causes that fought against racism, militarism, and nuclear weapons; on the other, he created images inspired by the tragic deaths of innocent people in the flames of burning tenement buildings, crematoria, and nuclear firestorms, and by the words of second-century Greek scholars and Hebrew prophets calling for tolerance, justice, and new beginnings. Such words encapsulated, for Shahn, the larger moral issues at the heart of these contemporary causes, issues of culture and values increasingly ignored by politicians and military leaders. In 1951, Shahn set forth a challenge that still has meaning today:

> [I]f either art or society is to survive the coming half-century, it will be necessary for
> us to reassess our values. The time is past due for us to decide whether we are a moral

people, or merely a comfortable people, whether we place our own convenience above the life-struggle of backward nations, whether we place the sanctity of enterprise above the debasement of our public. If it falls to the lot of artists and poets to ask these questions, then the more honorable their role. It is not the survival of art alone that is at issue, but the survival of the free individual in a civilized society.[55]

Notes

1. "Allegory," in *Encyclopaedia Judaica*, vol. 2 (Jerusalem: Keter, 1971), 642. The *New Catholic Encyclopedia*, vol. 1 (New York: McGraw Hill, 1967), 320, differs from this definition, stating that allegory "is an extension of symbol (not of metaphor, as has been commonly supposed)." "Allegorical Interpretation," in *The Jewish Encyclopedia*, vol. 1 (New York: Funk and Wagnalls, 1901), 403.

2. See Stephen Polcari's essay in this catalogue, as well as Cécile Whiting, *Antifascism in American Art* (New Haven: Yale University Press, 1989).

3. Ben Shahn, "The Biography of a Painting," in *The Shape of Content* (Cambridge: Harvard University Press, 1957), 40–41, 45, 47.

4. Ibid., 47.

5. Ben Shahn, *Love and Joy about Letters* (New York: Grossman Publishers, 1963), 5.

6. Irving Howe, *World of Our Fathers* (New York: Harcourt Brace Jovanovich, 1976).

7. Shahn, *Love and Joy,* 10.

8. For more information on Shahn's involvement in President Franklin D. Roosevelt's New Deal arts programs, see the essay by Diana L. Linden in this book as well as Linden's "The New Deal Murals of Ben Shahn: The Intersection of Jewish Identity, Social Reform, and Government Patronage" (Ph.D. diss., City University of New York, 1997), and Frances K. Pohl, *Ben Shahn: New Deal Artist in a Cold War Climate, 1947–1954* (Austin: University of Texas Press, 1989).

9. Selden Rodman, *Portrait of the Artist as an American, Ben Shahn: A Biography with Pictures* (New York: Harper and Brothers, 1951), 39.

10. Henry McBride, "The Whitney Museum Show—Has One Picture the Dean of Canterbury Would Just Love," *New York Sun,* 1948, Ben Shahn Papers, Museum of Modern Art, New York. The Dean of Canterbury, the Very Reverend Dr. Hewlett Johnson, was well-known for his support of progressive causes. For example, he attended the All-Union Peace Conference held in Moscow August 25–27, 1949.

11. For more on the State Department exhibition, see Pohl, *Ben Shahn, 33–37.*

12. Shahn, *Shape of Content.* The essays in this collection were presented at Harvard as the Charles Eliot Norton Lectures in 1956 and 1957.

13. John Bartlow Martin, "The Hickman Story," *Harper's* 197 (August 1948): 39–52.

14. Shahn, "The Biography of a Painting," 28.

15. Ibid.

16. Ibid., 29–30.

17. See Rodman, *Portrait of the Artist,* 175.

18. Daniel S. Gillmor, "Guilt by Gossip," *New Republic,* May 31, 1948, 27. The head of the lion in *Allegory* also appeared on the cover of the November 1948 anniversary cultural supplement of *Jewish Life.*

19. Shahn, "The Biography of a Painting," 32.

20. Ibid., 32–33.

21. Ziva Amishai-Maisels, "Ben Shahn and the Problem of Jewish Identity," *Jewish Art* 12–13 (1986–87): 304–19. See also Ziva Amishai-Maisels, *Depiction and Interpretation: The Influence of the Holocaust on the Visual Arts* (Oxford: Pergamon Press, 1993). The random disordered piling of bodies was used by George Segal to commemorate the Holocaust in his sculpture, *The Holocaust,* 1982. Such piles, shown in many postwar photos and newsreels, provide striking images of contempt for life and for the sacredness of death.

22. Shahn, "The Biography of a Painting," 32.

23. Ralph E. Lapp, "The Voyage of the Lucky Dragon," *Harper's* 206 (December 1957): 27–36; 207 (January 1958): 48–55; 207 (February 1958): 72–79.

24. See also the painting *Helix and Crystal,* 1957, the serigraph *Scientist,* 1957, and the mosaics *Atomic Table,* 1963–64, and *Tree of Life,* 1963–64.

25. Donald A. McQuarrie and John D. Simon, *Physical Chemistry, a Molecular Approach* (Sausalito, Calif.: University Science Books, 1997), 1186. I would like to thank my colleague Dr. Fred Grieman for explaining Bravais lattices and suggesting possible symbolic references.

26. Bernarda Bryson Shahn, *Ben Shahn* (New York: Harry N. Abrams, 1972), 257.

27. Avram Kampf, *Contemporary Synagogue Art: Developments in the United States, 1945–1965* (Philadelphia: The Jewish Publication Society of America, 1966), 134. Kampf was referring to Shahn's mosaic entitled *The Call of the Shofar,* completed in 1959 for the vestibule of Temple Ohabai Sholom in Nashville, Tennessee. The hand appears again in Shahn's design of 1965 for a stained glass window with an inscription from Job 38:4–7 for Temple Beth Zion in Buffalo, New York.

28. For more on the FBI's surveillance of Shahn, see Pohl, *Ben Shahn,* 120–25.

29. Ben Shahn, *Paragraphs on Art* (Spiral Press, 1952), n.p.

30. "Religion and the Intellectuals: Editorial Statement," *Partisan Review* 27 (February 1950): 103. The symposium was continued in the March, April, and May–June issues.

31. Meyer Schapiro, "Religion and the Intellectuals," *Partisan Review* 27 (April 1950): 331. I would like to thank Deborah Martin Kao for bringing this *Partisan Review* symposium to my attention.

32. Ibid., 339.

33. For more information on Shahn's involvement with Henry Wallace and the Progressive Party, see Pohl, *Ben Shahn: New Deal Artist.*

34. Shahn, *Ben Shahn,* 257.

35. Barbara Kirshenblatt-Gimblett, "Introduction," in *Life Is with People: The Culture of the Shtetl,* rev. ed. (New York: Schocken Books, 1995), xi. Kirshenblatt-Gimblett calls into question the accuracy of the presentation of East European Jewish towns as closely bound, timeless communities found in *Life Is with People* and, by extension, in Howe's *World of Our Fathers* and Shahn's own writing. She argues, instead, that many East European Jewish towns in the nineteenth century were part of a complex market economy with ties not only to each other, but to a larger, non-Jewish world. The timeless shtetl, according to Kirshenblatt-Gimblett, was for the writers of *Life Is with People* "a textual way to achieve coherence, totality, and authority in the representing of East European Jewish culture" (xxxiii). That the myth of the timeless shtetl had such immediate and long-lasting popularity is testimony to its ability to help a generation of American Jews deal with their sense of loss in the aftermath of the Holocaust. I would like to thank Susan Chevlowe for bringing Kirshenblatt-Gimblett's Introduction to my attention.

36. Kathryn Yochelson to Ben Shahn, September 27, 1955, Ben Shahn Papers, Archives of American Art, Smithsonian Institution, Washington, D.C., Roll D148:1011.

37. J. Strassberg to Ben Shahn, July 11, 1956, Ben Shahn Papers, Archives of American Art, Roll D148:874. The penciled note reads, "3rd Allegory—arc [sic] into Temple."

38. John D. Morse, "Ben Shahn: An Interview," *Magazine of Art* 37 (April 1944): 136.

39. The blue of the blanket may be a reference to the color of the cloth used to cover the ark, the altar, and other objects, according to Numbers 4:5–15. Blue stripes also often appear in prayer shawls (see Numbers 15:37–41), and are part of the flag of the modern state of Israel.

40. "Wine, diamonds, ships, prayer shawls and you—State of Israel," *Time,* February 5, 1951, 44–45.

41. Daniel DeKoven to Ben Shahn, n.d., Ben Shahn Papers, Archives of American Art, Roll D144:9. In this letter, DeKoven informs Shahn that his poster design for an "Israeli and Their Land" bond-buying campaign has been rejected because it was felt that the young girl gave "the distinct impression of want and suffering . . . rather than a sense of bold, self-confidence or a courageous people."

42. The luxury liner SS *Shalom* was built by the Zim Israel Navigation Company. For more information on the two murals, see Frances K. Pohl, *Ben Shahn* (Rohnert Park, Calif.: Pomegranate Artbooks, 1993), 29–30.

43. For a summary of these various debates and others that took place in the United States see "Zionism," *Encyclopaedia Judaica,* vol. 16, 1030–1162. For more on Shahn and Roosevelt, N.J., see Pohl, *Ben Shahn: New Deal Artist,* 82–97.

44. Clement Greenberg, "Self-Hatred and Jewish Chauvinism," *Commentary* 10 (November 1950): 429. For a fuller discussion of Greenberg's article, see Matthew Baigell, *Jewish-American Artists and the Holocaust* (New Brunswick, N.J.: Rutgers University Press, 1997), 21–23. Meyer Schapiro also wrote in 1950 that "[i]n the short period of the existence of the state of Israel, the orthodox synagogue has placed obstacles in the way of science and personal freedom in the name of Biblical revelation" (Schapiro, "Religion and the Intellectuals," 334).

45. James Thrall Soby, "A Going in the Mulberry Trees," *Saturday Review,* July 2, 1949, 30–31. For a discussion of George Dondero's attacks on modern art as communistic, see Pohl, *Ben Shahn: New Deal Artist,* 72–77.

46. Sylvia Zenia Wiener, "Footnote to the Ben Shahn Exhibition," *Light* [Temple Israel] 24 (Fall 1976): 7. My own guide in my biblical readings has been Rabbi Devorah Jacobson, whose valuable comments and corrections have been incorporated into this essay.

47. Herbert G. May and Bruce M. Metzger, eds., *The New Oxford Annotated Bible* (New York: Oxford University Press, 1973), 382.

48. Ibid., 1537.

49. See "Shofar," *Encyclopaedia Judaica,* vol. 14, 1442–47.

50. The Vatican Museums, *The Vatican Collections, The Papacy and Art* (New York: Metropolitan Museum of Art and Harry N. Abrams, 1983), 23–25.

51. For a general overview of Vatican Council II, see R. F. Trisco, "Vatican Council II," *New Catholic Encyclopedia,* vol. 14, 563–72.

52. For a discussion of the reception of Vatican II, see Giuseppe Alberigo, Jean-Pierre Jossua, and Joseph A. Komonchak, eds., *The Reception of Vatican II* (Washington, D.C.: The Catholic University of America Press, 1987).

53. David L. Shirey, "The U.S. Committee of Religion and Art: 'We are not after plastic Madonnas,'" *Artnews* 73 (Summer 1974): 24.

54. Maurizio Calvesi, "Ben Shahn," in *Ben Shahn,* exh. cat. (Rome: De Luca Editore, 1962), 11. Author's translation.

55. Ben Shahn, "The Future of the Creative Arts," *University of Buffalo Studies* 19 (February 1952): 127–28. Shahn presented this article as a talk the previous year at the Niagara Convocation in Buffalo, N.Y.

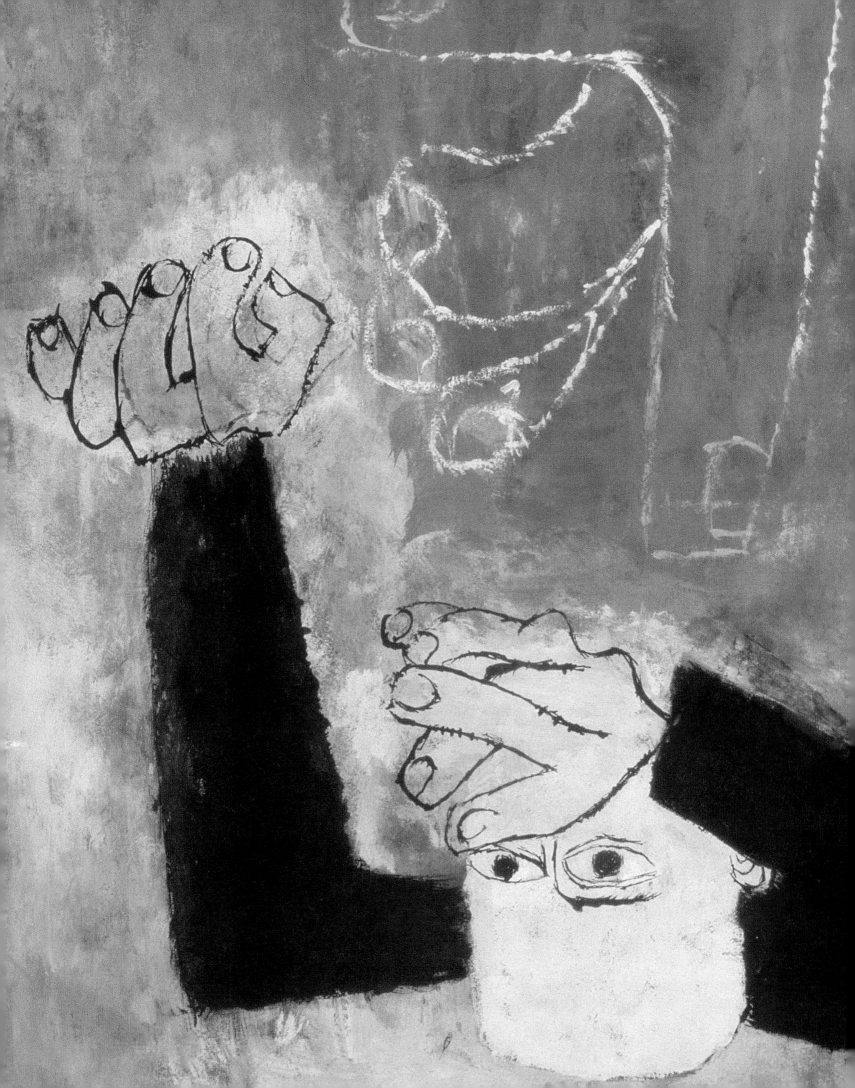

COLOR PLATES

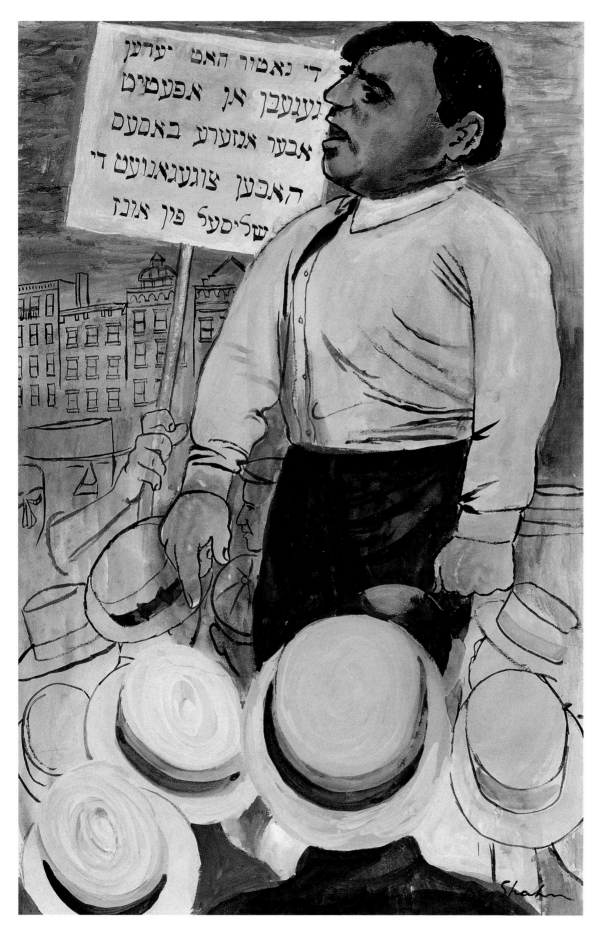

Plate 1

East Side Soap Box
(Study for Jersey Homesteads Mural), 1936
Gouache on paper,
18½ × 12¼ in. (47.0 × 31.1 cm)
The Jewish Museum, New York
Museum purchase with funds provided by
Deana Bezark, in memory of Leslie Bezark;
and by Mrs. Jack N. Berkman;
Susan and Arthur Fleischer;
Dr. Jack Allen and Shirley Kapland Fund;
Hanni and Peter Kaufmann; Hyman L. and
Joan C. Sall; and the Bequest of
Margaret Goldstein, 1995-61

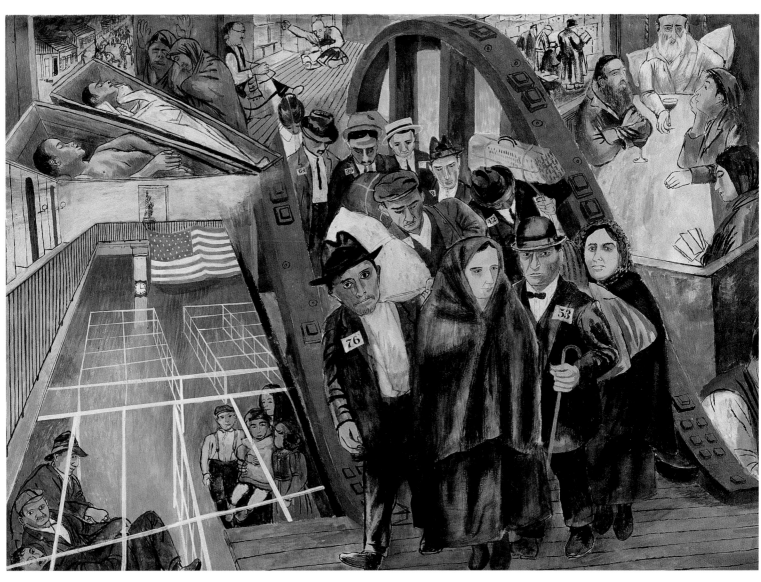

Plate 2

Study for Jersey Homesteads Mural, c. 1936
Tempera on paper on Masonite,
19½ × 27½ in. (49.5 × 69.9 cm)
Collection of Merrill C. Berman

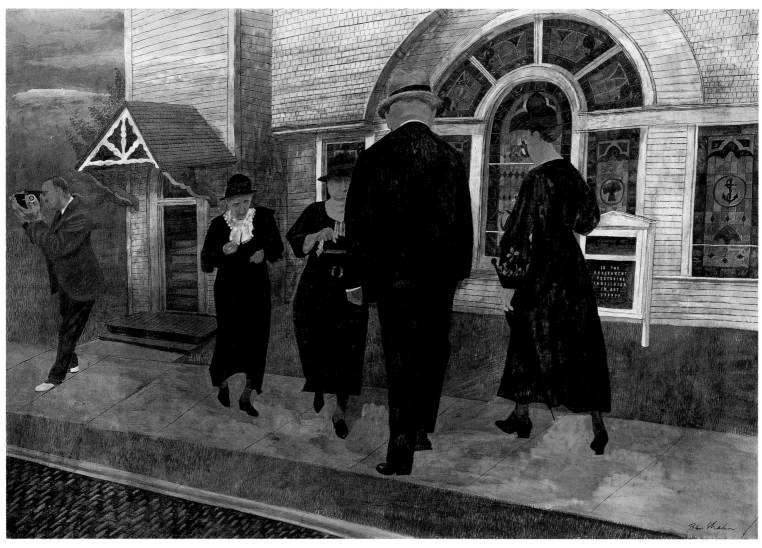

Plate 3

Myself Among the Churchgoers, 1939
Tempera on Masonite,
20 × 29½ in. (50.8 × 74.9 cm)
Curtis Galleries, Minneapolis, Minnesota

Plate 4

Portrait of Myself When Young, 1943

Tempera on cardboard,

20 × 27⅞ in. (50.8 × 70.8 cm)

The Museum of Modern Art, New York

Purchase

Plate 5
Italian Landscape, 1943–44
Tempera on paper, 27½ × 36 in. (69.8 × 91.4 cm)
Collection Walker Art Center, Minneapolis,
Minnesota. Gift of the T. B. Walker Foundation,
Gilbert M. Walker Fund, 1944

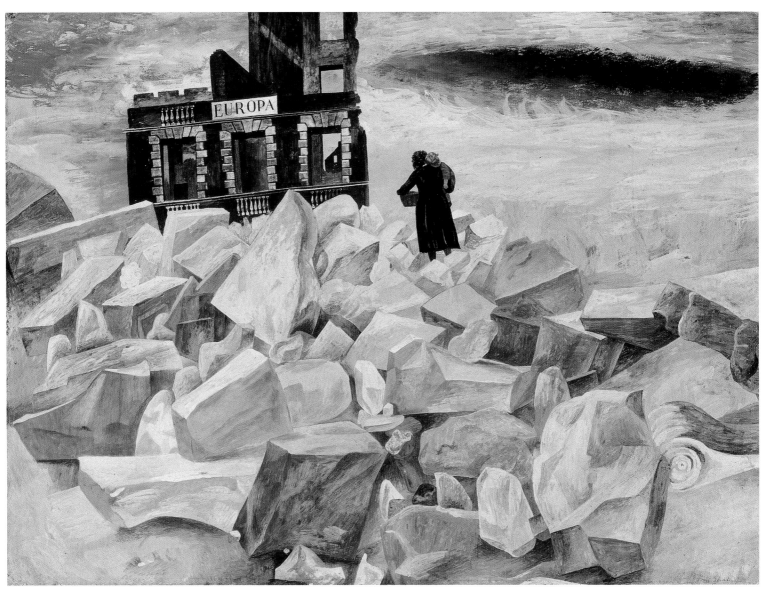

Plate 6
Italian Landscape II: Europa, 1944
Tempera on board, 22½ × 30 in. (57.2 × 76.2 cm)
Collection of the Montgomery Museum of Fine Arts,
Montgomery, Alabama. The Blount Collection

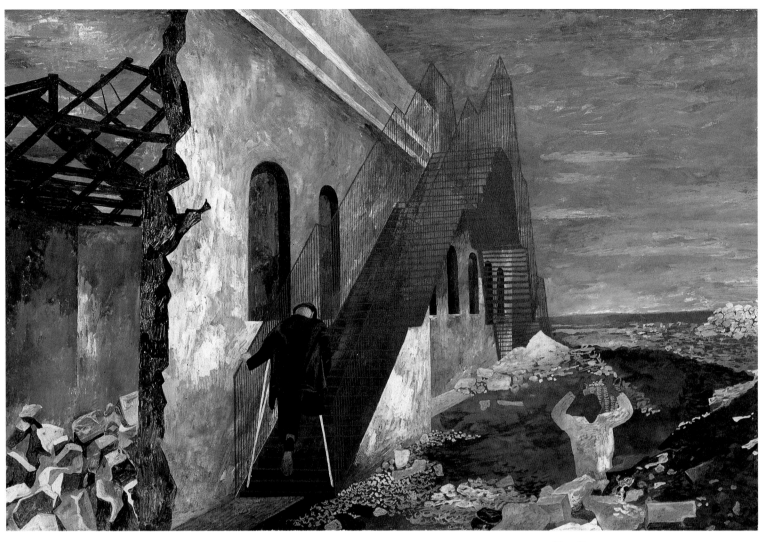

Plate 7

The Red Stairway, 1944

Tempera on Masonite, 16 × 23⁵⁄₁₆ in. (40.6 × 60.9 cm)

The Saint Louis Art Museum

Purchase

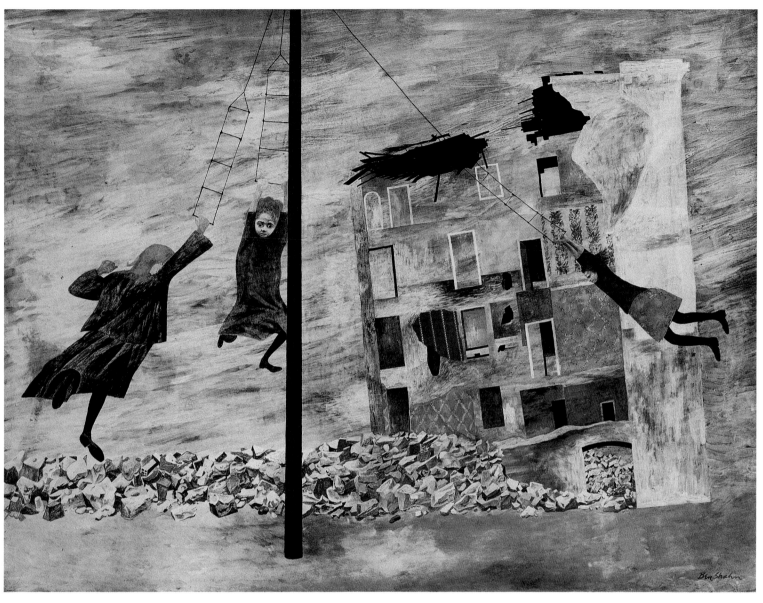

Plate 8
Liberation, 1945
Tempera on cardboard mounted on composition board,
29¾ × 40 in. (75.6 × 101.6 cm)
The Museum of Modern Art, New York
James Thrall Soby Bequest

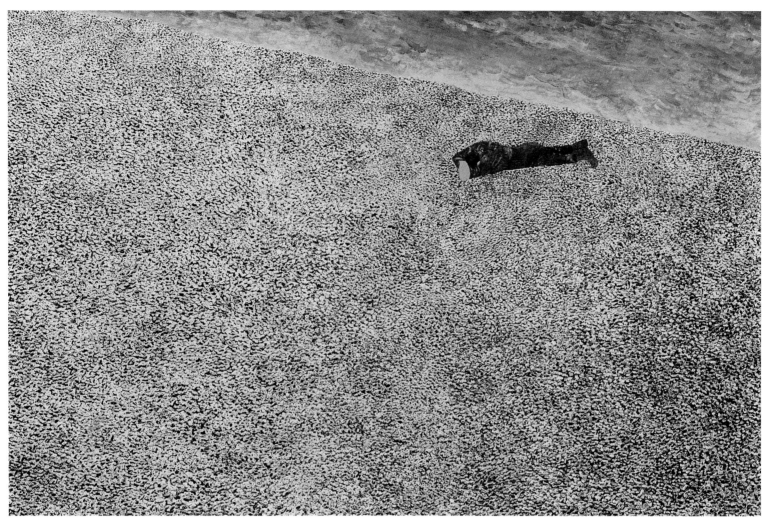

Plate 9
Pacific Landscape, 1945
Tempera on paper mounted on composition board,
25¼ × 39 in. (64.1 × 99.1 cm)
The Museum of Modern Art, New York
Gift of Philip L. Goodwin

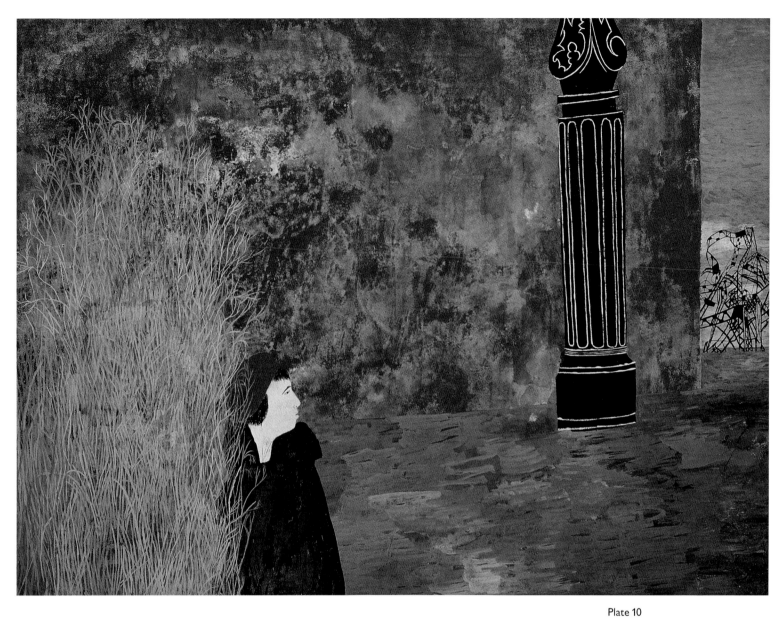

Plate 10

Renascence, 1946

Gouache on Whatman hotpressed board,

21⅞ × 30 in. (55.6 × 76.2 cm)

Fred Jones Jr. Museum of Art,

The University of Oklahoma, Norman

State Department Collection

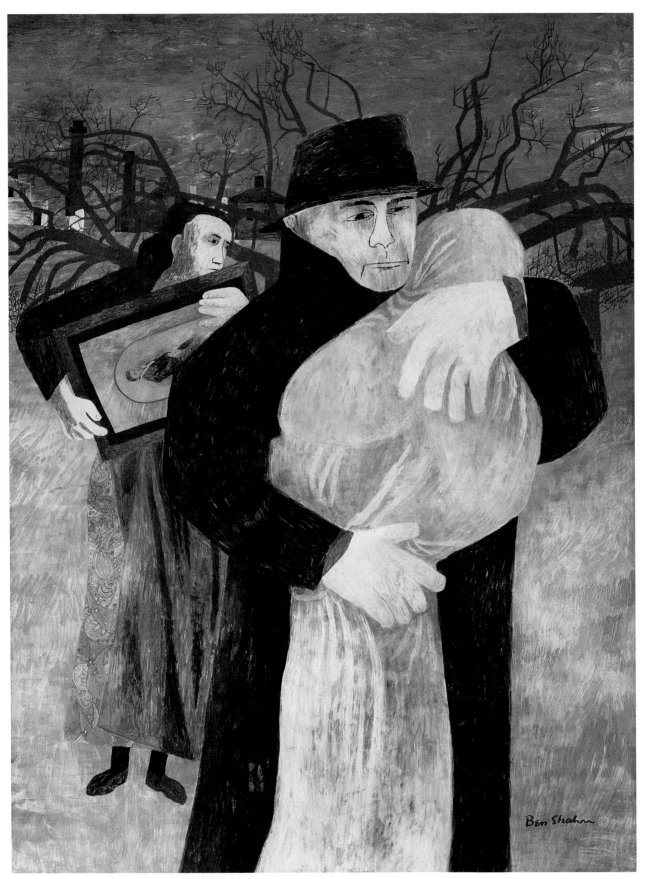

Plate **11**

Father and Child, 1946

Tempera on cardboard, 39⅞ × 30 in. (101.5 × 76.2 cm)

The Museum of Modern Art, New York

Gift of James Thrall Soby

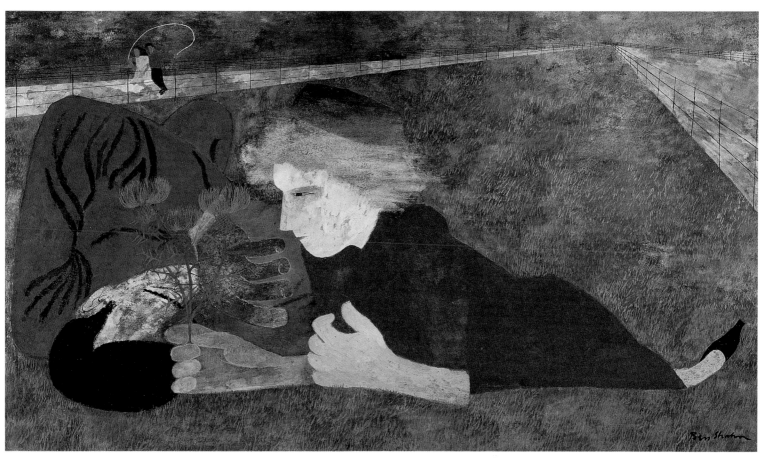

Plate 12

Spring, 1947

Tempera on Masonite, 17 x 30 in. (43.2 x 76.2 cm)

Albright-Knox Art Gallery, Buffalo, New York

Room of Contemporary Art Fund, 1948

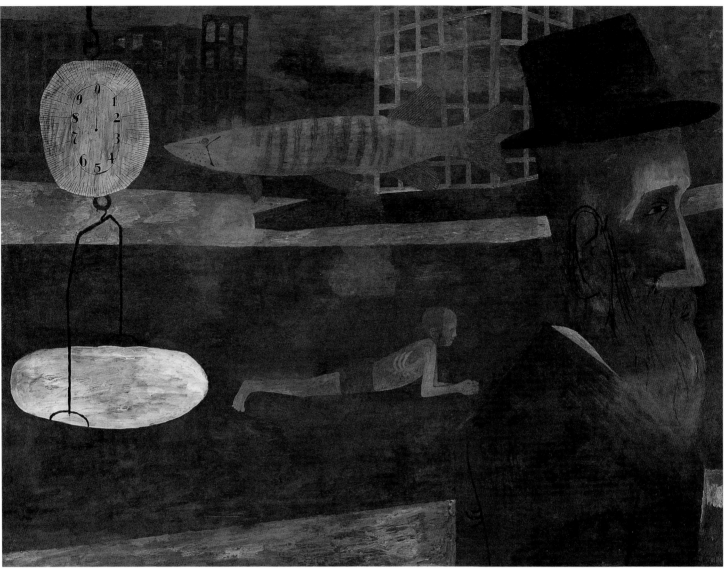

Plate 13

New York, 1947

Tempera on paper mounted on panel, 36 × 48 in. (91.4 × 121.9 cm)

The Jewish Museum, New York

Museum purchase with funds provided by the Oscar and Regina Gruss

Charitable and Educational Foundation, 1996-23

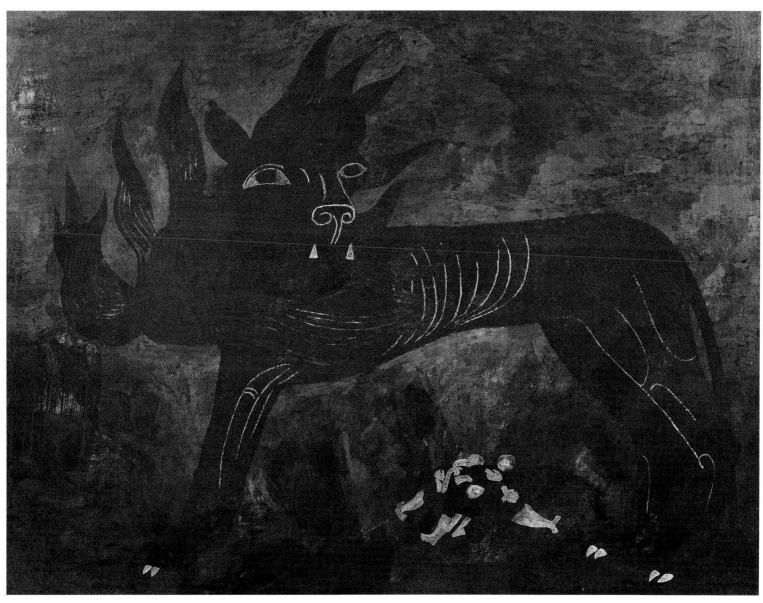

Plate 14
Allegory, 1948
Tempera on panel, 36⅛ × 48⅛ in. (91.8 × 122.2 cm)
Collection of the Modern Art Museum of Fort Worth
Gift of Mr. W. P. Bomar, Jr., in Memory of Mrs. Jewel Bomar
and Mr. Andrew Chilton Phillips

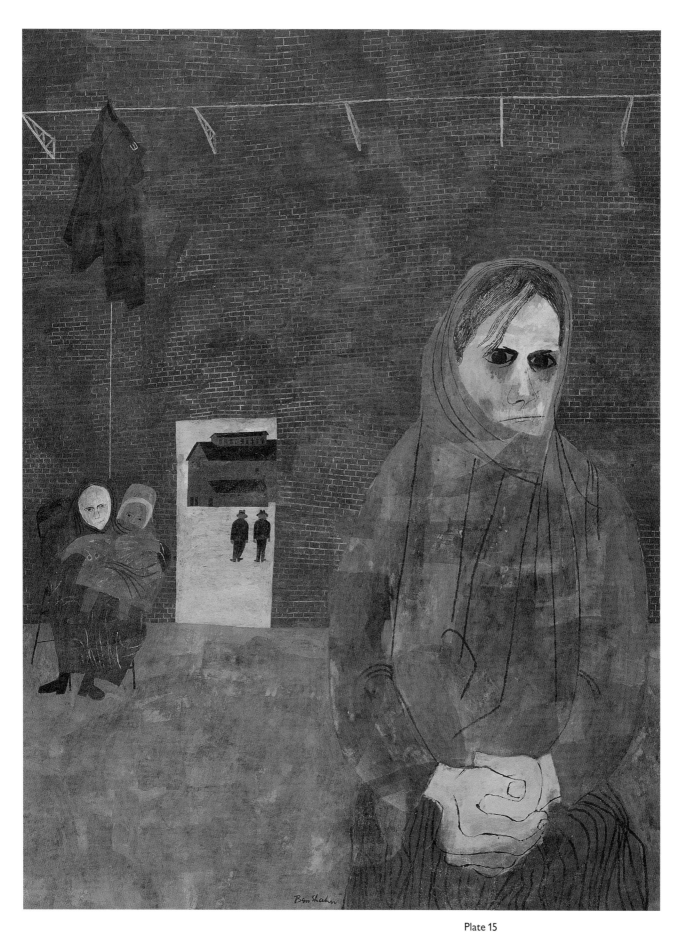

Plate 15

Miners' Wives, 1948

Egg tempera on board, 48 × 36 in. (121.9 × 91.4 cm)

Philadelphia Museum of Art

Gift of Wright S. Ludington

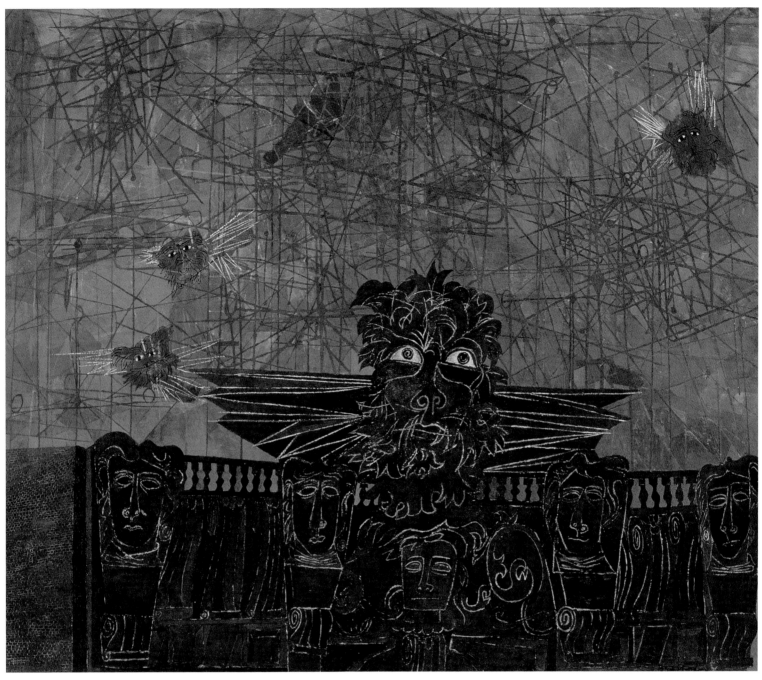

Plate 16

The City of Dreadful Night, 1951

Tempera and gouache on board, 47⅝ × 56 in. (121 × 142.4 cm)

Fukushima Prefectural Museum of Art, Japan

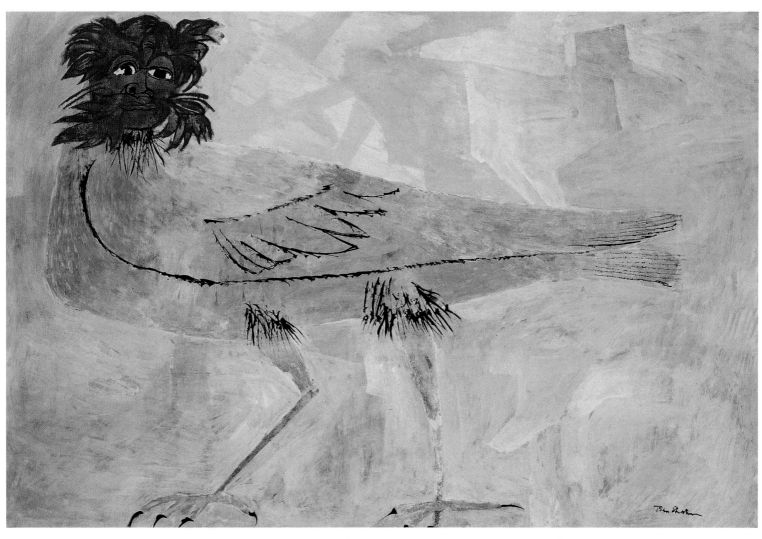

Plate 17

Harpy, 1951

Tempera and gouache on paper; 25 × 38 in. (63.5 × 96.5 cm)

Collection of Mrs. Robert B. Mayer, Chicago

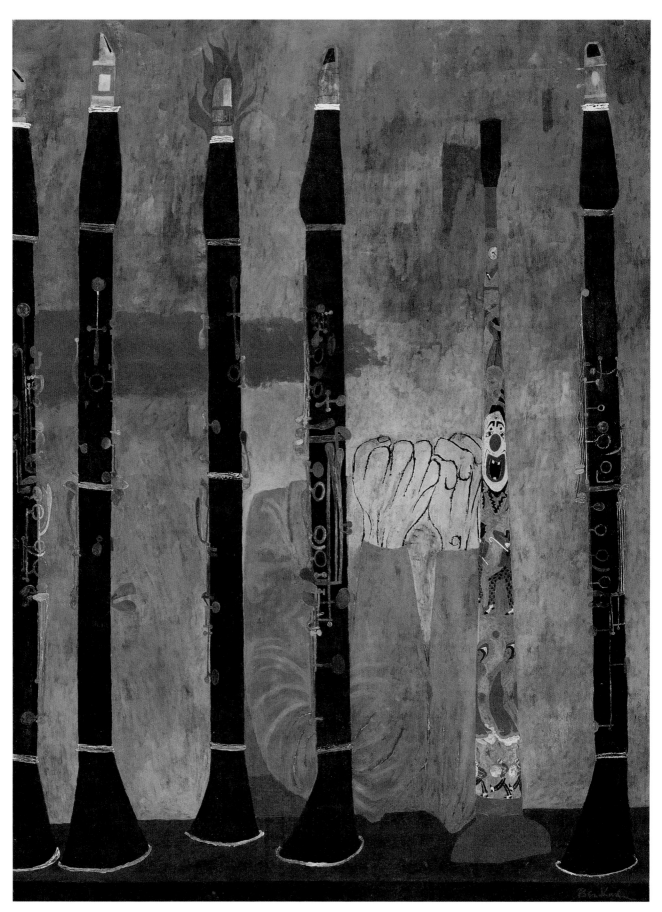

Plate 18

Composition for Clarinets and Tin Horn, 1951

Tempera on panel, 48 × 36 in. (121.9 × 91.4 cm)

The Detroit Institute of Arts. Founders Society Purchase,

Friends of Modern Art Fund

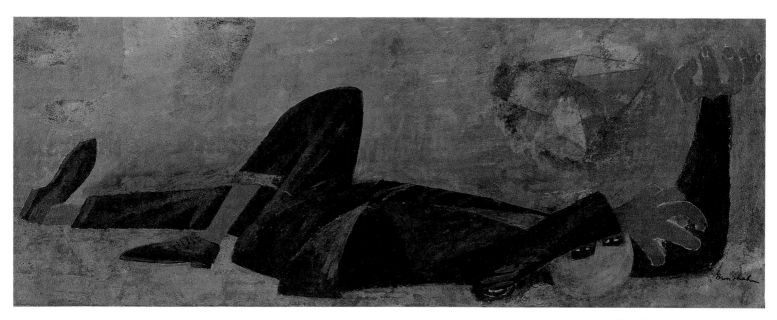

Plate 19

Man, 1952

Tempera on canvas mounted on board,

8 × 21 in. (20.3 × 53.3 cm)

Private collection, Japan

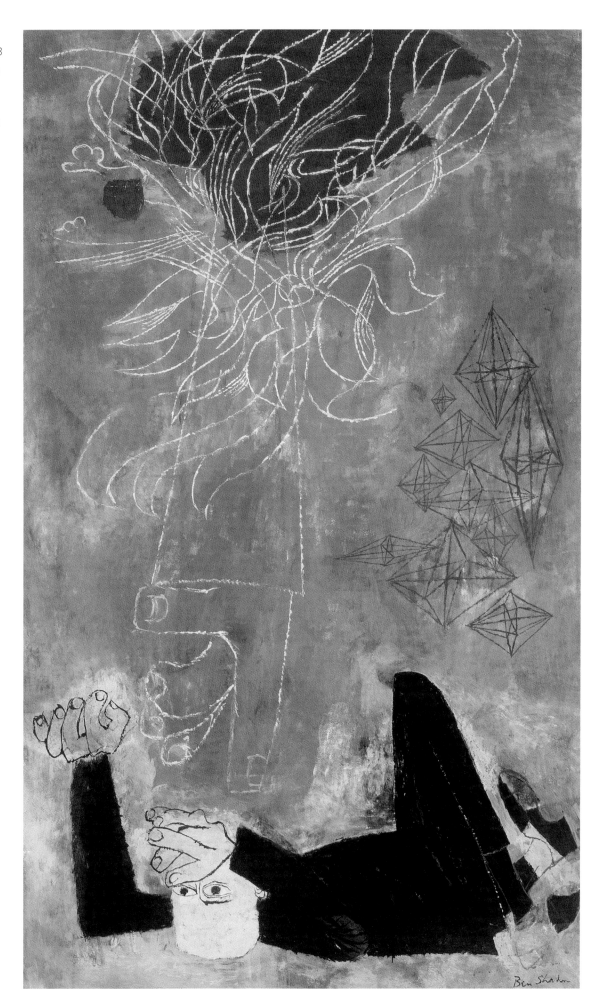

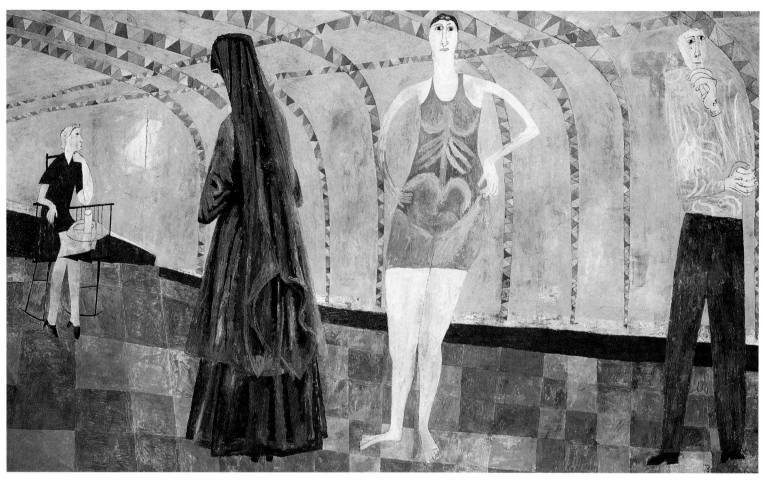

Plate 21

Age of Anxiety, 1953

Tempera on paper mounted on fabric mounted on fiberboard,

31 × 51⅞ in. (78.7 × 131.9 cm)

Hirshhorn Museum and Sculpture Garden,

Smithsonian Institution, Washington, D.C.

Gift of Joseph H. Hirshhorn Foundation, 1966

Plate 22

Bookshop: Hebrew Books,
Holy Day Books, 1953
Tempera on wood panel,
27 × 20 in. (68.58 × 50.8 cm)
The Detroit Institute of Arts
Gift of John S. Newberry

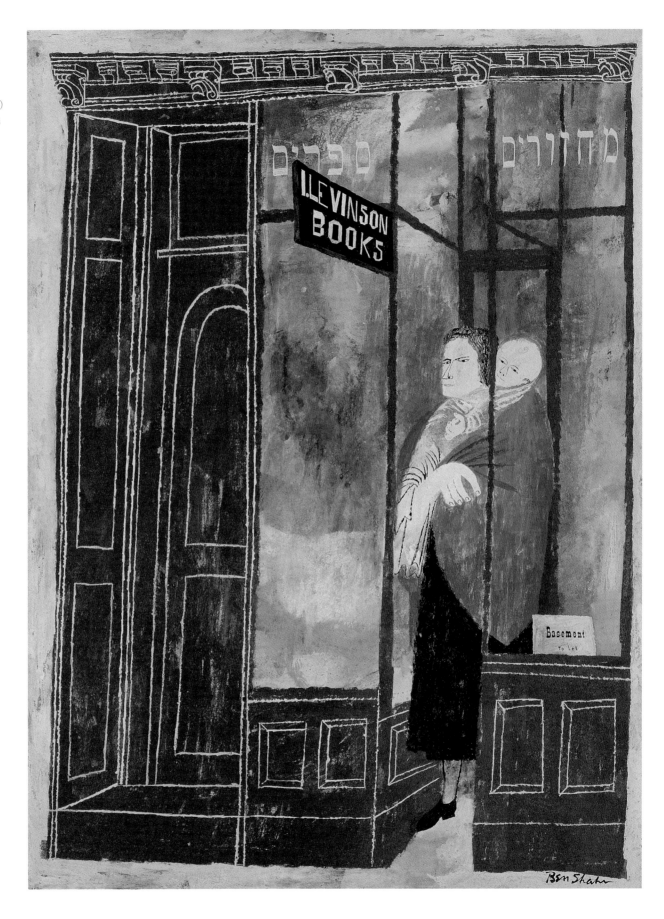

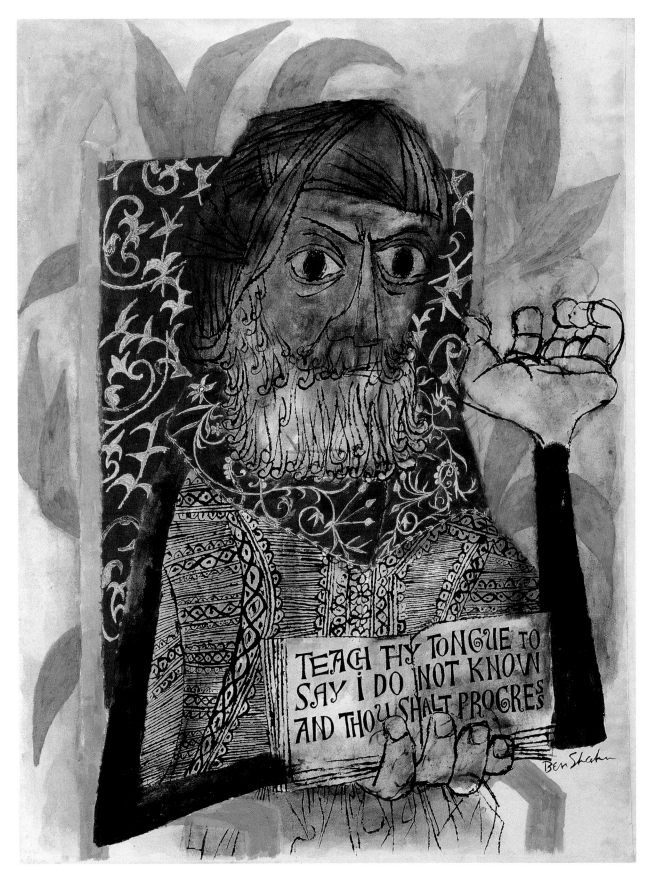

Plate 23

Maimonides, 1954

Tempera on paper mounted

on board, 34½ × 26 in.

(87.6 × 66 cm)

The Jewish Museum,

New York. Promised Gift

from the Private Collection of

Mr. and Mrs. Jacob Weintraub

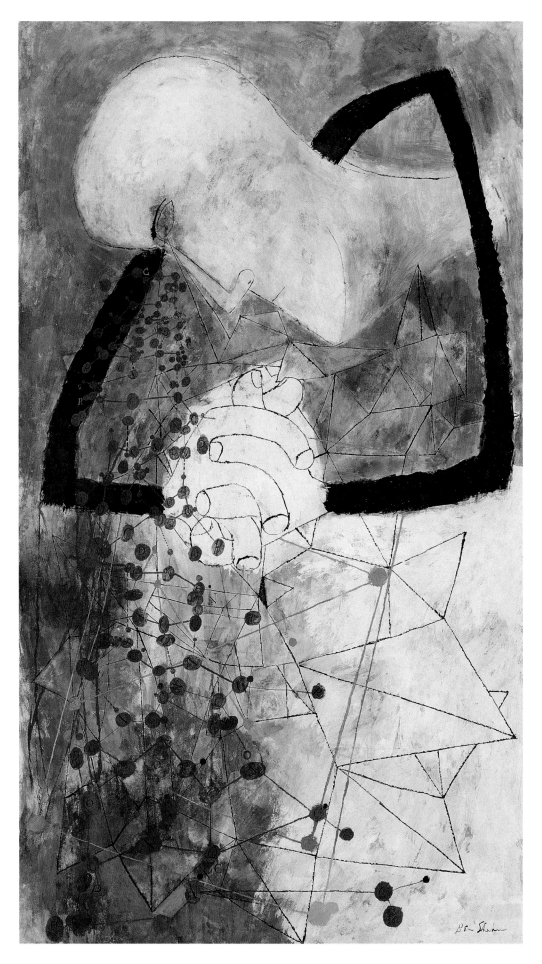

Plate 25

Helix and Crystal, 1957

Tempera on board,

53 × 30 in. (134.6 × 76.2 cm)

San Diego Museum of Art

Purchased through Earle W. Grant

Endowment Funds

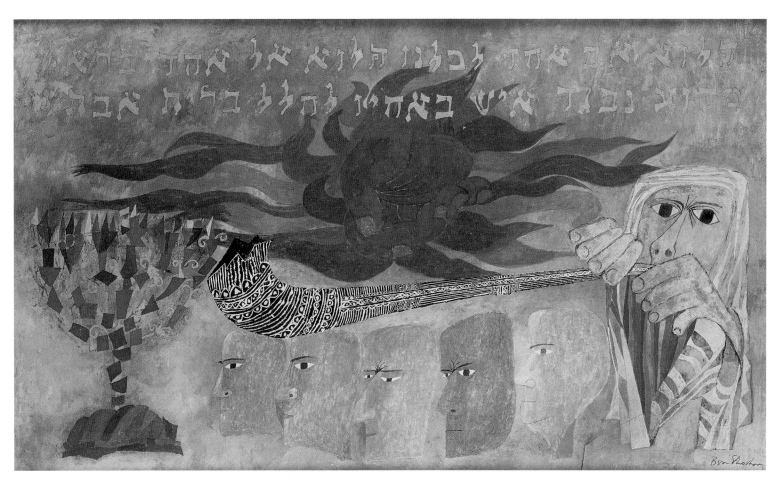

Plate 26
Ram's Horn and Menorah, 1958
Tempera and gold leaf on board,
16½ × 28 in. (41.9 × 71.1 cm)
Sid Deutsch Gallery, New York

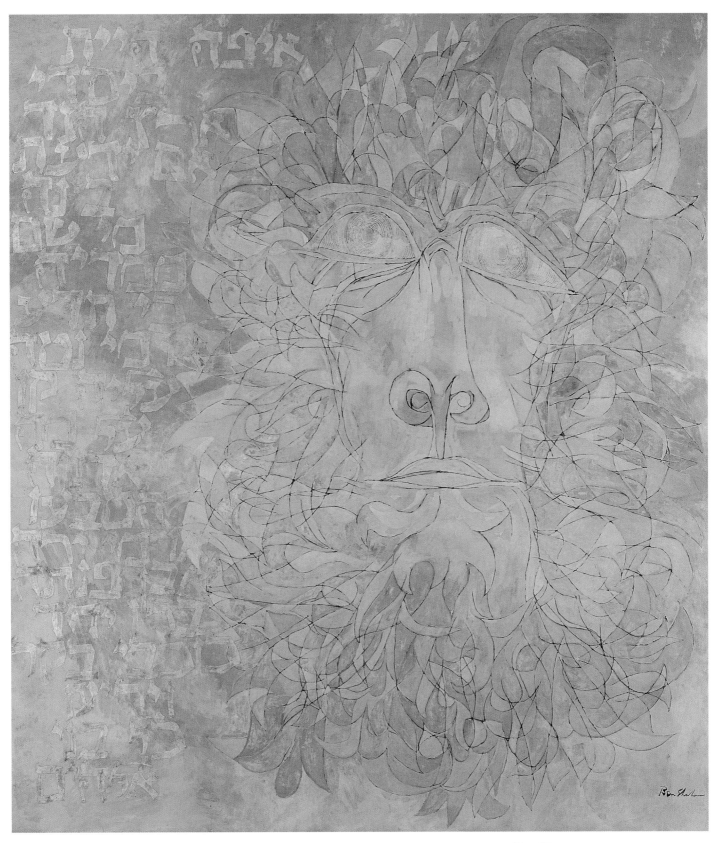

Plate 27

"When the Morning Stars . . . ," 1959

Tempera and gold leaf on paper mounted on panel,

54 x 48 in. (137.2 x 121.9 cm)

Collection of Alex and Beatrice Silverman

Plate 28

The Lucky Dragon,
from the *Lucky Dragon* series, 1960
Tempera on board, 84½ × 48 in.
(213.4 × 122 cm)
Fukushima Prefectural Museum of Art,
Japan

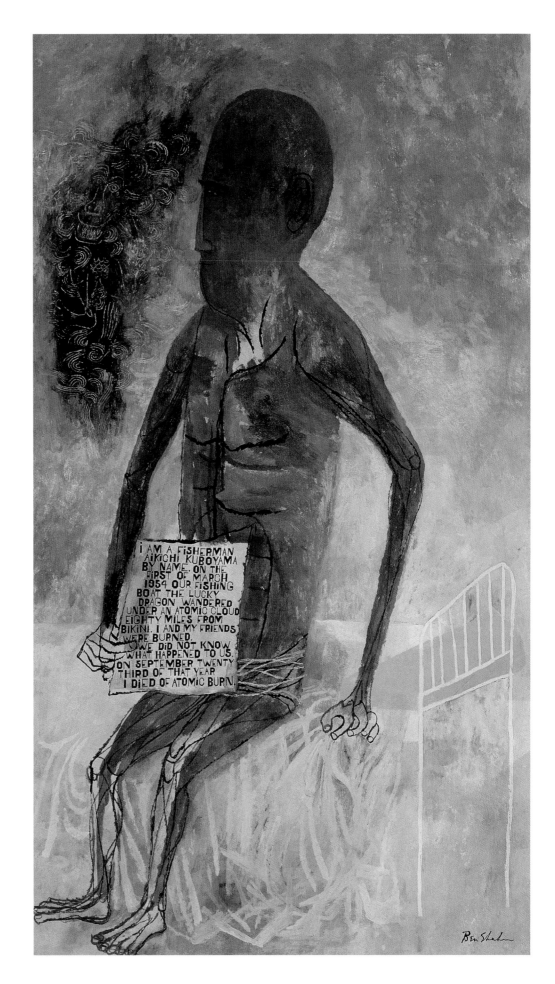

Plate 29

Farewell,

from the *Lucky Dragon* series, 1961

Gouache on paper, 23 × 31 in. (58.4 × 78.7 cm)

Vatican Museums, Vatican City

Plate 30

A Score of White Pigeons,
from the *Lucky Dragon* series, 1960
Tempera on wood, 46⅞ × 29⅛ in.
(119 × 74 cm)
Moderna Museet, Stockholm

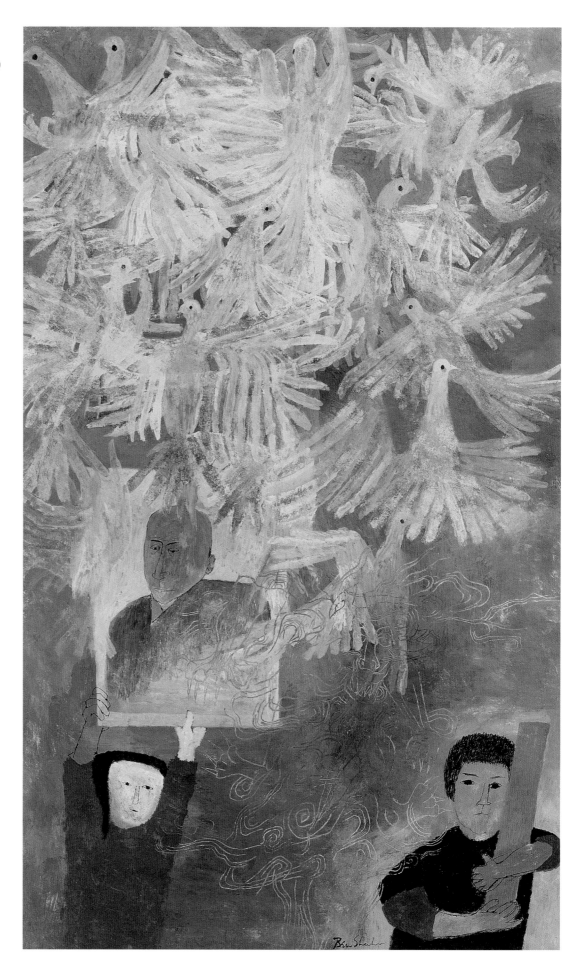

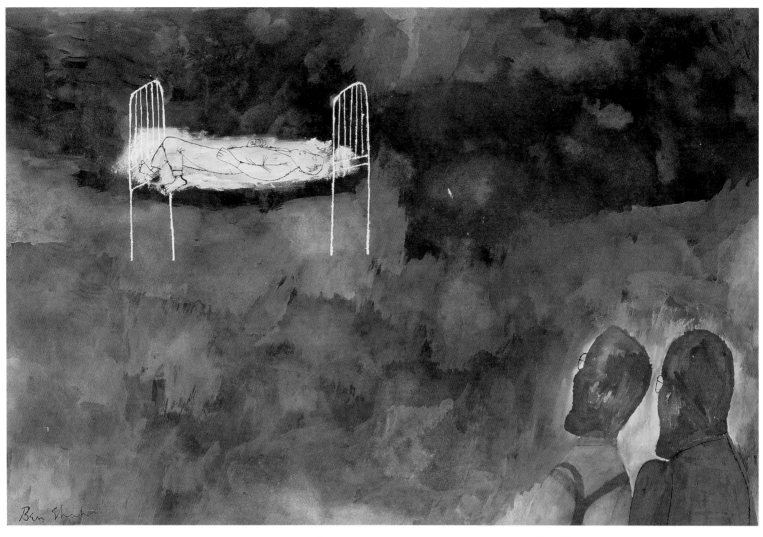

Plate 31

It's No Use to Do Anymore,
from the *Lucky Dragon* series, 1961–62
Tempera on board, 25½ × 39 in. (64.8 × 99.1 cm)
Maier Museum of Art, Randolph-Macon Woman's College,
Lynchburg, Virginia. Louise Jordan Smith Fund, 1966

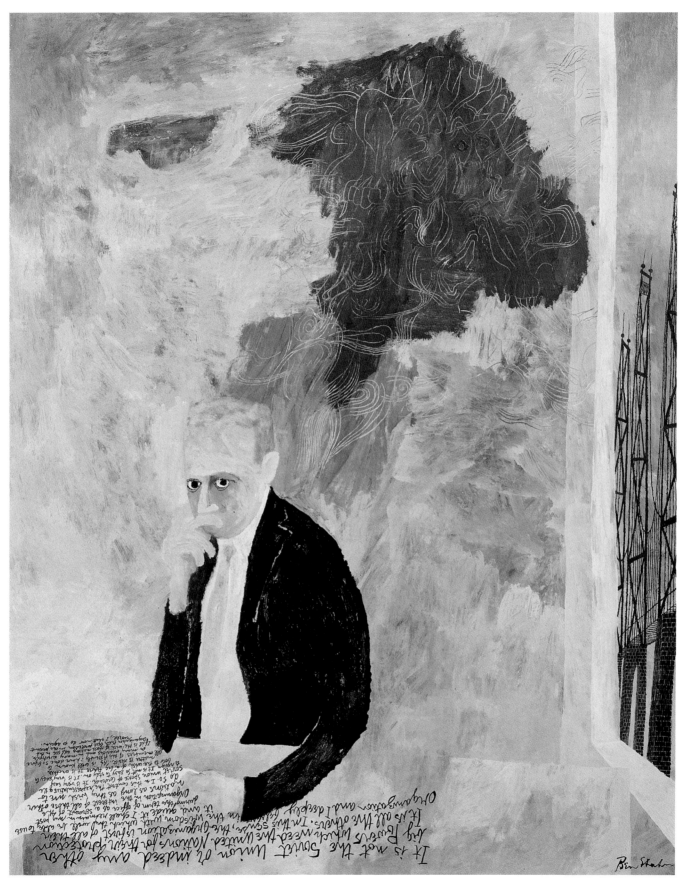

Plate 32

Portrait of Dag Hammarskjöld, 1962

Tempera on plywood, 59⅞ × 48 in.

(152 × 122 cm)

Nationalmuseum, Stockholm

Catalogue of the Exhibition

1

East Side Soap Box (Study for Jersey Homesteads Mural), 1936
Gouache on paper, 18½ × 12¼ in. (47 × 31.1 cm)
The Jewish Museum, New York
Museum purchase with funds provided by Deana Bezark, in memory of
Leslie Bezark; and by Mrs. Jack N. Berkman; Susan and Arthur Fleischer;
Dr. Jack Allen and Shirley Kapland Fund; Hanni and Peter Kaufmann; Hyman L. and Joan C. Sall; and the Bequest of Margaret Goldstein, 1995-61
Plate 1

2

Study for Jersey Homesteads Mural, c. 1936
Tempera on paper on Masonite, 19½ × 27½ in. (49.5 × 69.9 cm)
Collection of Merrill C. Berman
Plate 2

3

Scotts Run, West Virginia, 1937
Tempera on cardboard, 22¼ × 27⅞ in. (56.5 × 70.8 cm)
Whitney Museum of American Art, New York
Purchase
Figure 3

4

Sunday Painting, 1938
Tempera on gessoed Masonite panel, 15 × 23 in. (38.1 × 58.4 cm)
Courtesy of Bernarda B. Shahn
Figure 5

5

Myself Among the Churchgoers, 1939
Tempera on Masonite, 20 × 29½ in. (50.8 × 74.9 cm)
Curtis Galleries, Minneapolis, Minnesota
Plate 3

6

Democracies Fear New Peace Offensive (Spring 1940), 1940
Tempera on paper, 14¼ × 21⅜ in. (36.2 × 54.3 cm)
Collection Museum of Contemporary Art, Chicago
Promised Gift of the Mary and Earle Ludgin Collection
Exhibited New York only
Figure 4

7

Portrait of Myself When Young, 1943
Tempera on cardboard, 20 × 27⅞ in. (50.8 × 70.8 cm)
The Museum of Modern Art, New York
Purchase, 273.48
Exhibited New York and Allentown only
Plate 4

8

1943, A.D., c. 1943
Tempera on pressboard, 30¾ × 27¾ in. (78.1 × 70.5 cm)
Courtesy of the Syracuse University Art Collection
Figure 7

9

Italian Landscape, 1943–44
Tempera on paper, 27½ × 36 in. (69.8 × 91.4 cm)
Collection Walker Art Center, Minneapolis, Minnesota
Gift of the T. B. Walker Foundation, Gilbert M. Walker Fund, 1944
Plate 5

10

Italian Landscape II: Europa, 1944

Tempera on board, 22½ x 30 in. (57.2 x 76.2 cm)

Collection of the Montgomery Museum of Fine Arts,

Montgomery, Alabama. The Blount Collection

Plate 6

11

Cherubs and Children, 1944

Tempera on composition board, 15 x 22⅞ in. (38.1 x 58.1 cm)

Whitney Museum of American Art, New York. Purchase

Figure 35

12

Blind Accordion Player, 1945

Tempera on board, 25½ x 38¼ in. (64.8 x 97.2 cm)

Collection Neuberger Museum of Art, Purchase College,

State University of New York. Gift of Roy R. Neuberger

Exhibited New York and Allentown only

Figure 16

13

Liberation, 1945

Tempera on cardboard mounted on composition board,

29¾ x 40 in. (75.6 x 101.6 cm)

The Museum of Modern Art, New York

James Thrall Soby Bequest, 1249.79

Exhibited New York and Allentown only

Plate 8

14

Pacific Landscape, 1945

Tempera on paper mounted on composition board,

25¼ x 39 in. (64.1 x 99.1 cm)

The Museum of Modern Art, New York

Gift of Philip L. Goodwin, 1.50

Exhibited New York and Allentown only

Plate 9

15

Brothers, 1946

Tempera on paper mounted on fiberboard mounted on wood on

fiberboard, 38¹⁵⁄₁₆ x 25¹⁵⁄₁₆ in. (98.9 x 65.9 cm)

Hirshhorn Museum and Sculpture Garden, Smithsonian Institution,

Washington, D.C. Gift of Joseph H. Hirshhorn Foundation, 1966

Figure 58

16

Renascence, 1946

Gouache on Whatman hotpressed board,

21⅞ x 30 in. (55.6 x 76.2 cm)

Fred Jones Jr. Museum of Art, The University of Oklahoma, Norman

State Department Collection

Plate 10

17

Father and Child, 1946

Tempera on cardboard, 39⅞ x 30 in. (101.5 x 76.2 cm)

The Museum of Modern Art, New York

Gift of James Thrall Soby, 157.57

Exhibited New York and Allentown only

Plate 11

18

Spring, 1947

Tempera on Masonite, 17 x 30 in. (43.2 x 76.2 cm)

Albright-Knox Art Gallery, Buffalo, New York

Room of Contemporary Art Fund, 1948

Plate 12

19

New York, 1947

Tempera on paper mounted on panel, 36 x 48 in. (91.4 x 121.9 cm)

The Jewish Museum, New York

Museum purchase with funds provided by the Oscar and Regina Gruss

Charitable and Educational Foundation, 1996-23

Plate 13

20

Deserted Fairground, 1947

Tempera on board, 11 x 20 in. (27.9 x 50.8 cm)

New Jersey State Museum Collection, Trenton

Gift of Mrs. Eric Eweson, FA1991.20

Exhibited Allentown and Detroit only

Figure 9

21

Trouble, 1947

Tempera on plywood, 24 x 36 in. (61 x 91.4 cm)

Sheldon Memorial Art Gallery, University of Nebraska-Lincoln

F. M. Hall Collection, 1948.H-280

Figure 53

22

Allegory, 1948

Tempera on panel, 36⅛ × 48⅛ in. (91.8 × 122.2 cm)

Collection of the Modern Art Museum of Fort Worth

Gift of Mr. W. P. Bomar, Jr., in Memory of Mrs. Jewel Bomar and

Mr. Andrew Chilton Phillips

Plate 14, figure 62

23

Death of a Miner, 1949

Tempera on muslin, treated with gesso, on wood,

27 × 48 in. (67.6 × 121.9 cm)

Lent by The Metropolitan Museum of Art, New York

Arthur Hoppock Hearn Fund, 1950

Exhibited New York only

Figure 8

24

Song, 1950

Tempera on canvas mounted on wood, 30⅞ × 52 in. (78.4 × 132 cm)

Hirshhorn Museum and Sculpture Garden, Smithsonian Institution,

Washington, D.C. Gift of Joseph H. Hirshhorn, 1966

Figure 12

25

The City of Dreadful Night, 1951

Tempera and gouache on board, 47⅜ × 56 in. (121 × 142.4 cm)

Fukushima Prefectural Museum of Art, Japan

Plate 16

26

Harpy, 1951

Tempera and gouache on paper, 25 × 38 in. (63.5 × 96.5 cm)

Collection of Mrs. Robert B. Mayer, Chicago

Exhibited New York only

Plate 17

27

Composition for Clarinets and Tin Horn, 1951

Tempera on panel, 48 × 36 in. (121.9 × 91.4 cm)

The Detroit Institute of Arts

Founders Society Purchase, Friends of Modern Art Fund

Plate 18

28

Beatitude, 1952

Tempera on panel, 27 × 40 in. (68.6 × 101.6 cm)

Himeji City Museum of Art, Japan

Figure 52

29

Detail No. 2: Labyrinth, c. 1952

Tempera on paper, 60¼ × 22¾ in. (153 × 57.8 cm)

Private collection

Figure 38

30

Man, 1952

Tempera on canvas mounted on board, 8 × 21 in. (20.3 × 53.3 cm)

Private collection, Japan

Plate 19

31

Second Allegory, 1953

Tempera on Masonite, 53⅜ × 31⅜ in. (135.6 × 79.7 cm)

Krannert Art Museum and Kinkead Pavilion,

University of Illinois, Champaign

Plate 20, figure 65

32

Age of Anxiety, 1953

Tempera on paper mounted on fabric mounted on fiberboard,

31 × 51⅞ in. (78.7 × 131.8 cm)

Hirshhorn Museum and Sculpture Garden, Smithsonian Institution,

Washington, D.C. Gift of Joseph H. Hirshhorn Foundation, 1966

Plate 21

33

Bookshop: Hebrew Books, Holy Day Books, 1953

Tempera on wood panel, 27 × 20 in. (68.6 × 50.8 cm)

The Detroit Institute of Arts

Gift of John S. Newberry

Plate 22

34

Blind Botanist #2, 1954

Tempera on canvas mounted on board, 21⅛ × 17¼ in. (55.6 × 43.8 cm)

Collection Neuberger Museum of Art, Purchase College,

State University of New York

Gift from the Dina and Alexander E. Racolin Collection

Figure 17

35

Everyman, 1954

Tempera on composition board, 72 × 24 in. (182.9 × 61 cm)

Whitney Museum of American Art, New York. Purchase

Figure 10

36

Incubus, 1954

Gouache on paper, 39 × 25 in. (99.1 × 63.5 cm)

Collection of Mr. and Mrs. William C. Bahan

Figure 11

37

Maimonides, 1954

Tempera on paper mounted on board, 34½ × 26 in. (87.6 × 66 cm)

The Jewish Museum, New York

Promised Gift from the Private Collection of

Mr. and Mrs. Jacob Weintraub

Plate 23

38

Apotheosis (Study for William E. Grady Mural), 1956

Watercolor, gouache, and ink on paper, 7½ × 48¼ in. (19.1 × 122.6 cm)

Collection of Irene and Mark Kauffman

Figure 61

39

Helix and Crystal, 1957

Tempera on board, 53 × 30 in. (134.6 × 76.2 cm)

San Diego Museum of Art

Purchased through Earle W. Grant Endowment Funds

Exhibited New York only

Plate 25

40

The Parable, 1958

Oil on canvas, 48 × 37¾ in. (121.9 × 95.9 cm)

Munson-Williams-Proctor Institute Museum of Art, Utica, New York

Figure 39

41

Ram's Horn and Menorah, 1958

Tempera and gold leaf on board, 16½ × 28 in. (41.9 × 71.1 cm)

Sid Deutsch Gallery, New York

Plate 26

42

Cat's Cradle in Blue, c. 1959

Tempera on composition board, 39¾ × 25¾ in. (101 × 65.4 cm)

Museum of American Art of the Pennsylvania Academy of the Fine Arts, Philadelphia. Joseph E. Temple Fund

Exhibited Allentown and Detroit only

Figure 13

43

"When the Morning Stars . . . ," 1959

Tempera and gold leaf on paper mounted on panel,
54 × 48 in. (137.2 × 121.9 cm)

Collection of Alex and Beatrice Silverman

Plate 27

44

I Never Dared to Dream (*Lucky Dragon* series), 1960

Gouache on paper mounted on board, 40 × 27 in. (101.6 × 68.6 cm)

Norton Museum of Art, West Palm Beach, Florida

Figure 19

45

We Did Not Know What Happened to Us
(*Lucky Dragon* series), 1960

Tempera on wood, 48 × 72⅛ in. (121.9 × 183.2 cm)

National Museum of American Art, Smithsonian Institution,
Washington, D.C. Gift of S. C. Johnson & Son, Inc.

Exhibited New York and Allentown only

Figure 66

46

A Score of White Pigeons (*Lucky Dragon* series), 1960

Tempera on wood, 46⅞ × 29⅛ in. (119 × 74 cm)

Moderna Museet, Stockholm

Plate 30

47

Farewell (*Lucky Dragon* series), 1961

Gouache on paper, 23 × 31 in. (58.4 × 78.7 cm)

Vatican Museums, Vatican City

Exhibited New York only

Plate 29

48

Desolation (*Lucky Dragon* series), 1961

Gouache on paper, 20 × 26 in. (50.8 × 66 cm)

Terry Dintenfass, Inc., in association with Salander-O'Reilly Galleries

Figure 37

49

Kuboyama (*Lucky Dragon* series), 1961

Painting in ink on paper, 38 × 25 in. (96.5 × 63.5 cm)

Collection of Carol A. Straus

Figure 20

50

It's No Use to Do Anymore (*Lucky Dragon* series), 1961–62

Tempera on board, 25½ × 39 in. (64.8 × 99.1 cm)

Maier Museum of Art, Randolph-Macon Woman's College, Lynchburg, Virginia. Louise Jordan Smith Fund, 1966

Plate 31

51

Boy's Day (*Lucky Dragon* series), 1962

Tempera on panel, 38 × 25¼ in. (96.5 × 64.1 cm)

Collection of Dorothy Eweson

Figure 22

52

The Heron of Calvary No. 1, 1962

Watercolor and gouache on paper, 23½ × 32 in. (59.7 × 81.3 cm)

Collection of Mr. and Mrs. Maurice G. Levine

Figure 60

53

Portrait of Dag Hammarskjöld, 1962

Tempera on plywood, 59⅞ × 48 in. (152 × 122 cm)

Nationalmuseum, Stockholm

Plate 32

54

Where Wast Thou?, 1964

Gouache and gold leaf on paper mounted on Masonite, 51¾ × 42 in. (131.4 × 106.7 cm)

Amon Carter Museum, Fort Worth, Texas, 1967.198

Exhibited Allentown and Detroit only

Figure 18

55

Branches of Water or Desire, 1965

Watercolor and gouache on paper, 26½ × 21 in. (67.3 × 53.5 cm)

Forum Gallery, New York

Figure 14

1898

Born September 12, in Kovno (Kaunas), Lithuania, to Joshua Hessel and Gittel (Lieberman) Shahn.

1902

Moves with his mother, younger brother Phil, and younger sister Hattie to nearby Vilkomir after his father is exiled to Siberia for alleged revolutionary activities.

1902–6

Forms deep attachment to paternal grandfather Wolf-Leyb, a carpenter/woodcarver (as was Hessel), who, as his surrogate father, exerts great influence on Shahn.

1906–12

Immigrates to the United States where the family joins Hessel, who, having fled Siberia, had recently made his way to America by way of South Africa. Family moves to the Williamsburg section of Brooklyn where, during the next few years, they live at 243 Moore Street, Lorimer Street, and at various addresses on Walton Street. A sister, Eva, is born in 1908, and a brother, Hymie, is born in 1909.

1913–16

Taken out of school to work as an apprentice at Hessenberg's, a lithography shop at 101 Beekman Street, Manhattan. Develops a passion for reading at the public library and for the letters of the alphabet at his lithographer's job. Attends high school at night.

1916–17

Attends classes at the Art Students League in Manhattan and attains the status of journeyman lithographer, a profession he practices sporadically for several years.

1919–21

Attends New York University, City College of New York, and receives scholarship to study zoology at the Marine Biological Laboratory in Woods Hole, Massachusetts.

1921

Abandons quest for academic degree. Attends New York's National Academy of Design, which he finds too conservative.

1922

On August 8, marries Tillie (Ziporah) Goldstein, whom he had known for three years. Moves to 120 Columbia Heights in Brooklyn Heights.

Joshua Hessel, Ben's father

Passport of Ben and his first wife, Tillie Goldstein, issued February 2, 1928

1925

Travels with his wife to North Africa and Europe, spending four months in Paris, where he studies art and learns French.

1926

Lives on Willow Street in Brooklyn Heights. Work is first publicly shown as part of a group exhibition at The Jewish Art Center in New York. Offered a one-man exhibition at New York's Montross Gallery, but rejects the offer, feeling his painting is too derivative. Spends summer in Truro, Massachusetts, in a broken-down home he and Tillie had bought and began rebuilding in 1924. In August, his youngest brother Hymie drowns in the Pamet River while on a short visit to Truro. This tragedy precipitates a break with his past and with most friends and relatives (including his mother) connected with it.

1928–29

Travels abroad again, spending several months on the island of Djerba. Arrives in Paris in May 1929, where daughter Judith Hermine is born July 14. Upon their return to America, the Shahns reside at 8 Hicks Street in Brooklyn Heights.

1930

Meets Edith Halpert, owner of the Downtown Gallery in Manhattan, who exhibits some of his work as part of a group exhibition. After three works are shown at New York's Museum of Modern Art, Halpert gives Shahn his first one-man show at her gallery. Commissioned by his friend Philip Van Doren Stern to illustrate Thomas De Quincey's *Levana, and Our Ladies of Sorrow.*

1931

An immensely productive summer in Truro, during which Shahn creates his most original and finest work to date: an illustrated *Haggadah*

(now part of the collection of The Jewish Museum in New York); a series of gouaches on the Dreyfus Affair (exhibited, together with a number of photos by his friend Walker Evans, in a neighbor's barn); and twenty-three works illustrating the trial of Sacco and Vanzetti, the anarchist immigrants convicted of killing two bank payroll guards in South Braintree, Massachusetts. Moves with wife and daughter to apartment on Bethune Street, Manhattan, opposite a studio he shares with Walker Evans.

1932

Exhibition of *Sacco and Vanzetti* series at Downtown Gallery (April 5–17), his first critical and commercial success. In October, these works, together with Dreyfus series, shown at Harvard Society of Contemporary Art, Cambridge. Represented by two mural panels in the exhibition *Murals by American Painters and Photographers* (May 3–31) at the Museum of Modern Art, New York, and by one painting in the Whitney Museum of American Art's first biennial.

1933

Exhibition at Downtown Gallery (May 5–20) of fifteen gouaches narrating the trial and conviction of Tom Mooney, labor leader accused of taking part in bombing of a San Francisco parade. Assists Diego Rivera in the Mexican artist's work on a large mural for Rockefeller Center in New York. For political reasons, work was stopped before mural was completed; it was later destroyed. Son Ezra Ben is born November 12.

1934

Under auspices of the Public Works of Art Project submits eight tempera paintings on the theme of Prohibition for a mural proposed to decorate the Central Park Casino. Proposal rejected and project aban-

Ben with his dog Cookie in front of the shack he used as a studio, Truro, Massachusetts, probably 1932 or 1933

doned. With Lou Block, researches and prepares sketches for mural project showing the history of penology for a prison at Rikers Island. With encouragement of Walker Evans, begins to take photographs of New York City. Moves with family to 333 West 11th Street, Manhattan.

1935

Despite praise from artistic quarters, Rikers Island proposal rejected by Municipal Art Commission. In fall, takes job with Resettlement Administration (RA) in Washington, assigned to travel throughout the South to photograph the desperate conditions prevalent in rural America during the Depression. Separates from Tillie, their relationship having hopelessly deteriorated; invites Bernarda Bryson, an artist-journalist from Ohio (later his wife), to join him in Washington and on the trip, resulting in a uniquely compassionate pictorial documentation of the country and its people. At end of year, returns to Washington, works for Roy Stryker as part of group to be known as the Farm Security Administration (FSA) photographers.

1936

Continues to work as artist, designer, and photographer for Resettlement Administration. Publishes poster, *Years of Dust*. Daughter Susanna born October 6.

1937

Works on gouaches for mural on history of the state's liberal political movement (never executed) for the Administration Building of Glendale, Wisconsin, near Milwaukee.

1936–38

Works on sketches for fresco mural for the community center of the newly created housing development of Jersey Homesteads (later named Roosevelt), near Hightstown, New Jersey. In summer 1937, embarks on second trip for RA. Divides time between Jersey Homesteads and Washington until November 1937 when actual work on the mural is started. Mural completed in May 1938.

1938

In May, with Bernarda, wins competition sponsored by Section of Fine Arts of the Treasury Department for commission to execute thirteen fresco panels for lobby of the Bronx Central Post Office, in New York. Spends summer in Worthington, Ohio, home of Bernarda's family, where son Jonathan is born June 17. Assigned by Stryker to photograph scenes of rural and small-town Ohio. Ends career as photographer. In fall, returns to New York where he, Bernarda, and their children live at 300 East 89th Street. Works on Bronx mural, which is completed in August 1939.

(Left to right) Morris Kantor, painter, David Smith, sculptor, Harry Knight, director of the New York Section of the PWAP Treasury Art Project, and Ben Shahn, New York waterfront, c. 1934

1939

Moves to Jersey Homesteads, his residence for the rest of his life. Work shown at Corcoran Gallery in Washington, D.C., and Whitney Museum in New York.

1940–41

Returns to easel painting. Series of so-called "Sunday paintings" shown at Julien Levy Gallery in New York, May 7–21. Executes small mural for Jamaica, New York, Woodhaven Branch, Post Office. Wins competition sponsored by Section of Fine Arts to paint murals in corridor of Social Security Building, Washington (now Wilbur J. Cohen Building). Works on designs in Jersey Homesteads and Washington. Daughter Abigail is born July 31. In December 1941, moves with family to apartment in Arlington, Virginia.

1942

Washington mural completed in June. In August, joins Office of War Information (OWI) to design posters and pamphlets explaining need for and purpose of U.S. participation in World War II. Because of limitations imposed upon the artists, only two posters are actually published and distributed. In November, returns to Jersey Homesteads.

1943

In February, represented by eleven works in Museum of Modern Art exhibition, *American Realists and Magic Realists*. In July, along with other artists and writers, resigns from OWI, citing undue influence of advertising men running the organization. Begins to accept commercial assignments, including highly effective advertisements for the Container

Ben Shahn and Alexander Calder photographed in separate mirrors on a battered wall in the Rome flea market, Porta Portese, March 1956

Corporation of America, and later illustrations for Columbia Broadcasting System, *Fortune, Time, Esquire, Harper's,* and *Scientific American.*

1944

Works for Political Action Committee of the Congress of Industrial Organizations (CIO-PAC) for the re-election of Franklin D. Roosevelt. One-man exhibition, Downtown Gallery (November 12–December 2). Resigns CIO job, following November election, to return to painting.

1945

Returns to CIO as director of Graphic Arts Division, PAC.

1946

Short trip through the South on assignment for *Fortune* magazine. Paintings begin to be shown in museums throughout the United States and Europe.

1947

In summer, teaches at Boston Museum of Fine Arts Summer School in Pittsfield, Massachusetts. Large retrospective of paintings, drawings, posters, illustrations, and photographs at Museum of Modern Art, New York (September 30–January 9, 1948).

1948

Works briefly for Henry A. Wallace's Progressive Party campaign. Chosen as one of the ten best American painters in a poll conducted by *Look* magazine. Fame grows, becomes a "celebrity." Commissioned

by *Harper's* magazine to illustrate John Bartlow Martin's "The Blast in Centralia No. 5" (published in March) and "The Hickman Story" (published in August).

1949

Exhibition, Downtown Gallery (October 25–November 12). Produces first Christmas-card booklet, *A Partridge in a Pear Tree.* Lectures at University of Wisconsin.

1950

Exhibitions at Albright Art School, Buffalo; Frank Perls Gallery, Los Angeles; Phillips Gallery, Washington, D.C. During summer, teaches at University of Colorado.

1951

Publication of *Portrait of the Artist as an American, Ben Shahn: A Biography with Pictures* by Selden Rodman. Teaches at Brooklyn Museum of Art School. During the summer, four weeks at Black Mountain College, North Carolina, mark a fundamental change in direction of his work. Exhibition at Downtown Gallery (May 22–June 8). Participates in three-man exhibition with Willem de Kooning and Jackson Pollock at Arts Club of Chicago (October 2–27).

Ben and Bernarda Shahn, 1957

1952

Attends and makes drawings of Democratic National Convention in Chicago. One-man exhibitions at Downtown Gallery (March) and Boris Mirsky Gallery, Boston (May). Participates in three-man exhibition with Karl Knaths and Lee Gatch at Santa Barbara Museum of Art in California, Palace of the Legion of Honor in San Francisco, and Los Angeles County Museum of Art.

1953

Represented in *Twelve Modern American Painters and Sculptors* exhibition, sponsored by Museum of Modern Art, which travels to Paris, Zurich, Düsseldorf, Stockholm, Helsinki, and Oslo. Work shown in London, Calcutta, and São Paulo (where Shahn wins an $800 prize).

1954

Chosen, along with Willem de Kooning, to represent United States at Venice Biennale. Participates in three-man exhibition with Charles Sheeler and Joe Jones at Detroit Institute of Arts. One-man exhibition at Allyn Art Gallery, University of Southern Illinois in Carbondale and the Art Institute of Chicago. Works for Columbia Broadcasting System, with Edward R. Murrow, on program about J. Robert Oppenheimer. Publication of deluxe book, *The Alphabet of Creation*.

1955

Exhibition of paintings and drawings at Downtown Gallery celebrating twenty-five-year association with the gallery (January 18–February 12). First one-man exhibition in Italy, at Galleria Tartaruga in Rome. Again works for CBS, with Edward R. Murrow, on program about Louis Armstrong.

1956

Represented in *Modern Art in the United States: Painting, Sculpture, and Prints, A Selection from the Collections of the Museum of Modern Art* (January 5–February 12). Spends academic year 1956–57 in Cambridge, Massachusetts, serving as Charles Eliot Norton Professor of Poetry at Harvard University. Delivers six lectures, published in 1957 by Harvard University Press under the title *The Shape of Content*. Illustrates John Berryman's *Homage to Mistress Bradstreet*. Awarded Joseph E. Temple Gold Medal by Pennsylvania Academy of the Fine Arts and elected to National Institute of Arts and Letters.

1957

Commissioned by New York City Board of Education to design mosaic mural for William E. Grady Vocational High School in Brooklyn. Illustrates Edward Dahlberg's *The Sorrows of Priapus*. With Leonard Baskin, designs and produces *Thirteen Poems by Wilfred Owen*. Exhibitions at

Ben Shahn in his studio, Roosevelt, New Jersey, c. 1966

American Institute of Graphic Arts, New York (March 1–28) and Institute of Contemporary Art, Boston (April 10–May 31). Publication of *Ben Shahn: His Graphic Work,* by James Thrall Soby. Drawings for Ralph E. Lapp's "The Saga of the Lucky Dragon," in December 1957, January 1958, and February 1958 issues of *Harper's* magazine.

1958

Designs sets and poster for *New York Export—Opus Jazz,* a Jerome Robbins ballet first performed at the Festival dei Due Mondi in Spoleto, Italy. Spends much of summer there and in other parts of Italy. Designs and illustrates Alastair Reid's *Ounce Dice Trice.* Awarded gold medal of the American Institute of Graphic Arts. Represented in group exhibition *American Artists Paint the City* at Venice Biennale. Exhibitions at St. Mary's College in Notre Dame, Indiana, Bucknell University in Lewisburg, Pennsylvania, and Felix Landau Gallery in Los Angeles. Chance meeting with publisher Arnold Fawcus at inn near Dijon, France, leads to publication, by Fawcus's Trianon Press, of two of his finest works—deluxe limited editions of an illustrated *Haggadah* (including reproductions of the eleven illustrations of 1931) and an illustrated *Ecclesiastes.*

The Shahn house as seen from the studio, Roosevelt, New Jersey, c. 1966

1959

Elected member of American Academy of Arts and Sciences. Completes mosaic mural for Congregation Ohabai Sholom in Nashville, Tennessee. Exhibitions at Downtown Gallery (March 3–28), Katonah Gallery in Katonah, New York (April 19–May 20), Galleria dell' Obelisco in Rome, Italy (October 31–November 10), Leicester Galleries in London, England (November), and Downtown Gallery (December 8–24). Represented in *The Museum and its Friends: Eighteen Living American Artists Selected by the Friends of the Whitney Museum* and in *American Painting and Sculpture,* a cultural exchange exhibition organized by the United States Information Agency (USIA) and shown in Moscow (July 25–September 5). Executes drawings for an abbreviated television version of *Hamlet,* published by the Columbia Broadcasting System. Publication of translation of "On Nonconformity," one of his Harvard lectures, in the USIA Russian-language magazine *Amerika.*

1960

Travels to Far East; especially moved by visit to Kyoto, Japan. Completes mosaic mural for Congregation Mishkan Israel in New Haven, Connecticut. Begins work on series of paintings and drawings based on *Harper's Lucky Dragon* illustrations. Exhibition at University of Louisville, Galleria dell'Obelisco in Rome, and the University of Utah in Salt Lake City.

1961

Retrospective exhibition (December 22, 1961–June 24, 1962), organized by the International Council of the Museum of Modern Art, traveling to Amsterdam, Brussels, Rome, and Vienna. Sets for Jerome Robbins' *Events,* performed in Spoleto, Italy. Exhibition, *The Saga of the Lucky Dragon,* at Downtown Gallery (October 10–November 4).

1962

Completes portrait of Dag Hammarskjöld commissioned by National Museum, Stockholm. Posters for Lincoln Center for the Performing Arts in New York and the Boston Arts Festival. Selections from Museum of Modern Art retrospective exhibition opens in Baden-Baden (August) and travels to Zagreb, Ljubljana, Stockholm, Lund, Jerusalem, ending in Tel Aviv (July 9, 1963). Publication in Japan of *Ben Shahn* by Yoshiaki Tono.

1963

Mosaic mural *Alternatives* dedicated for Hollis F. Price Library at LeMoyne College in Memphis, Tennessee. Completes tapestry and two mosaic murals for SS *Shalom* (bought by New Jersey State Museum when ship was sold in 1968). Publication of his book *Love and Joy about Letters* and James Thrall Soby's *Ben Shahn: Paintings* in New York, and *Ben Shahn* by Mirella Bentivoglio in Rome.

1964

Completes mosaic mural for Far Hills, New Jersey, estate of Sydney and Dorothy Spivack. Illustrates *Love Sonnets,* anthology edited by Louis Untermeyer. Moved by assassination of John F. Kennedy, illustrates and writes by hand a poem by Wendell Berry, *November Twenty-Six Nineteen Hundred Sixty Three.* Exhibition at Leicester Galleries, London (June–July).

1965

Publication of *Kuboyama and the Saga of the Lucky Dragon,* by Richard Hudson, with *Lucky Dragon* series of illustrations. Creates stained-glass window for Temple Beth Zion in Buffalo, New York. Produces portfolio of nine prints for American Civil Liberties Union and portfolio of three prints (portraits of James Chaney, Andrew Goodman, and Michael Schwerner, civil rights heroes) for Human Relations Council of Greater New Haven, Connecticut.

1966

Publication by Trianon Press, Paris, of deluxe edition of *Haggadah.* In July, attends design conference in Aspen, Colorado, and delivers lecture, "In Defense of Chaos." Exhibitions in St. Paul, Minnesota (February), Lynchburg, Virginia (March), and Milan, Italy (April–May).

1967

Publication by Trianon Press, Paris, of deluxe edition of *Ecclesiastes.* Completes outdoor mosaic mural on theme of Sacco and Vanzetti for Huntington Beard Crouse Building at Syracuse University in Syracuse, New York. Exhibition at Philadelphia Museum of Art, *The Collected Prints of Ben Shahn* (November 15–December 31). Exhibitions at Santa

Barbara Museum of Art (July 30–September 10), La Jolla Museum of Art (October 5–November 12), Indianapolis Museum of Art (December 3–January 3, 1968). On May 8, tragic death in London of daughter Susanna.

1968

Twenty-four color lithographs and Afterword for Rainer Maria Rilke's *For the Sake of a Single Verse.* Terminates relationship with Edith Halpert and Downtown Gallery. First exhibition with new dealer Lawrence Fleischman at Kennedy Galleries, New York (October 12–November 2). Health deteriorates (diabetes, heart trouble); weak and tired, uses cane to walk.

1969

Frequently hospitalized in Princeton, New Jersey; transferred to Mount Sinai Hospital in New York. While in hospital, signs 100 copies of print (portrait of Martin Luther King) to be sold for charity. On March 14, after successful surgery for bladder cancer, suffers heart attack and dies.

Ben Shahn at the unveiling of the *Sacco and Vanzetti* mosaic mural at Syracuse University, shown with an official of Syracuse University and Gabriel Loire of Chartres *(right),* who executed the mural, 1967

Selected Bibliography

Amishai-Maisels, Ziva. "Ben Shahn and the Problem of Jewish Identity." *Jewish Art* 12–13 (1986–87): 304–19.

Anreus, Alejandro, ed. *Ben Shahn: The Passion of Sacco and Vanzetti.* Exh. cat. Jersey City, N.J.: The Jersey City Museum, forthcoming.

Anreus, Alejandro, Diana L. Linden, and Jonathan Weinberg, eds. *The Social and the Real: Political Art of the 1930s in the Americas.* Princeton: Princeton University Press, forthcoming.

Baigell, Matthew. *The American Scene: American Painting During the 1930s.* New York: Praeger, 1974.

———. *Jewish-American Artists and the Holocaust.* New Brunswick, N.J.: Rutgers University Press, 1997.

Baigell, Matthew, and Julia Williams, eds. *Artists Against War and Fascism: Papers of the First American Artists' Congress.* New Brunswick, N.J.: Rutgers University Press, 1986.

Benison, Saul, and Sandra Otter. Interviews with Ben Shahn. Columbia University Oral History Research Office, New York.

Bentivoglio, Mirella. *Ben Shahn.* Rome: De Luca Editore, 1963.

Berman, Greta. *The Lost Years: Mural Painting in New York City under the Works Progress Administration Federal Art Project, 1935–1943.* New York: Garland, 1978.

Berman, Greta, and Jeffrey Wechsler. *Realism and Realities: The Other Side of American Painting, 1940–1960.* Exh. cat. New Brunswick, N.J.: Rutgers University Art Gallery, 1981.

Bush, Martin H. *Ben Shahn: The Passion of Sacco and Vanzetti.* Syracuse, N.Y.: Syracuse University Press, 1968.

Carlisle, John Charles. "A Biographical Study of How the Artist Became a Humanitarian Activist: Ben Shahn, 1930–1946." Ph.D. diss., University of Michigan, 1972.

Contemporary Great Masters: Ben Shahn. Tokyo: Kodansha, 1992.

Contreras, Belisario R. *Tradition and Innovation in New Deal Art.* Lewisburg: Bucknell University Press, 1983.

Doss, Erika. *Benton, Pollock, and the Politics of Modernism: From Regionalism to Abstract Expressionism.* Chicago: University of Chicago Press, 1991.

Edwards, Susan H. *Ben Shahn and the Task of Photography in Thirties America.* Exh. cat. New York: Bertha and Karl Leubsdorf Art Gallery, Hunter College, 1995.

———. "Ben Shahn: The Road South." *History of Photography* 19 (Spring 1995): 13–19.

Fogg Art Museum. *The Art of Ben Shahn.* Exh. cat. Cambridge: Fogg Art Museum, 1956.

———. *Ben Shahn as Photographer.* Exh. cat. Cambridge: Fogg Art Museum, 1969.

Frascina, Frances, et al. *Modernism in Dispute: Art Since the Forties.* New Haven: Yale University Press, 1993.

Frascina, Francis, ed. *Pollock and After: The Critical Debate.* New York: Harper and Row, 1985.

Grossman, Emery. *Art and Tradition, the Jewish Artist in America.* New York: Thomas Yoseleff, 1967.

Guilbaut, Serge. *How New York Stole the Idea of Modern Art: Abstract Expressionism, Freedom and the Cold War.* Trans. Arthur Goldhammer. Chicago: The University of Chicago Press, 1983.

Halasz, Piri. *The Expressionist Vision: A Central Theme in New York in the 1940s.* Exh. cat. Greenvale, N.Y.: Hillwood Art Gallery, School of the Arts, C. W. Post Center, Long Island University, 1983.

Harris, Jonathan. *Federal Art and National Culture: The Politics of Identity in New Deal America.* Cambridge: Cambridge University Press, 1995.

Hess, Thomas. "Ben Shahn Paints a Picture." *Art News* 48 (May 1949): 20–22, 55–56.

Hills, Patricia. *Social Concern and Urban Realism: American Painting of the 1930s.* Exh. cat. Boston: Boston University Art Gallery, 1983.

Kao, Deborah Martin, and Laura Katzman. *Ben Shahn's New York: The Photography of Social Conscience.* Exh. cat. New Haven: Yale University Press in association with Harvard University Art Museums, forthcoming.

Katzman, Laura. "Art in the Atomic Age: Ben Shahn's *Stop H Bomb Tests.*" *Yale Journal of Criticism* 11, no. 1 (Spring 1998): 139–58.

———. "The Politics of Media: Ben Shahn and Photography." Ph.D. diss., Yale University, 1997.

———. "The Politics of Media: Painting and Photography in the Art of Ben Shahn." *American Art* 7, no. 1 (Winter 1993): 60–87.

Kostelanetz, Richard. "Ben Shahn, Master 'Journalist' of American Art (1969)." In *On Innovative Art(ist)s: Recollections of an Expanding Field.* Jefferson: McFarland, 1992.

Kuh, Katherine. "Ben Shahn." In *The Artist's Voice: Talks with 17 Artists.* New York: Harper and Row, 1962.

Leja, Michael. *Reframing Abstract Expressionism: Subjectivity and Painting in the 1940s.* New Haven: Yale University Press, 1993.

Linden, Diana L. "Ben Shahn's Murals for the Bronx Central Post Office." *Antiques Magazine* 150, no. 5 (November 1996): 708–15.

———. "The New Deal Murals of Ben Shahn: The Intersection of Jewish Identity, Social Reform and Government Patronage." Ph.D. diss., City University of New York, 1997.

McKinzie, Richard D. *The New Deal for Artists.* Princeton: Princeton University Press, 1973.

Marling, Karal Ann. *Wall to Wall America: A Cultural History of Post Office Murals in the Great Depression.* Minneapolis: University of Minneapolis Press, 1982.

Morse, John D., ed. *Ben Shahn.* New York: Praeger, 1972.

Museum of Art, Williams College. *Ben Shahn, the Thirties.* Exh. cat. Williamstown, Mass.: Museum of Art, Williams College, 1977.

The Museum of Modern Art. *Ben Shahn 1898–1969.* Exh. cat. New York: The Museum of Modern Art, 1969.

National Museum of Modern Art. *The Exhibition of Ben Shahn.* Exh. cat. Tokyo: National Museum of Modern Art, 1970.

O'Connor, Francis V. *Federal Support for the Visual Arts: The New Deal and Now.* Greenwich, Conn.: New York Graphic Society, 1969.

O'Connor, Francis V., ed. *Art for the Millions: Essays from the 1930s by Artists of the WPA Federal Art Project.* Greenwich, Conn.: New York Graphic Society, 1973.

———. *The New Deal Art Projects: An Anthology of Memoirs.* Washington, D.C.: Smithsonian Institution Press, 1972.

Park, Marlene, and Gerald E. Markowitz. *New Deal for Art: The Government Art Projects of the 1930s with Examples from New York City and State.* Exh. cat. New York: The Gallery Association of New York State, 1977.

Pohl, Frances K. "An American in Venice: Ben Shahn and the U.S. Foreign Policy at the 1954 Venice Biennale." *Art History* 4, no. 1 (March 1981): 80–113.

———. "The Artist and the Politicians: Ben Shahn, 1947–54." Ph.D. diss., University of California, Los Angeles, 1985.

———. *Ben Shahn.* Rohnert Park, Calif.: Pomegranate Artbooks, 1993.

———. "Ben Shahn." In *American National Biography.* Oxford: Oxford University Press, 1997.

———. "Ben Shahn and *Fortune* Magazine." *Labor's Heritage* 1, no. 1 (January 1989): 46–55.

———. *Ben Shahn: New Deal Artist in a Cold War Climate, 1947–1954.* Austin: University of Texas Press, 1989.

———. "Constructing History, A Mural by Ben Shahn." *Arts Magazine* 62, no. 1 (September 1987): 36–40.

Polcari, Stephen. *Abstract Expressionism and the Modern Experience.* New York: Cambridge University Press, 1991.

Pratt, Davis, ed. *The Photographic Eye of Ben Shahn.* Cambridge: Harvard University Press, 1975.

Prescott, Kenneth W. *Ben Shahn, a Retrospective 1898–1969.* Exh. cat. New York: The Jewish Museum, 1976.

———. *Ben Shahn Retrospective Exhibition.* Exh. cat. Fukushima City, Japan: Fukushima Prefectural Museum of Art, 1991.

———. *Prints and Posters of Ben Shahn.* New York: Dover, 1982.

———. *The Complete Graphic Works of Ben Shahn.* New York: Quadrangle/The New York Times Book Company, 1973.

Rodman, Selden. *Portrait of the Artist as an American, Ben Shahn: A Biography with Pictures.* New York: Harper and Brothers, 1951.

Selvig, Forrest. "Interview: Ben Shahn Talks with Forrest Selvig." *Archives of American Art Journal* 17, no. 3 (Fall 1977): 14–21.

Shahn, Ben. *Love and Joy About Letters.* New York: Grossman, 1963.

———. Ben Shahn Papers. Archives of American Art, Smithsonian Institution, Washington, D.C.

———. *Paragraphs on Art.* New York: Spiral, 1952.

———. *The Shape of Content.* Cambridge: Harvard University Press, 1957.

Shahn, Bernarda Bryson. *Ben Shahn.* New York: Harry N. Abrams, 1972.

Shapiro, David, and Cecile Shapiro. *Abstract Expressionism: A Critical Record.* Cambridge: Cambridge University Press, 1990.

Shapiro, David, ed. *Social Realism: Art as a Weapon.* New York: Frederick Ungar, 1973.

Soby, James Thrall. *Ben Shahn.* Exh. cat. New York: The Museum of Modern Art and Penguin Books, 1947.

———. *Ben Shahn: His Graphic Art.* New York: George Braziller, 1957.

———. *Ben Shahn: Paintings.* New York: George Braziller, 1963.

The Stephen Lee Taller Ben Shahn Archive. Cambridge: Harvard University.

United States Capitol. *Homage to Ben Shahn.* Exh. cat. Washington, D.C.: United States Capitol, 1978.

Vishny, Michele. "On the Walls: Murals by Ben Shahn, Philip Guston and Seymour Fogel for the Social Security Building, Washington, D.C." *Arts Magazine* 61, no. 7 (March 1987): 40–43.

Whiting, Cécile. *Antifascism in American Art.* New Haven: Yale University Press, 1989.

Index of Names

Photographic Credits

Albright-Knox Art Gallery, Buffalo (plate 12 and cover detail)

Amon Carter Museum, Fort Worth, Texas (fig. 18)

Archives of American Art, Smithsonian Institution, Washington, D.C., photo Robert McClintock/Photo Assist (figs. 1, 26, p. 184 left)

© 1998 The Art Institute of Chicago. All Rights Reserved (figs. 45, 46)

Auburn University, Auburn, Alabama (fig. 6)

The Brooklyn Museum of Art (fig. 47)

Christie's Images, New York (fig. 67)

Curtis Galleries, Minneapolis, Minnesota (plate 3)

© 1998 The Detroit Institute of Arts (plate 18); © 1991 (plate 22)

Sid Deutsch Gallery, New York (plate 26)

Terry Dintenfass, Inc., in association with Salander-O'Reilley Galleries, photo John Parnell (fig. 37)

© 1996 Estate of Ben Shahn/Licensed by VAGA, New York, N.Y. (figs. 5, 34)

Forum Gallery, New York (fig. 14)

Fred Jones Jr. Museum of Art, The University of Oklahoma, Norman (plate 10 and detail p. 2)

The Free Library of Philadelphia, photo Will Brown (fig. 55)

Fukushima Prefectural Museum of Art, Japan (plates 16, 28)

Courtesy Galerie Nichido, Tokyo (plate 19)

Hirshhorn Museum and Sculpture Garden, Smithsonian Institution, Washington, D.C.

(fig. 43); photo Lee Stalsworth (figs. 12, 58, plate 21)

The Jewish Museum, New York, photo John Parnell (figs. 48, 50, plates 1, 13 and back cover)

Paul Jonason Photography (plate 27)

Courtesy Irene and Mark Kauffman (fig. 61)

Kennedy Galleries, Inc., New York (figs. 31, 32, 33, 60)

Krannert Art Museum and Kinkead Pavilion, University of Illinois, Champaign (fig. 65, plate 20 and detail pp. 142–43)

LeMoyne-Owen College, Memphis, Tennessee, photo Morgan A. Mukarran (fig. 69)

Library of Congress, Washington, D.C. (fig. 41)

Maier Museum of Art, Randolph-Macon Woman's College, Lynchburg, Virginia (plate 31)

The Metropolitan Museum of Art, New York (figs. 8, 57)

Allen Mewbourn Photography (fig. 20)

Modern Art Museum of Fort Worth (fig. 62, plate 14 and detail p. 110)

Moderna Museet, Stockholm, photo SKM 1998/Per Anders Allsten (plate 30)

Montgomery Museum of Fine Arts (plate 6 and detail p. 66)

Munson-Williams-Proctor Institute Museum of Art, Utica, New York (fig. 39)

© Museum of Contemporary Art, Chicago (fig. 4)

© 1998 The Museum of Modern Art, New York (figs. 51, 54, plates 4, 8, 9, 11)

Nationalmuseum, Stockholm, photo SKM 1995 (plate 32)

National Museum of American Art, Smithsonian Institution, Washington, D.C. (figs. 42, 66)

Neuberger Museum of Art, Purchase College, State University of New York, photo Jim Frank (figs. 16, 17, 56)

New Jersey State Museum, Trenton (fig. 9)

Norton Museum of Art, West Palm Beach, Florida (fig. 19)

Okawa Museum of Art, Gumma, Japan (fig. 21)

John Parnell Photography (plate 23)

The Pennsylvania Academy of the Fine Arts, Philadelphia (fig. 13)

Philadelphia Museum of Art, photo Graydon Wood (plate 15)

Courtesy Michael Rosenfeld Gallery, New York (plate 2 and detail p. 36)

The Saint Louis Art Museum (plate 7)

San Diego Museum of Art (plate 25 and detail p. ii)

Courtesy Bernarda B. Shahn (pp. 185, 188); photo Max Scheler (p. 186 left); photo Selden Rodman (p. 186 right); photo Newark News Photos (p. 187); photo Syracuse University Photo Lab/Center for Instructional Communications (p. 189)

Courtesy Judith Shahn (pp. 183, 184 right)

Sheldon Memorial Art Gallery, University of Nebraska-Lincoln (fig. 53)

Smith College Museum of Art, Northampton, Massachusetts, photo Herbert P. Vose (fig. 72)